MW01000589

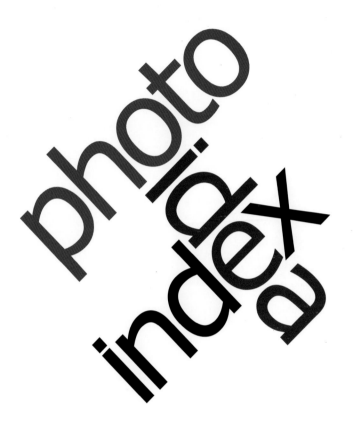

JIM KRAUSE

F+W Publications, Inc.
CINCINNATI, OHIO

Photo Idea Index. Copyright © 2005 by Jim Krause. Manufactured in China. All rights reserved. No other part of this book may be reproduced in any form or by any electronic or mechanical means including information storage and retrieval systems without permission in writing from the publisher, except by a reviewer, who may quote brief passages in a review. Published by HOW Books, an imprint of F+W Publications, Inc., 4700 East Galbraith Road, Cincinnati, Ohio 45236. (800) 289-0963. First edition.

09 08 07 06 05 5 4 3 2 1

Distributed in Canada by Fraser Direct
100 Armstrong Avenue
Georgetown, ON, Canada L7G 5S4
Tel: (905) 877-4411

Distributed in the U.K. and Europe by David & Charles
Brunel House, Newton Abbot, Devon, TQ12 4PU, England
Tel: (+44) 1626 323200, Fax: (+44) 1626 323319
E-mail: mail@davidandcharles.co.uk

Distributed in Australia by Capricorn Link
P.O. Box 704, Windsor, NSW 2756 Australia
Tel: (02) 4577-3555

Library of Congress Cataloging-in-Publication Data

Krause, Jim,
 Photo idea index : explore new ways to capture and create exceptional images with digital cameras and software / Jim Krause.
 p. cm.
 Includes index.
 ISBN 1-58180-766-X (flexibind : alk. paper)
 1. Photography--Digital techniques. I. Title.
TR267.K73 2006
775--dc22
 2005018945

Cover and interior design by Jim Krause
Edited by Amy Schell
Production coordinated by Kristen Heller

A sincere thank you for all who provided inspiration, gave advice, loaned props, and agreed to appear in images for this book:

Brian B.	Jason K.
Katherine B.	Peter K.
Tricia B.	Alex L.
Vinnie B.	Daniel L.
Amy C.	Amy O.
Nico C.	Heidi O.
Mark D.	Anne P.
Toby D.	Kate R.
Andrew F.	Amy S.
Kristi F.	David S.
Ash G.	Jesse S.
Kelly H.	Kristin S.
Laurel H.	Melina S.
Evan K.	Sukhi S.

About the Author.
Jim Krause has worked as a designer/illustrator/ photographer in the Pacific Northwest since the 1980s. He has produced award-winning work for clients large and small and is the author and creator of five other titles available from HOW Books: *Idea Index, Layout Index, Color Index, Design Basics Index* and *Creative Sparks.*
WWW.JIMKRAUSEDESIGN.COM

DIGITAL FREEDOM.

The thrill of recording an image—one that conveys the essence of a significant moment or the beauty of a spectacular sight—never grows stale to those who love taking pictures. This is true regardless of how much experience the photographer has or what type of camera they use to capture images.

Photo Idea Index specifically promotes digital photography. Why? Well, it's not because digital cameras take better pictures than cameras that use film. Rather, it's that cameras that capture their images electronically give the photographer creativity-boosting breaks in ways that film cannot. (And as you'll see in the pages ahead, this book grants strong favoritism toward creativity and artistic exploration in the image-creation process.) For one thing, digital cameras let the photographer review shots as they are taken to see what is working and what is not. This allows us to take chances with the camera, try out all kinds of new shooting techniques, and to refine our picture-taking methods on-the-fly until successful shots are captured. In the days of film-only shooting a photographer had to wait until their shots came back from processing to find out exactly how the camera was seeing things when the shutter was clicked.

Another great perk of digital media is that you

don't have to pay for film and developing costs for all of the photos that you take (the good, the bad *and* the underexposed). This may not seem like a big deal if you are an uber-experienced photographer who rarely takes a shot that doesn't come out as planned, but for the rest of us, this means that all of a sudden we have at our fingertips a medium that does not ask us to pay for unsuccessful photographs.

Just imagine—a medium that grants instant grati-fication, encourages creative exploration and does not penalize us monetarily for our mistakes! Viva la digital!

SOMETHING FOR JUST ABOUT EVERYONE.
If you are new to photography (or the visual arts in general), *Photo Idea Index* will encourage you to use whatever skills and instincts you have, and at the same time, will offer suggestions designed to help

raise your creative savvy to new heights. *Photo Idea Index* also offers a great deal of practical information that will expand the technical know-how of read-ers who are currently at the shallow end of photog-raphy's learning curve.

Photo Idea Index is aimed toward graphic design-ers, illustrators and fine artists who want to sharpen and expand their picture-taking skills for image-creation and communicative purposes. The content of this book

is meant to be about 80% inspirational and 20% infor-
mational—a formula that connects well with most cre-
ative types who learn through visual examples and
hands-on exploration. Right-brained individuals
such as these are encouraged to view all of the samples
in this book as *creative prompts* as well sources of infor-
mation. As prompts, the visuals are intended to enter
the mind of the creative reader, mix with the myriad of
ideas already cooking in there, and ignite chain reac-
tions that will result in new ways of effectively captur-
ing and presenting images.

If you are an intermediate or advanced photog-
rapher, or a photographer making a switch in empha-
sis from film to digital media, *Photo Idea Index*
has something for you as well. Just about every
spread in this book contains examples and text that

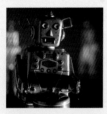 are intended to inspire, kick-
start—and maybe even revolu-
tionize—your approach to pho-
tography. All of us, no matter
how much time we've spent in
the creative arts, benefit when we come across some-
thing that causes us to ask ourselves something like,
*Hey, what if I combined a concept like this with the
ideas that I already have brewing for such-and-such
project of my own...?*

As with other books in the Index series,* *Photo
Idea Index* is primarily a "what if" book—as opposed

to a "how to" book. If there's one thing that this book aims to leave in the mind of the individual reader (regardless of their level of photo- graphic or artistic experience), it's this: *YOU are your camera's best viewfinder. Constantly cultivate your creative instincts and your eye for aesthetics so that whatever technical skills you possess will be put to their best use.*

A NEW KIND OF DARKROOM.

As stated near the beginning of the Digital Effects sec- tion, *"Software is to digital photography as the dark- room is to film."* And just as most photographers who use film consider the darkroom *the* place where the artistic value of an image is either maximized or destroyed, those of us who use digital media should consider the use of software an essential intermediate step between the taking of a picture and its display. (Nearly every image in this book was treated using Photoshop's image-enhancement controls in prepara- tion for printing. Most of the time, this meant applying minor adjustments within the LEVELS or CURVES controls to fine-tune the photo's contrast and/or color balance.)

Since Photoshop is such a widely used and ver-

Idea Index (2000); Layout Index (2001); Color Index (2002); Design Basics Index (2004); and also, Creative Sparks (2003).

satile program, all of the digital enhancement examples in this book are presented within the environment of this program. These examples are aimed toward readers with at least a moderate level of Photoshop competency. If you have never used an image enhancement program, consider spending the time and resources necessary to get a handle on the basic functions of Photoshop (or 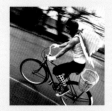 any other image-oriented program that has an adequate array of contrast, color and touch-up capabilities). With these skills, you will be able to bring the quality of your images to their full potential in preparation for electronic display or printing.

SPENDTHRIFT PHOTOGRAPHY.

An intentional and unconventional decision was made at the beginning of this book's creation: *All of the images would be shot using cameras and equipment that are available within the low to middle range of the cost spectrum.*

Most of shots in this book were taken using the 4 megapixel Canon pocket digital camera shown on page 274. All but a few of the remaining images were shot using a relatively inexpensive 8 megapixel Canon SLR, with one of four lenses. These items can be seen on pages 322-323. The lighting equipment for the studio

shots was purchased at a hardware outlet (as opposed to a photography store). These lights, and the reflector and photographer's umbrella used with them, are featured on pages 258-259.

The reasons for this creativity-before-pricey-equipment approach to photography are aligned with the beliefs that good composition and intriguing subject matter are independent of the camera that captures them, and that a photographer who is creative and resourceful will be able to capture aesthetically sound and communicative photographs using practically any kind of functioning equipment.

ENJOY.

Have fun with *Photo Idea Index*. As the author, I hope that this book inspires each reader toward a more enthusiastic and expansive approach to their own picture-taking forays—just as its creation did for me.

I would love to see examples of the photos you take! Feel free to e-mail me some of your favorites at favorites@jimkrausedesign.com.*

Best,

Jim K.

Jim Krause

*My server will accept e-mails of 1mb or less.

To consistently capture and present effective images, you need to possess a good understanding of your digital camera, of your image-oriented software, and of the effects of light. Still, your *most* valuable assets as a photographer are the creative skills and aesthetic instincts that shape and drive all of your picture-taking endeavors. After all, it's YOU who decides *what* to take pictures of and *where, when* and *how* to take them. It's YOUR sense of creativity and your eye for aesthetics that will result in images that draw attention and communicate meaning. This section—the largest in *Photo Idea Index*—focuses on creative, compositional and conceptual skills that can be applied to all kinds of photo opportunities. Consult the glossary beginning on page 352 if you come across photographic terms that you are unfamiliar with throughout this book.

section:

1

You

POINT OF VIEW

Ansel Adams once said, *"A good photo is knowing where to stand."* And who are we to argue? Whenever possible, explore a variety of viewpoints of your subject or scene before deciding on favorites. Hunt tenaciously for points of view that will help your main subject(s) stand out from surrounding elements while eliminating unwanted items from the composition. Look for vantage points that will make the best use of available light and put the overall image into a satisfying aesthetic arrangement. Take your time (if time allows) when exploring camera angles and keep your mind open to pleasant surprises along the way—rarely does the first p.o.v. that we consider turn out to be the best. *Get close; get really close; move far away; crouch or lie beneath your subject; tower above it (use a ladder?); hold the camera straight and level; tilt it at a crazy angle; stand next to, walk around or run with your subject.* Be sure to investigate perspectives that are both "normal" and radical (and don't be surprised if these alternative viewpoints turn out to be favorites when it comes time to review your shots).

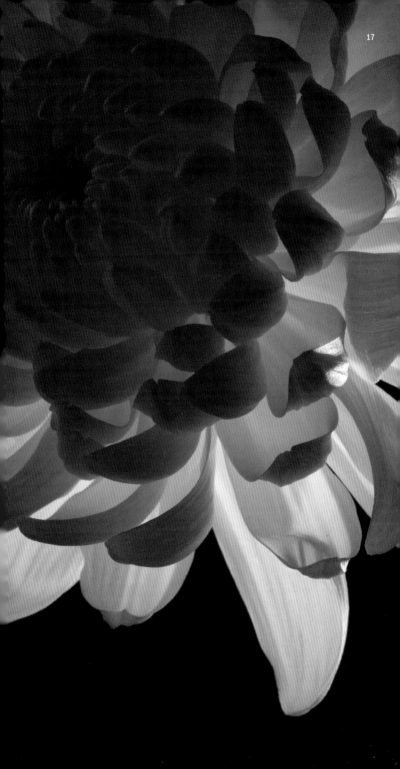

SECTION 1: YOU: POINT OF VIEW

Get in the habit of considering and exploring viewpoint options whenever you come across something that you want to take a picture of.

In addition to looking for vantage points that will put your subject and its surroundings into a satisfying visual arrangement (SEE THE CHAPTER ON COMPOSITION BEGINNING ON PAGE 74), take thematic considerations into account as well. Ask yourself, *Are there viewpoints that include secondary elements that will bolster the thematic conveyances of the main subject? Are there viewpoints that should be avoided because they include elements that contradict the stylistic delivery I'm after?*

Avoid "tunnel vision"—the tendency to notice only the main subject in your viewfinder or on your LCD. Get in the habit of looking all around the scene to see if improvements could be made to the shot by moving the camera to a different vantage point or tilting it at a different angle.

Challenge yourself to find ever-new ways of seeing the world through your camera—and be sure to take full advantage digital photography's greatest of advantage over film: the freedom to take plenty of pictures without worrying about processing costs.

These two perspec- ▶ ▶
tives of a historic
tower in NW
Washington State
were chosen because
of the "framing" effect
provided by the
lightposts and tele-
phone poles. Framing
adds compositional
strength to an image
and helps direct the
viewer's attention.
SEE **FRAMING**, PAGE 90.

Think outside ▶ ▫
the box—or (as in
this case) *inside*
a nearby building
when considering
vantage points.

Here, interaction ▫ ▶
between angular,
curved, and ornate
forms result in a
strong composition.
SEE **LINES AND CURVES**,
PAGE 102.

These two viewpoints ▶ ▶
present the tower in
less conventional
ways—the viewer has
to search to find its
form within each
image. SEE **VISUAL
HIERARCHY**, PAGE 94,
AND **INTENTIONAL DIS-
TRACTION**, PAGE 190.

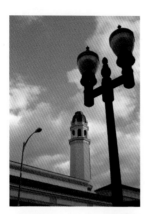
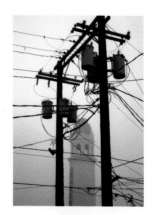
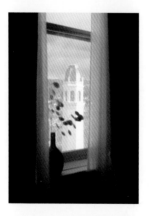
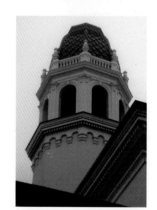
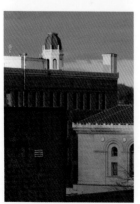
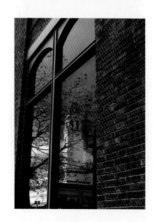

Exploring different vantage points applies to all kinds of subjects and situations.

Here, the search for effective points of view takes place in miniature proportions.

Be thorough when exploring points of view for an image. Take plenty of pictures as you go; take chances as well—all you have to lose is a few MB of disk space.

I located this antique toy airplane online and purchased it from a seller in Scotland for a very reasonable price. The Web makes prop-collecting (pardon the pun) easier than ever.

In addition to giving examples of viewpoint exploration, these images also introduce a number of topics that are covered in the pages ahead:

CROPPING (PAGES 34-37). Excess image-area has been removed (cropped) from each of these photos. Cropping can be used to change the proportions of an image; to remove unwanted elements; and to create a stronger overall composition.

BACKDROP (PAGES 38-69). A scrap of metallic insulation was chosen as a backdrop for the plane because it echoed the metal construction of the subject, reflected color throughout the scene, and provided an intentionally ambiguous backing that contrasted well with the plane itself.

DIRECT AND REFLECTED LIGHT (PAGES 256-299): A single 500-watt quartz bulb (inexpensive and very bright) was used to light these shots. Color was added throughout each scene by reflecting light off of colored sheets of paper that were held out-of-frame. AN IN-DEPTH LOOK AT THE LIGHTS AND REFLECTORS USED FOR IMAGES THROUGHOUT THIS BOOK ARE FEATURED ON PAGES 258-259.

JUXTAPOSITION (PAGES 248-249). The toy plane's antiquity was intentionally amplified by contrasting it with a shiny, modern backdrop.

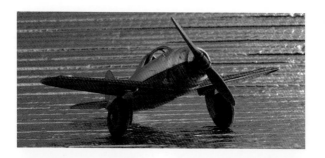

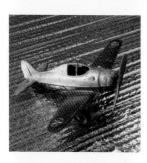

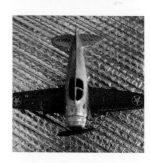

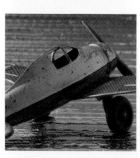

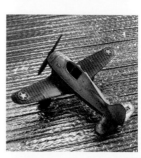

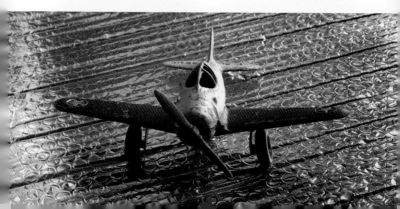

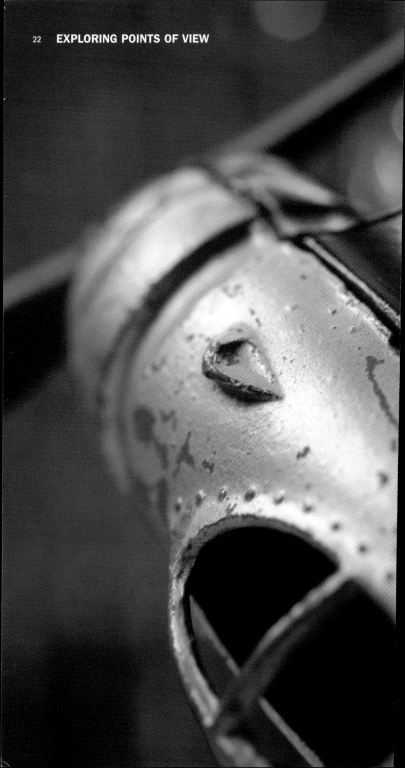

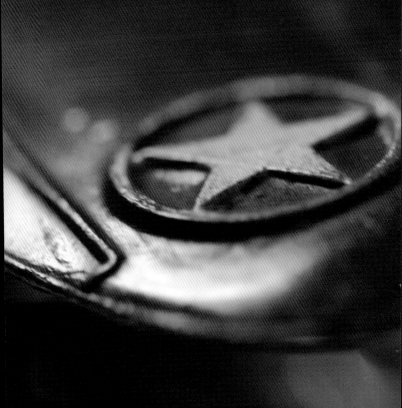

Regardless of what kind of photo you are shooting—portrait, still life, landscape, studio or spur-of-the-moment—be sure to investigate radical points of view. Very often, these viewpoints reveal aspects of a subject's beauty that might have otherwise gone unnoticed.

Most of the photos in this book were taken using a pocket digital camera. These photos, however, were taken with a digital SLR equipped with a "macro" lens (a type of lens that is able to take very sharp close-up photos, SEE PAGE 323). The blurred background in each photo is the result of the lens' very shallow depth of field capability. SEE **DEPTH OF FIELD,** PAGES 306-309.

Embrace opportunity! Take pictures whenever you find yourself viewing the world from a novel perspective. Each of these photos was taken through the window of an airliner using a pocket digital camera.

You are keeping your camera with you at all times… right?

If a ride on an airplane isn't in your near future, consider taking an elevator to the upper floor of a tall building and taking photos from there; visit the top of a parking garage; hike to the peak of a scenic overlook. *Remember: Your camera depends on you to take it to exciting vantage points.*

The colors in each of these photos were originally quite muted (thanks to the plexiglass window and the less-than-transparent air between the camera and its subjects). Color and contrast controls within Photoshop were used to amplify the hues in each image to ready them for presentation. SEE **LEVELS ADJUSTMENTS**, PAGE 332, AND **HUE AND SATURATION**, PAGE 336.

▶ Be on the lookout for interesting clouds—whether they are above or below your head. SEE **COLLECT CLOUDS**, PAGE 196.

▶ It's not every day that you find yourself above a 14,000-foot volcano. I was glad to have my camera on hand as the airliner I was traveling in passed over the glacier-covered flanks of Mt. Rainier.

▶ Sometimes an image's "flaws" add to its visual or thematic presentation. The motion-blur in this photo resulted from the movement of the airplane from which it was taken. I saved the shot since the effect seemed to enhance the feeling of bustle in this rush-hour freeway scene. SEE **SHAKE IT**, PAGE 242.

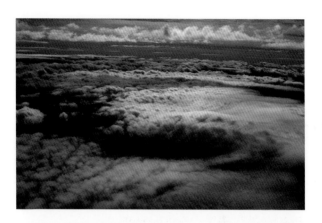

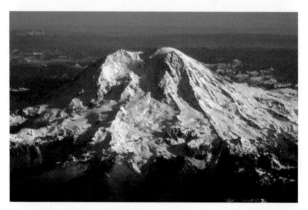

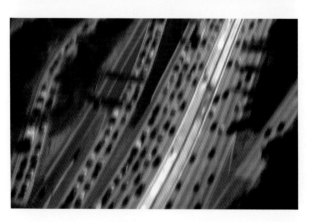

Micro photo opportunities are everywhere. Becoming aware of them means you'll never run out of intriguing and readily available subject matter.

Take close-ups of toys, fabric, plants, people, animals, soil, asphalt, and anything else that is all-too-easy to overlook when your attention is being held up by larger matters. Shoot images that are abstract, representational and anywhere in between.

Nearly all digital cameras have a close-up setting that allows them to focus on subjects that are very near the lens. Consult your manual if you are unsure of how to use this feature on your camera.

Digital SLRs can accept "macro" lenses that are specifically designed for ultra close-ups. The following spread provides a dramatic example of a macro lens' capabilities.

This close-up of a ▶ dahlia's petals was taken with a hi-tech camera and a low-tech light source. The camera: a digital SLR with a macro lens. The light source: a simple flashlight, aimed from behind the flower. see **BACK-LIGHTING,** PAGES 278-281 AND **FLASHLIGHTS,** PAGE 284.

Close-ups can reveal ▶ surprising beauty in commonplace items.

The sturdy weave of a messenger bag makes an interesting abstraction when seen up close. Shots like this could be featured as they are or used as a back-drops within a digital composition.

While taking photos ▶ of a tall and elegant flagpole, I chanced to look down and see what I considered to be the even more beautiful forms of its cable tie-off. Be on the lookout for unexpected close-up photo opportunities whenever you have your camera in-hand.

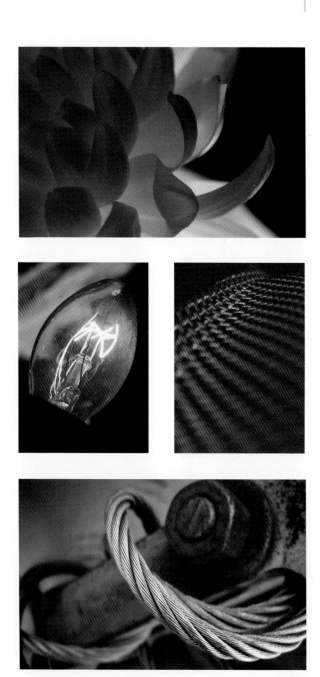

A macro lens can bring tiny subject matter up to a size where it can be more fully appreciated.

The macro lens used for this shot captured a significant amount of detail in both the wasp and its paper backdrop. Notice the tiny hairs on the wasp's body and the fibers in the paper behind it.
SEE **LENSES,** PAGE 322.

The spotlight effect was achieved by aiming a flashlight from above. The blue highlights on the wasp were added by directing a simple key-chain light at its body.
SEE **FLASHLIGHTS,** PAGE 284, AND **MINI-SPOT,** PAGE 286.

I found the body of this wasp on my front porch and thought it would be a perfect subject for my macro lens. And, since it was a paper-making wasp, I decided to use a sheet of paper (complete with a printed pattern of flowers) as a backdrop for the scene. Train yourself to think of all kinds of found objects and happenstance occurrences as potential subject matter for photos.
SEE **BEYOND THE OBVIOUS,** PAGE 202, AND **HAPPENSTANCE HAPPENS,** PAGE 216.

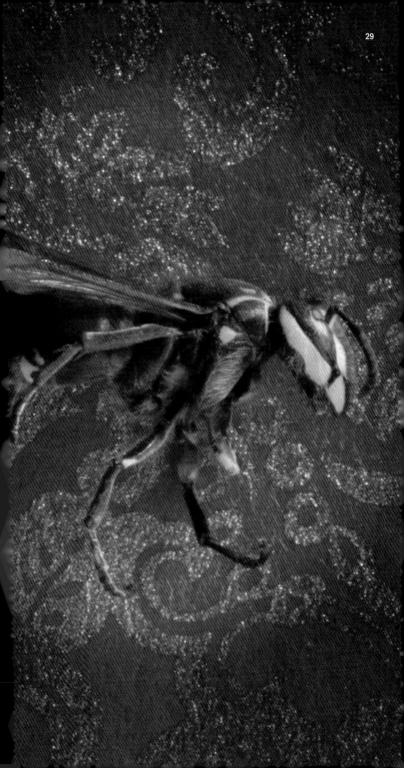

You CAN take it with you.
They are words worth remembering—and ones that are oft-repeated throughout this book: Keep your camera with you **as much as possible** and take **lots** of pics when the shooting is good. Take pictures of people, plants, animals, land-scapes, everyday objects, unique occurrences and textures, and select your favorites after the picture-taking is done.

Film cameras are superb artistic tools. Digital cameras, however, have an advantage over film when it comes to being able to review pictures on the spot. In addition, you don't have to worry about film or processing costs. Take advantage of these perks—shoot lots of images and don't be afraid to take chances!

Everyday checklist:
- Pocket digi-cam
- Extra battery
- Media card
- Waterproof carrying case

Advanced photoshoot (minimal) checklist:
- Digital SLR or advanced digital camera
- At least one extra battery
- Large capacity media card(s)
- Tripod
- Portable reflectors (see page 258)
- Lens-cleaning equipment
- Extra lenses (opt., see page 322)
- Flash unit w/ batteries (opt.)
- Waterproof bag/case

Many images can benefit from a skewed presentation.

A visually dynamic result can be obtained by tilting the camera—even if what you are aiming at is perfectly still. SEE CONVEYING ACTION, PAGES 166-169.

Many people find it unnatural to hold their camera at an odd angle when composing a shot. *Get over it! Experiment! Have fun!* If picture-taking perspectives such as these are new to you, take note of the photos you see and enjoy in books, on the web and in advertising. You may be surprised to find how common it is for professional photographers to shoot from all kinds of canted angles.

Tip: Don't be bashful about it when you tilt your camera to frame a scene. Avoid taking shots that look as though they are crooked by accident—such as when the horizon line in a landscape is almost, but not quite level.

Keep in mind that a tilted presentation can also be achieved by *cropping* your image at an angle. SEE CROP, PAGES 34-37.

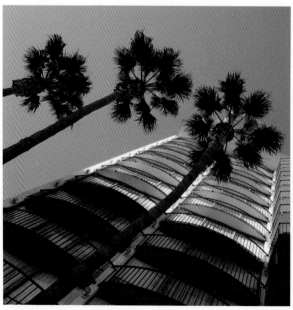

The presentation of many photos can be improved when unwanted or distracting elements are eliminated through cropping.

Cropping can be used to improve composition by changing the relationships between an image's borders and the elements inside. SEE THE **COMPOSITION PRIMER** ON PAGES 76-79.

Graphic designers almost always have to crop images to fit the proportional requirements of their layouts.

Most cameras and computers come packaged with software that can be used to digitally crop images.

Each of the images, opposite, were featured on previous pages. The yellow boxes show how the originals were cropped.

A square cropping ▶ was taken from this rectangular original so that the image would fit into its allotted space on the previous page.

It is often necessary ▶ to crop equipment (such as the blue reflector-panel seen to the left of the subject in this image) from shots taken in the studio.

I kept cropping ▶ tighter and tighter on this photo until I finally found a composition that I liked. If the resolution of an image is high enough, aggressive cropping such as this is feasible.
SEE, **SHARING PIXELS,** PAGE 124.

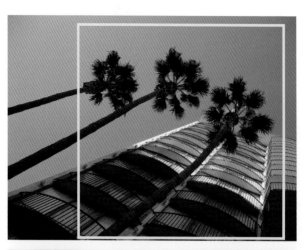

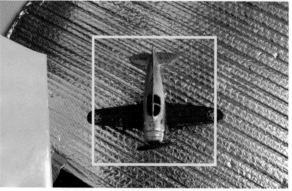

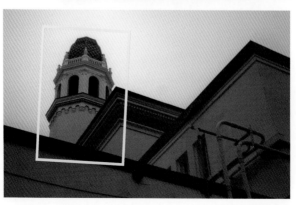

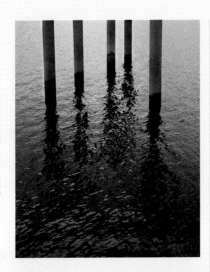

This cropping results ▶ in a highly structured composition. Here, the pillars are the main subjects and their reflections are a visual footnote. SEE **ABSTRACTION,** PAGES 230-233.

The reflections are ▶ given the dominant role in this active composition. Note how the tilted cropping enhances the dynamic presentation of the image. SEE **TILT,** PAGE 32, AND **VISUAL HIERARCHY,** PAGE 94.

Keep your mind open to potential sub-images within larger photos. This shot of a group of pilings and their reflections (above) offered material for a several completely different compositions, both identifiable and abstract (opposite).

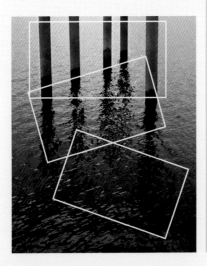

An interesting ▶ abstraction is taken from a portion of the foreground; the pillars have been eliminated entirely from this composition. SEE **REFLECTIVE SURFACES,** PAGES 66-69.

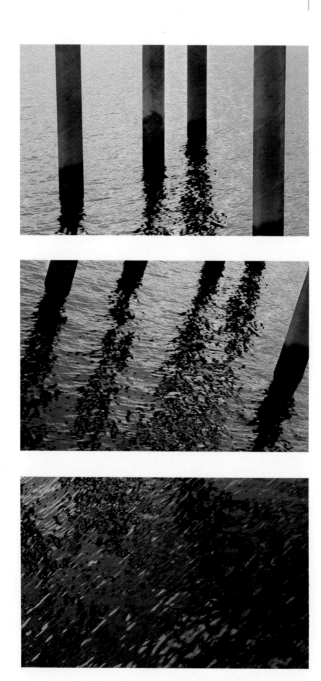

ESTABLISHING ENVIRONMENT

Professional photographers take a great deal of care when establishing an environment for the people and things they are shooting: They know that a subject's backdrop and setting will either add to—or take away from—the visual and thematic impact of the overall image. Before clicking the shutter, take note of the visual elements surrounding your subject(s) and consider their effects. Ask: *Is the backdrop competing for visual dominance with the main subject? Is the backdrop too dark, too light, too busy, too plain, too colorful or too gray to best complement the subject? Could a different point of view remove distracting elements from the composition? Is everything in the scene contributing to the thematic look and feel of the overall image? Should the scene's environment be altered by adding something to it? How about taking something away? Is everything perfect just as it is?* The examples in this section are mostly presented in controlled studio environments. Their lessons, however, can be applied to all kinds of photo opportunities: naturally occurring; staged; controlled; or completely out-of-control.

It is important to consider the value* contrast between your subject and its backdrop. Efficient control of value helps a subject stand apart from its surroundings. Most of the time, it's desirable to ensure that whatever you are taking a picture of is either lighter or darker than the backdrop it is set against.

Bold contrast tends to enforce themes that are themselves strong. Softer contrast can lend notes of quietude and comfort to an image. Ask yourself: *How much contrast is appropriate given the subject-matter being photographed and the stylistic outcome I am aiming for?*

Contrast is affected by the colors and shades of an images's elements, as well as by the way light is striking those elements. Whenever possible, thoroughly explore lighting, setting and arrangement options in search of solutions that provide good value contrasts throughout a scene.

Learn more about the effects of value contrast through observation: noteworthy photographers, cinematographers and painters of all kinds take great care to manage the value contrasts in their images.

**Value = the relative lightness or darkness of a color or shade compared to a scale of white to black.*

The kiwi fruit in this ▶ arrangement has been given visual prominence by putting it in white bowls that are set against a light backdrop. Good value contrasts (light vs. dark) are essential in helping a subject stand out against its backdrop.

These onions' skins ▶ are only slightly darker than their backdrop. Subtle contrasts can be used to bring a note of calm to an image. *The lighting effect in this shot was achieved by aiming a bright quartz bulb through the slats of a crate. Warm light was bounced into the scene from the left using a gold reflector.*

In this contemporary ▶ image, light and shadow are the only things separating the un-cut Kiwano fruit from its backdrop. It is usually best to establish decisive contrast between a subject and its backing. Sometimes, however, "rules" such as this can be bent when an intriguing result is being sought.

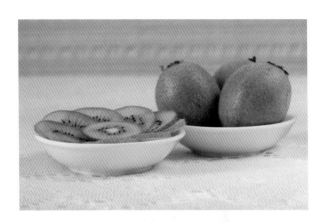

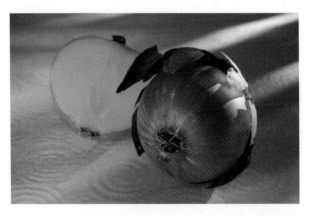

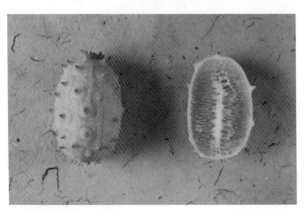

Great artists are notorious for breaking the "rules" of their craft in order to catch viewers' attention and deliver thematic messages. The most effective rule-breakers seem to be those who understand a rule's purpose, and therefore have an idea of what to expect when it is bent or smashed.

The "busy backdrop rule" goes something like this: *Don't place a subject against a busy backdrop—especially if the subject itself is visually busy. Why? Because the result can be chaotic and confusing to the eye.*

However, when the thematic result for an image is *meant* to be active, chaotic or even disturbing, *a busy backdrop might be just the thing that is called for...*

Let your artistic instinct tell you when to break the busy backdrop rule. And, once you've decided to defy this axiom, it's up to you to decide how far to go. Experiment with backdrop, lighting and point of view options that either amplify or subdue the sense of visual tension between your subject and its setting.

The backdrops behind these subjects are hardly passive. In the top image, the result could be described as visually active; in the lower photo, the effect is nearly chaotic. Note, however, how each image is infused with certain harmonious characteristics to keep it from overwhelming the viewer's eye: The fabric's pattern in the top photo echoes the shape of the main subject; in the lower photo, the tablecloth's colors echo the hues of the half-eaten pomegranate.

Sometimes the unsightly can be just what you are looking for. SEE **UGLY IS BEAUTIFUL**, PAGE 192.

...and speaking of backdrops, there are times when a subject is best displayed with none at all. The digital era makes backdrop-removal easier than ever. SEE **CLIPPING PATHS,** PAGE 346.

In addition to considering the *visual* relationship between your subject and backdrop, be sure to consider *thematic* aspects as well.

Whether capturing images in a studio or on the go, ask yourself, *Should the subject complement—or contrast with—its backdrop?*

▶ Most times, photographers look for settings and props that complement their main subject(s).

▶ But what about mixing things up in order to add a note of humor, intrigue or even confusion to the image? Images used in fine arts, advertising and design often deliver their messages through unexpected juxtapositions. SEE **METAPHOR**, PAGE 246, AND **JUXTAPOSITION**, PAGE 248.

For this shot, I aimed a flashlight ▶ *upward from near the base of the bowl to add to the scene's feeling of faux drama. This lighting technique also took advantage of the the interesting ways that the cut glass reflected and refracted the flashlight's beam.* SEE **FLASHLIGHTS**, PAGE 284, AND **MINI-SPOT**, PAGE 286.

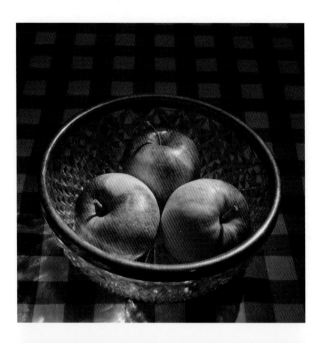

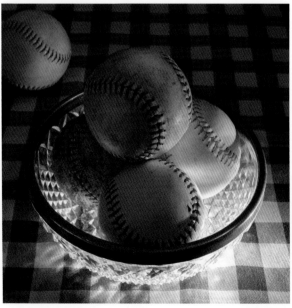

When it comes to studio backdrops, paper is probably the most varied and easily accessible material there is.

Have you visited your local paper or art store lately and taken a look at what's available?

If you plan on shooting pictures of people or things for commercial or personal projects, consider accumulating a stockpile of different papers that could be used as backdrops.

And even though certain art papers can be pricey, don't forget that there are plenty of budget options such as newsprint, butcher paper (far image, lower right) and cardboard.

Some of the backdrops featured on this spread provide an unobtrusive, supportive setting for the subject. Others compete with the subject for attention. Choose a backdrop that emphasizes the overall look and feel you are are after.

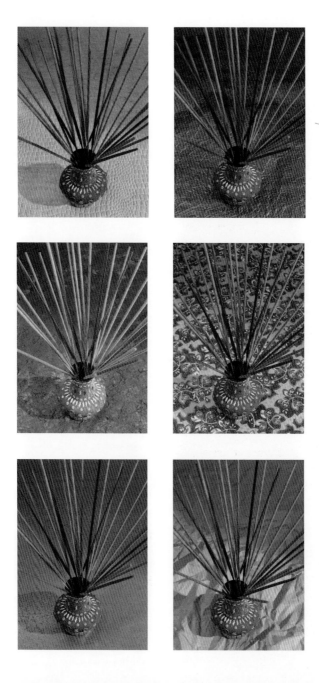

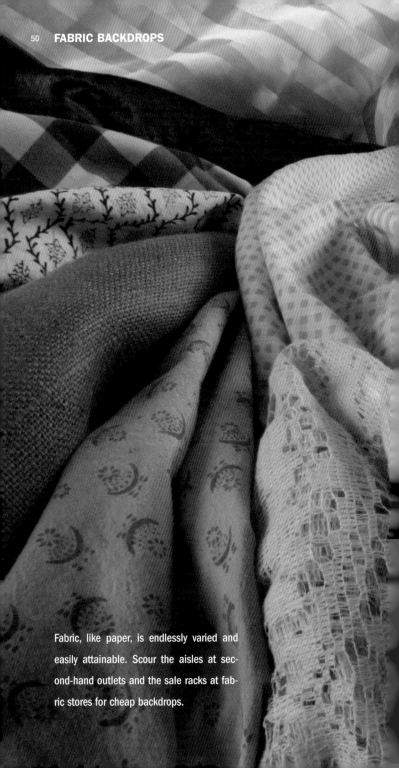

Fabric, like paper, is endlessly varied and easily attainable. Scour the aisles at second-hand outlets and the sale racks at fabric stores for cheap backdrops.

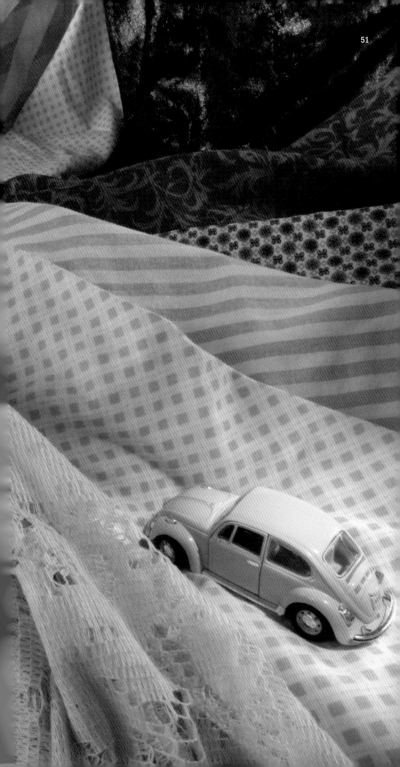

A "natural" setting is a visual context in which the featured subject(s) would normally be seen. A natural setting might also be considered one where materials such as wood, soil, stone, plants, or natural fabrics or papers are used to create a scene's environment. In the samples at right, both of these definitions have been applied in various ways.

Natural materials can be used to add notes of warmth and comfort to user-friendly items such as the bars of soap featured on the opposite page.

Natural materials can be contrasted against mechanical or hi-tech subjects to add a sense of thematic tension or irony.

When deciding how to establish a setting around your subject(s), ask: *What sort of environment would best support the look and feel being sought? Am I going for a complementary—or contrasting—association between subject and setting? What specific background materials could be used to achieve this effect? Where can I find these materials? In addition to a backdrop, should the shot be accessorized with items that further enforce the overall theme? What kind of lighting should be used to enhance all of these considerations?*

Handmade paper ▶ and dried flowers echo the user-friendly conveyances of the bars of soap featured here. A sculpted glass block serves as a physical pedestal for the soap while providing visual separation between the main subject and its backdrop.

The light in this photo was cast by a quartz bulb aimed from the right of the subjects. Warm light was returned to the setting by a gold reflector, out of frame to the left. The spotlit patch of light behind the glass block was added using a handheld flashlight. SEE **AFFORDABLE LIGHT**, PAGE 258, **DIFFUSED LIGHT**, PAGE 272, AND **FLASHLIGHTS**, PAGE 284.

Consider the obvious: ▶ ■ Here, tile, wood and washcloths create a likely environment for the featured subject.

...What about using ■ ▶ *natural backdrop material, collected straight from nature?*

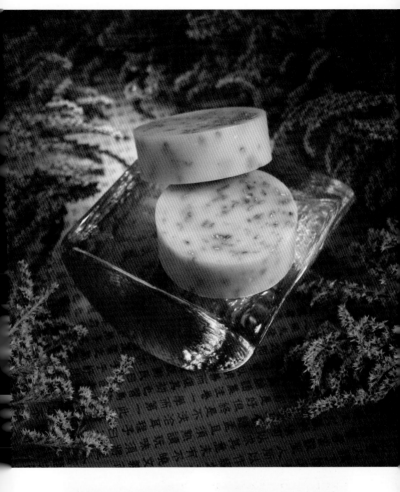

Here's another category to consider when deciding on a setting for your subject: *Industrial.*

Industrial settings are, of course, well-suited for subjects that are themselves mechanical in nature.

Industrial settings can also be employed to broadcast feelings of distress, discomfort, danger or alienation—especially when they are juxtaposed against more "innocent" subjects (three examples, opposite).

Secondhand stores, junk yards and hardware outlets are great places to search for industrial-looking props and backdrops for your images.

If feasible, also consider bringing your subject to an industrial environment and taking its picture there.

A jack's head on a saw blade? In a drawer of plumbing fixtures? Superimposed over the digitally-altered image of an electrical substation? What's going on here? Who knows? Photographs such as these can gain an added degree of notice precisely because of the obscurity of their message. These kinds of images are often used to draw attention to a poster, book cover, advertisement, or story whose textual content explains their message. SEE **IMPLYING STORY,** PAGE 244.

Note that the bottom image features a different sort of backdrop—one that has been added digitally. These days, it's important to remember that a backdrop need not be part of an original set-up; it can be added later using software such as Photoshop. SEE **CLIPPING PATHS**, PAGE 346, AND **IMAGE LAYERING DEMO**, PAGE 348.

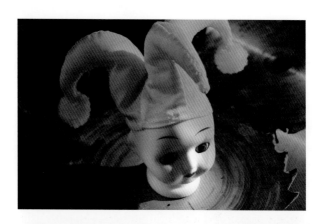

Have you considered a pseudo-cyber environment for your subject? Would this connect well with the visual and thematic goals you are after?

Hi-tech is a look that changes constantly (as does the technology that inspires it). If you wish to establish a hi-tech setting for an image, take care to do it in a way that fits today's concept of that genre. Either that, or come up with something that appears hi-tech in a non-specific way. (The backdrop in the lower photograph, opposite, is actually a rubber non-skid carpet pad.)

Consider all kinds of backdrops when thinking about how to best portray a subject. Natural, industrial, hi-tech, realistic, mythical, plain, busy, colorful, monochromatic, etc. Brainstorm: Come up with a large list of ideas before narrowing the possibilities and deciding on specifics. Look through magazines, catalogs, books and web sites for environment inspiration. Judge each potential idea in terms of its relation to the subject and the impression you are aiming for in your final image.

This image—like its ▶ predecessor on the previous page—is made up of layered photos. The circuit board and the 8-ball were photographed separately and digitally combined using Photoshop. A DEMONSTRATION OF HOW THIS IMAGE WAS CREATED IS FEATURED ON PAGE 348. ALSO SEE **HUE AND SATURATION**, PAGE 336, AND **COLLECTING BACKDROPS** ON THE NEXT SPREAD.

Hi-tech on a low ▶ budget: A textured rubber carpet pad has been lit with a simple flashlight to achieve an ambiguously techie-looking surface. The word inside the 8-ball and the image's blue tint were added in Photoshop. SEE **TINTING**, PAGE 342.

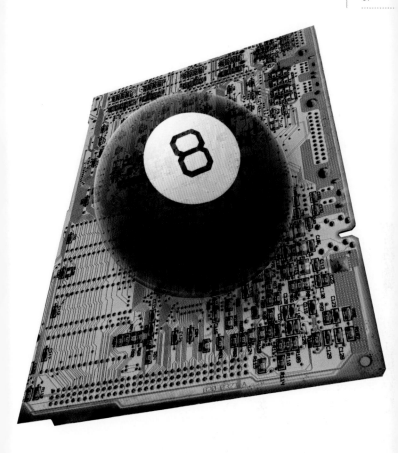

Capture and organize your own stockpile of images that could be used as digital backdrops within layered compositions.

Collect shots that are both realistic and abstract; colorful and plain; natural and manufactured; comforting and menacing. Organize them on your computer according to content and theme—a well-organized collection of such images is an invaluable resource for anyone who creates digital composites for personal or professional projects.

SEE **CLOSE-UP**, PAGES 26-29; **LIGHTPLAY**, PAGE 226; **ABSTRACTION**, PAGES 230-233, AND **PLAY WITH FIRE**, PAGES 236-239.

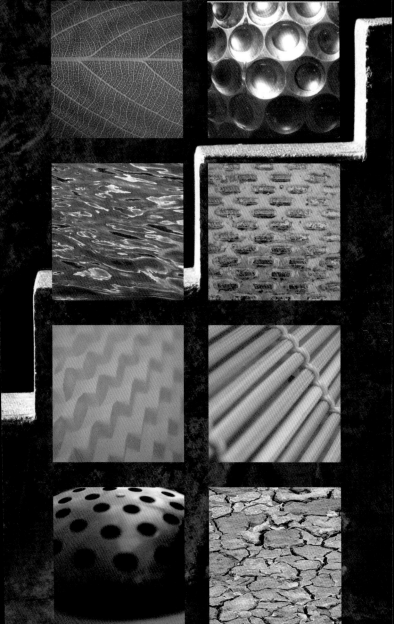

Instant studio.
Your pocket digital camera, a tripod and ordi-
nary lights can be used to take studio-like
shots. Here's a look at an improvised table-
top "studio" in action:

A sheet of colored paper A folded piece of
is clipped to a book and typing paper reflects
curled upward to seam- light into shadow
lessly fill the entire areas of the scene.
background behind the
subject.

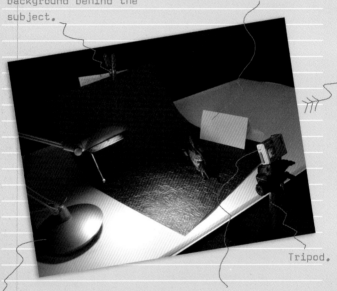

Tripod.

Pocket digi-cam.

Halogen desk lamp.

Naturally, a studio shot can be a lot more
complicated than this—but that doesn't mean it
has to be. Graphic designers and illustrators
who use photos can use a set-up like the one
shown above to quickly and conveniently capture
images for their projects.

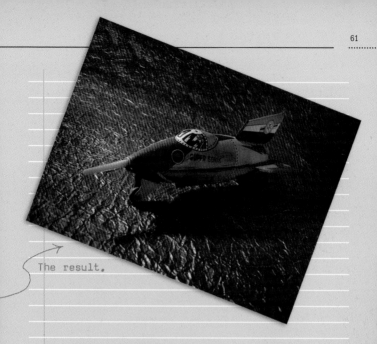

The result.

Become a collector.

If you enjoy taking studio-type shots,
how about starting a collection of props?
(Below is a snapshot of one corner of the
workspace where objects were stored for use
in this book. Some were used, others will be
saved for future projects...)

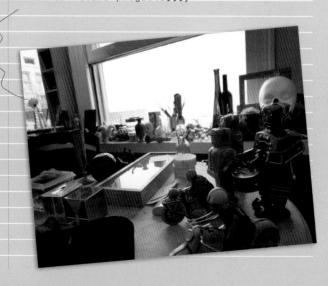

SECTION 1: YOU: ESTABLISHING ENVIRONMENT

When taking pictures of see-through subjects, investigate a variety of lighting and background options. Search for solutions that take advantage of these subjects' unique ability to both reflect and transmit light. SEE BACKLIGHTING, PAGES 278-281.

Even if your interests lie outside studio photography, you can benefit from studio-like exploration of transparent and translucent subject matter. A suggestion: Take a series of pictures using bottles, vases or eyeglasses as subjects. Use whatever light sources are available; try out different backdrops; strive for a wide range of outcomes. *Much can be learned from studio-like exploration such as this—knowledge that can be applied to all kinds of real world photo opportunities.*

Take advantage of ▶ ■ transparency. Here, a light has been aimed at the backdrop instead of the subject.

Activity amplified: Here, ■ ▶ the scene's visually busy backdrop is reflected in the bottle's transparent form, along with colors from the orange candies inside.

Colored glass bottles, ▶ a reflective surface, and a bright, out-of-focus background culminate in a scene that is full of light and visual energy.

Note: The table top was misted with water so that the bottles' colorful forms would be carried into the foreground by their reflections.

I used a digital SLR to take this photo since it allowed precise control over the lens's range of focus. Here, the depth of field is shallow enough to restrict the focus to the main subjects alone. SEE **DEPTH OF FIELD**, PAGE 306.

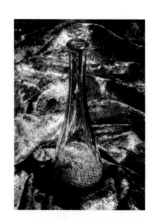

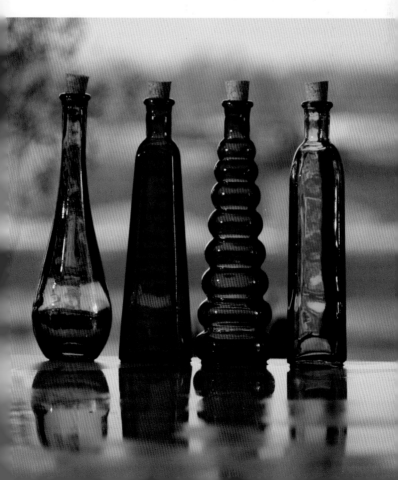

Under the right conditions, subject and backdrop can be made to nearly meld into one.

As a continuation of the exercise suggested on the previous spread, how about trying out a shot like this to see what you can discover about light, reflection and shadow? Strive for images that are both subtle and stark in their presentation. Explore lighting and point of view variations.

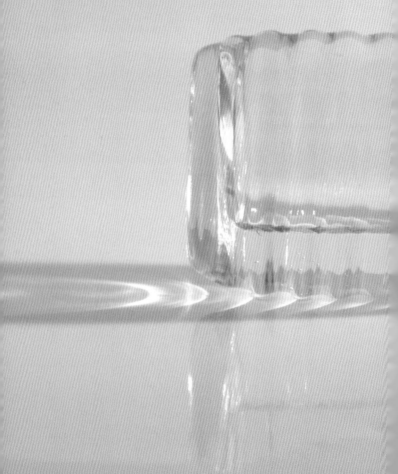

SECTION 1: YOU: ESTABLISHING ENVIRONMENT

Whether you are taking pictures of ceramic bowls in a studio or salt shakers on a deli countertop, consider including reflections of your subject in the shot. *Reflection can add visual richness and interest to an image.*

There are many kinds of tile, marble, linoleum, metal, foil, glass and coated paper that can be used as a reflective surface in the studio.

Reflective materials abound in everyday life as well; look for opportunities to incorporate their effects in the photos you take.

Water can be added to many dull surfaces to make them reflective (AS IN THE IMAGE OF THE COLORED BOTTLES AT THE BOTTOM OF PAGE 63).

When taking pictures of a scene that includes interesting reflections, be sure to experiment with different points of view—the angle from which you are aiming the camera can have a big effect on the reflections occurring in the shot.

Colors from the back- ▶ drop and hints of the subjects' forms are transmitted throughout this image by a glossy tile surface. Reflections dramatically enhance this scene's conveyances of energy and depth.

Here, the sensation ▶ of luxury is amplified by the mirror-like surface beneath the subjects. For this effect, an inexpensive sheet of chrome-coated paper was used—curled upward behind the subjects to create a seamless transition into a vertical backdrop.

Low in cost, high in ▶ visual impact: Aluminum foil can be used as an intriguing on-the-cheap backdrop. Though highly reflective, foil is easy to work with when crumpled like this since it does not reflect images of studio equipment in its scattered surfaces.

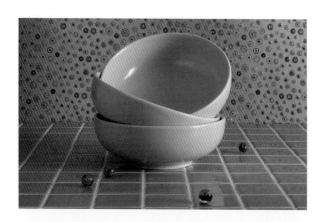

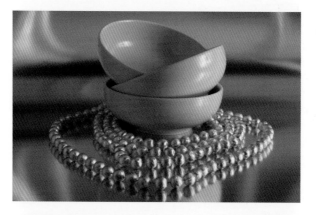

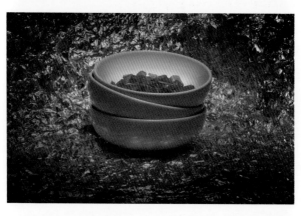

Most of us are oddly blind to reflections in the world around us. For example, we tend to look *through* glass rather than at the reflections *on* it; and when we look at a boat *on* the water, we often overlook its reflection *in* the water.

Train your eye and mind to notice reflections so that you can capture them with your camera.

Two examples of real-world reflective surfaces—one naturally occurring; one man-made. The top image was taken from a low angle to extend the sailboat's reflection well into the foreground. The glass blocks in the lower photo dramatically reflect light from the late afternoon sun. The aesthetic value of these scenes would be significantly diminished without the appealing effect of the reflections they contain.

You may have noticed that these photos are the first to appear in this book that are not in color. Though originally shot in color, I decided that their presentation was more appealing once their hues were converted to mono-chromatic tones. I often use my computer's software to take a quick look at black-and-white versions of my favorite shots. If the results look promising, I save a fresh copy of the revised image and explore additional options and enhancements. SEE: **GRAYSCALE ALTERNATIVES,** PAGE 340; **TINTING,** PAGE 342; **BLACK AND WHITE,** PAGE 112; AND **LEVELS ADJUSTMENTS,** PAGE 332.

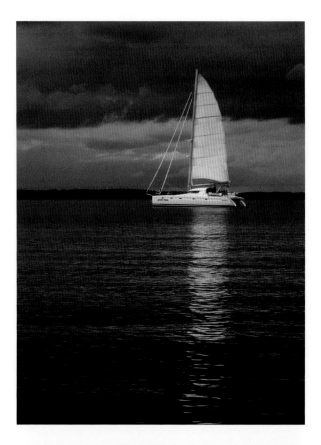

Arrange first, then add lights.

Many of the previous pages feature studio shots of arranged objects. Here's a demo of how a typical studio shot might come together. As a rule of thumb, it's usually best to **start** by looking through your camera's lens at the arrangement of your subjects. After you come up with a pleasing composition from the camera's point of view, it's time to explore lighting options. If you arrange the lighting before the composition is set, you will probably have to re-aim the lights after your subjects or camera angle have been moved. See the chapter on light beginning on page 256.

Start simple. An initial viewpoint is explored using minimal elements. Here, a bad tangent (defined on page 77) between the loaf and the table's edge will need to be fixed by lowering the camera's viewpoint. Window light is used to illuminate the scene at this stage.

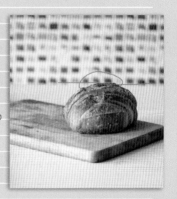

Add. Props are loosely fitted to the scene. Problems: items seem too spread out; the tops of the props form a line that slants out of the scene (this could be fixed by adding something along the left edge); backdrop is too blurred.

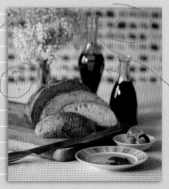

Coming together. Dishes have been added to the left to bring the overall composition into a strong triangular arrangement. The backdrop has been brought into sharper focus by closing down the camera's aperture (see Depth of field, page 306).

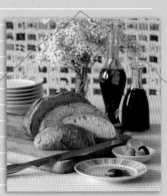

Light it. A quartz bulb is used to warmly light the scene from the right. A reflector has been placed to the left of the frame to return light into the scene. The background will need to be darkened since it seems to be competing with the subjects for attention.

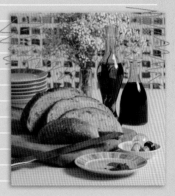

Fine-tune. The light has been re-aimed to darken the background. Now the subjects stand out better than before. The rear half of the table still seems a bit bright and the reflections on the bottles are too stark. (Continued on next page.)

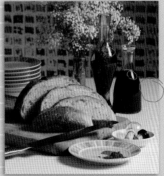

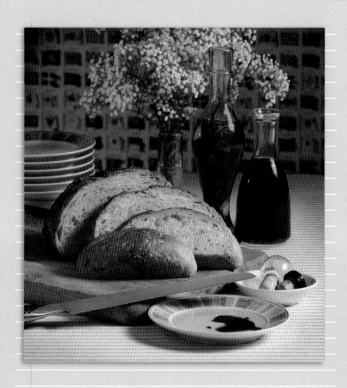

(Continued from previous page.)
The finale.
A piece of cardboard was placed out-of-frame
to the right to shield the rear of the table
from direct light. A diffusion panel was used
to soften the reflections on the bottles (see
Diffused light, page 272). Now the main sub-
jects stand out well in the midst of their
surroundings and the scene has a warm, com-
forting look that seems appropriate given the
subject matter. Take your time when setting up
a shot like this. Begin simple and add props,
lights and reflectors as you go.

Use a checklist such as the one shown on
the opposite page to help ensure that your
studio work goes as smoothly and efficiently
as possible.

Before you start:

- Decide on the stylistic result that you will be aiming for (maybe collect some sample images ahead of time to use as reference).
- If this is a commercial shot, make sure that you have a clear idea of what the client wants from the image. Consider inviting the client to take part in the photoshoot.
- Make sure your camera's battery is charged and that you have all the necessary photographic equipment. Have all props on hand.

As you arrange elements and during shooting:

- Strive for the strongest compositional arrangement for your scene. (See the chapter on composition beginning on page 74.)
- Be on the alert for bad tangents between elements.
- Make whatever changes are necessary to give clear dominance to the important elements of the shot (see Visual hierarchy, page 94). See to it that elements such as props and backdrops are supporting, rather than competing with, your main subject(s) for attention!
- Explore lighting options thoroughly.* Use reflectors or secondary lights to fill in "dead" shadow areas. Watch out for subjects that are casting unsightly shadows on others.
- Dim, diffuse, re-aim or reflect lights that are casting too much harsh light.
- Take pictures as you go and inspect your images carefully. Fix whatever needs fixing and keep checking your shots until everything is as it should be.
- Bracket your shots to improve your chances of success (see Bracketing, page 310).

* If you are using a flash unit, you will also want to take its effects into account.

CAPTURING COMPOSITION

Effective composition gives the eye a comfortable visual environment for exploration—free of pointless obstruction, dead ends and misleading directional cues. Painters *create* composition; photographers *capture* it. Unless a photographer is working in a controlled environment (such as a studio), he or she must work with subject matter as it presents itself. Some scenes readily offer strong compositional possibilities; others require an inventive viewpoint or camera angle to best capture their aesthetic potential. Either way, the trick is to *recognize* good composition when you see it through the viewfinder or on your camera's LCD. A photographer who is able to consistently recognize and capture instances of good composition is known as having "a good eye." Some people are born with a good eye (and sometimes *two*); others can develop their eye(s) through study, practice, learning from others, and by taking note of how great artists and photographers compose their images. If you feel that you are currently lacking in this type of artistic sensibility, don't be discouraged: Apply what you know and strive to expand your awareness of effective composition with every picture you take.

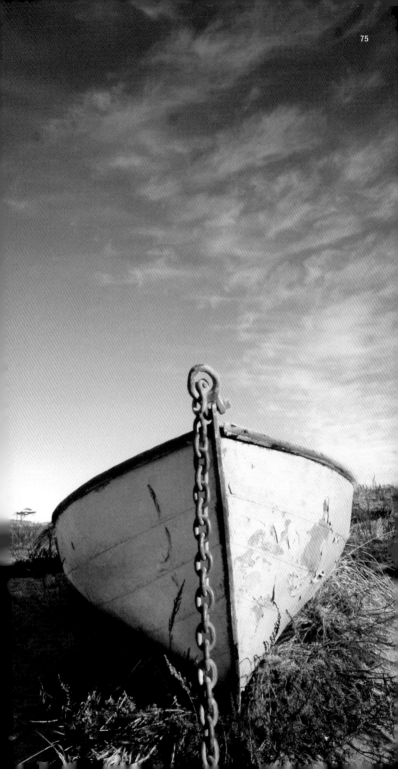

Visual delivery.
Think of an image's **content** as its cargo and
composition as its means of delivery.

If you are new to the ways of composition,
start by considering the basic axioms of eye-
pleasing aesthetics presented on this spread
and the next. Don't let the simplicity of
these guidelines fool you: Evidence of their
use is apparent in the work of great painters,
designers, cinematographers and photographers
of all levels of skill and experience.

**Incorporate as much compositional knowledge
and instinct you currently possess into every
photo you take. Creativity and artistic sense
grow with use!**

1. Unequal spaces. Unless
a static presentation is
desired, vary the amount
of space between your
main subject and the
image's edges. This gives
the viewer's eye some-
thing extra to consider
and play with while
looking at the image.
The distances between
the main subject and
other elements of the
composition should also
be varied if dynamic
conveyances are desired.

2. Avoid bad **tangents.**

A bad tangent occurs when the edges of two elements in a scene barely touch one another. In this set of examples, lowering the camera angle eliminates the bad tangent and simultaneously gives the cylinder strong dominance within the scene. (see Visual hierarchy, page 94). Get in the habit of scanning your viewfinder or LCD in search of bad tangents whenever you are considering a shot.

3. Unify. Avoid vantage points that portray a scene's elements as a scattered bunch of objects. Not all elements in an image need to be grouped together, but search for a point of view that gives the overall composition a feeling of unity. In these samples, the physical arrangement of objects is the same; only the camera angle is different.

Symmetry (see page 86).
Seek or create symmetrical compositions to convey notes of strength and order. (Note how the axiom of unequal spaces has been ignored here in favor of an intentionally static presentation.)

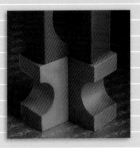

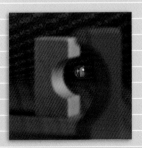

Asymmetry (see page 88).
Casual and chaotic themes can be delivered through loosely structured arrangements. Be mindful of bad tangents, good groupings and varied spacing within any compositional arrangement.

Framing (see page 90).
Try using certain elements to form a visual "frame" around another element. Framing, whether it is obvious (as in this sample) or subtle, helps direct and contain the viewer's attention.

Lines and curves (see page 102). Be on the lookout for pleasing associations between linear and curved elements within a scene. Photos of these details could be representational or abstract.

Repetition (see page 114). Consider including instances of repetition in your images to attract attention and convey harmony. Repetition can be used to create interesting patterns and visual textures.

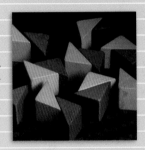

Effective composition streamlines the delivery of any photograph's visual and thematic message. Whenever possible, apply your ever-evolving compositional skills and instincts to the photos you take—whether you are capturing a portrait, working in a studio, photographing a landscape or taking pictures at a friend's birthday party.

One of the most powerful and ever-present compositional elements a photographer encounters is the horizon line. When it comes to deciding where to place the horizon in a photo, remember this: *Avoid the middle ground.*

Get in the habit of positioning the horizon line either well above—or well below—the vertical center of your images.

A high horizon compresses the sea and sky into the upper portion of this image. The garbage cans now have clear dominance over this deserted beach scene.

Note also how the shadows lend compositional help by leading the viewer's eye toward the main subjects.

Two compositional eye-irritants exist here: a dead-center horizon line and a bad tangent (DEFINED ON PAGE 77) between the cans' lids and the horizon. Raising the camera a few feet solved both of these issues (opposite, top).

A vantage point that gives strong prominence to the threatening sky was chosen for this shot since it seems to explain the lack of surfers and volleyball players in the scene. *I enjoy taking pictures when the weather is not conducive to the "normal" state of things in a particular place— the resulting photo opportunities are bound to be unique.*

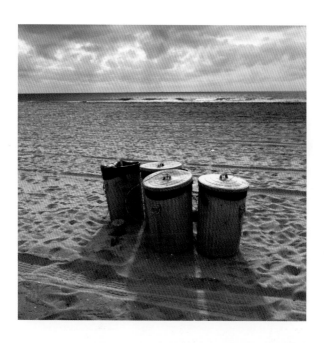

As mentioned in the Composition Primer (PAGES 76-79), varying the amount of space between a photograph's main subject and the edges of the image gives the viewer's sense of aesthetics extra fodder for consideration and enjoyment.

Still, don't fret if you snap an otherwise good photo where the main subject is stuck lifelessly in the center of the composition. After all, that's just the sort of thing image-alteration software is designed to help you take care of.

Good composition should start with the viewfinder or LCD, but it doesn't end there: Always consider your cropping options after you've downloaded your images into the computer.

Save multiple versions of a photo if you see more than one cropping solution you like as you explore alternatives. SEE **CROP** AND **AGGRESSIVE CROPPING,** PAGES 34-37.

▶ Dead center is not the most visually interesting spot for the bird to perch within this image. Another problem with the composition is that the bird seems "lost" within the overall image; if it is to be the star of the photograph, then it should dominate more clearly.

▶ Though still a simple composition, this cropping delivers dynamic visual conveyances through the varied spacing between the subject and the edges of the image. The tighter cropping also gives the bird clear hierarchy over the scene's territory. SEE **VISUAL HIERARCHY,** PAGE 94.

▶ Consider quirky solutions as well. Sometimes an unorthodox cropping can add notes of humor or intrigue to an image's presentation. Here, the photo has been tightly cropped, horizontally flipped and angled slightly to make it look as though the bird is peeking inquisitively into the frame.

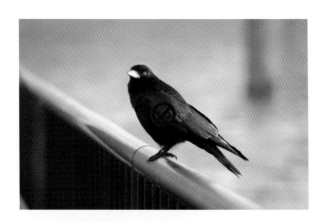

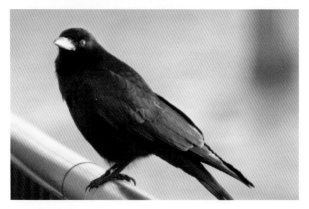

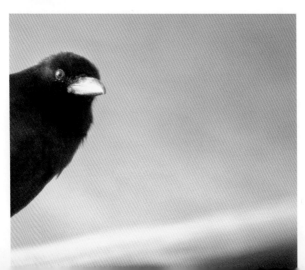

A photo's cropping is part of its composition, and it's all too easy to get stuck in a rut when it comes to image proportions.

Why not try something new every once in a while and experiment with extreme horizontal or vertical croppings?

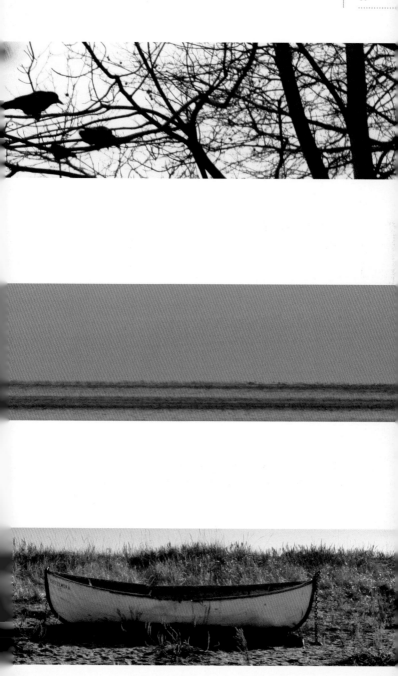

Symmetry, like a basic shape, is easy on the brain: It is a fundamental visual arrangement that does not challenge the viewer's comprehension.

Whether it is naturally occurring or contrived, symmetry lends a sense of compositional well-being to an image. Sometimes this conveyed sense of security is desirable—sometimes not. SEE ASYMMETRY, PAGE 88.

In real life, people tend to be intrigued by objects that are found in an unexpectedly symmetrical form or arrangement. Photographs taken of these unusual instances attract notice.

Symmetry need not be mathematically perfect to be eye-catching—the tree on the opposite page is a good example of attractive, freeflowing symmetry.

The symmetrical ▶ ▪ forms of a wading blue heron and its reflection combine to create an elegant impression.

An asymmetrical ▪ ▶ image of symmetrically arranged objects.

Organic symmetry– ▶ perfect in its imperfection.

I'd been having lunch near this tree for some time before I finally noticed its appealing and nearly symmetrical form. It's all too easy to **look** at something without **seeing** its aesthetic qualities. As a result, many outstanding photographic opportunities are missed. With practice, we can all hope to become better observers, and image-takers, of the world around us.

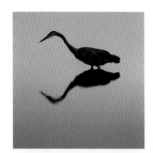

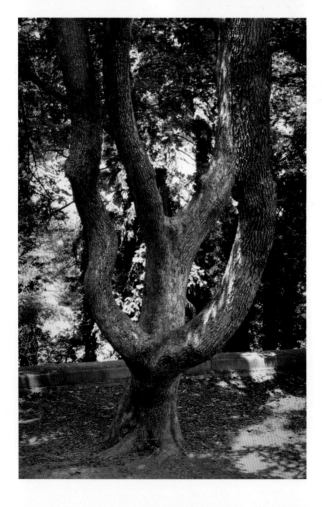

Symmetry comforts; *asymmetry challenges.*

Symmetry is yin; *asymmetry is yang.*

Symmetry is an easy environment for the eye to navigate. *Asymmetry is a visual wilderness—sometimes friendly, sometimes threatening.*

There is vast aesthetic and thematic potential in non-symmetrical forms and compositions—from casual to chaotic.

Perfect symmetry is clearly definable. Deciding when asymmetry is "perfect" is a judgment call. A photographer can develop their artistic instinct for effective asymmetrical balance and flow in the same way that a painter or sculptor does it: through observation, study and practice. Ask experienced artists and photographers for their opinions of your most compositionally challenging images.

The gnarled form of this giant cactus caught my attention outside a western-themed restaurant. I had to stick the camera (and my head) well inside the plant's girth to get an angle that excluded the less-than-photogenic facade of the restaurant.

Develop an eye for framing.

In this case, *framing* refers to the technique of surrounding your main subject (partly or in full) with other compositional elements.

Framing helps direct the viewer's eye to an image's center of interest. It also helps keep the eye from wandering outside an image's border.

Framing can be obvious or subtle. Some of the best examples of framing are those that are scarcely noticed.

Be careful not to allow an image's framing elements to overwhelm its main subject. (An obvious exception is when framing elements themselves are *meant* to be the main subject.)

Framing elements should have contextual, conceptual or aesthetic relevance to the main subject. Use complementary connections to build on a theme; contrasting associations to impart overtones of tension, intrigue or humor.

Look for examples of effective framing in the photos, paintings, cinematography and design. Learn from these examples and expand upon their lessons in your own photographic compositions.

An abandoned ▶ manufacturing plant framed by a disheveled security fence. Here, the main subject and its framing elements seem to thematically concur with the gloomy sky above.

A window-casing ▶ and a chair in the foreground frame the cat's head and direct attention to its gaze (which, in turn, is directed at a group of birds outside).

Dual duty: The palm ▶ fronds in this image not only act as framing elements around the building, they also lend a sense of context by giving clues to the subject's location and environment.

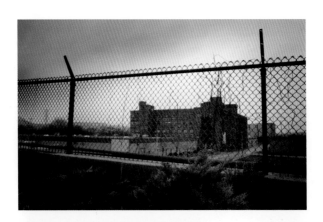

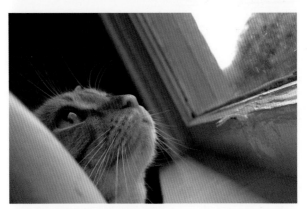

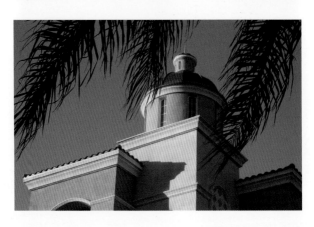

When you first looked at this image, did you notice how the break in the clouds helps frame the sign in the foreground? Framing need not be overt to be effective.

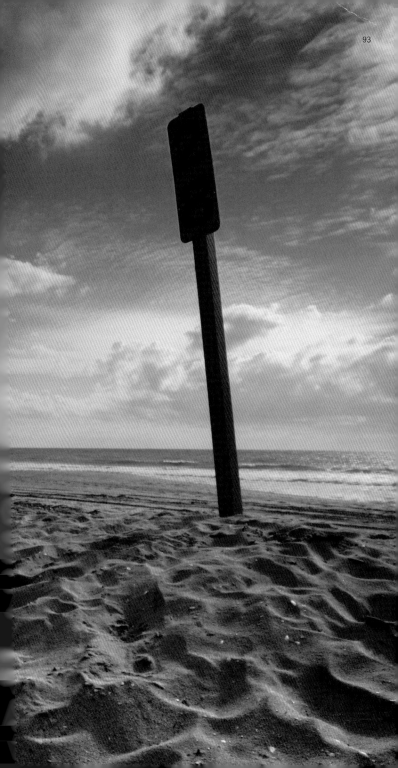

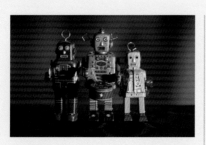

Three robots, each attracting about the same amount of visual attention. At right, arrangements and lighting effects that emphasize one 'bot over the others.

Apply levels of distinction to the elements in your photos in the same way that a stage director would assign parts in a play: Grant star status to one or two; place others in supporting roles, and cast the rest as extras. *More often than not, when a composition fails, it is because its elements are fighting each other for the viewer's attention.*

Whether you are taking a picture in a studio or out in the real world, explore variations of the scene's composition; how light is used; point of view options; and where the camera is focused to strengthen the sense of visual hierarchy in the shot.

In this arrangement, ▶ the "starring" robot stands near the lens in sharp focus while its co-stars hang back in the blurred distance. Taking advantage of an SLR lens's capability to alter its depth of field made this effect possible. SEE **DEPTH OF FIELD**, PAGE 306.

A spotlight is aimed ▶ ▣ at the smallest of the three robots to grant it visual dominance over its larger associates.

An offbeat solution: ▣ ▶ Here, the brightly illuminated yellow robot is framed by the dimly-lit legs of its foreground companion.

Center of attention ▶ need not be center-stage. Here, lighting and the camera's focus are used to direct the viewer's eyes to the robot at the left of the scene.

Explore variables such as these as you search for ways of establishing visual hierarchy in your images.

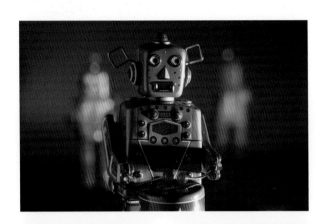

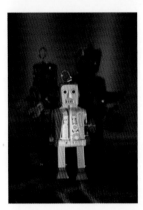

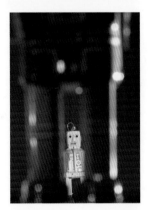

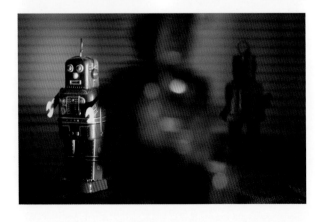

Visual dominance is relative.

Sometimes less is best when it comes
to an image's presentation.

Images such as this have potential
as backdrops for layouts or as layers
within digital compositions.

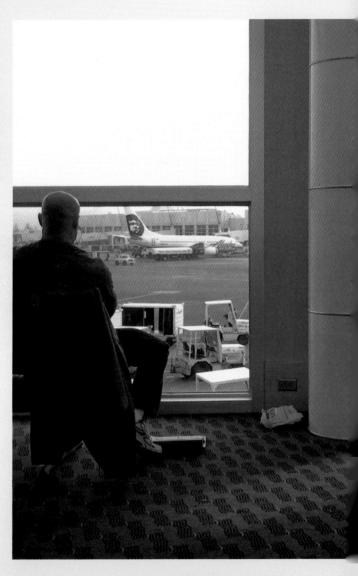

According to conventional design wisdom, it is improper to place a large obstruction smack-dab in the middle of a composition. Still, contemporary images often break rules such as this in favor of presenting a scene or situation in an intriguing manner. Here, a large column seems to accentuate the separation and isolation of the business travelers on either side of the image.

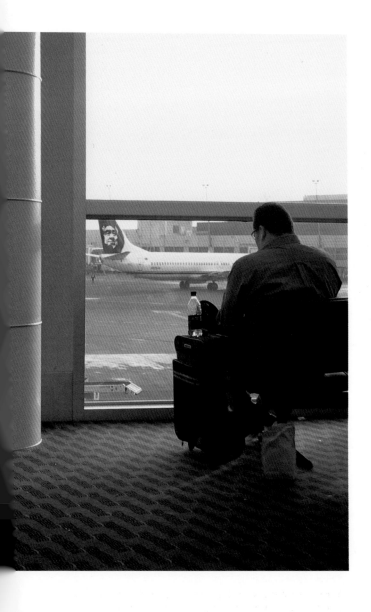

Most of us have been acquainted with simple geometric shapes since an early age. Geometric shapes, like instances of symmetry (PAGE 86), are easy for most viewers to wrap their head around and can lend a sense of familiarity and simplicity to a composition.

Geometric shapes are like self-contained designs within the larger composition of a photograph. Simple shapes infuse a photo with notes of order and sense.

Remember to explore different vantage points when considering a subject: Sometimes a particular point of view can transform the irregular contour of an object into a geometric shape (a cup of coffee, for example, when seen from above, can become a circle with a dark middle).

Be on the lookout for interesting and unexpected instances of simple shapes in the real world. If they are intriguing to you, then there's a good chance that others will be attracted to the photos you take of them.

A section of concrete pipe and a collection of bicycle wheels hung decoratively on a fence: simple geometric shapes in unexpected places and arrangements. Scenes such as these are ready-made compositions—just waiting to be photographed. SEE ALSO, **REPETITION**, PAGE 114, AND **LINES AND CURVES**, PAGE 102.

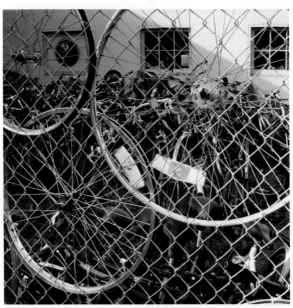

A curve is nothing more than a line that has been bent, right? Therefore, a curve is both related to, and different from, a line.

Why does this matter to photographers who want to improve the compositional integrity of their images? It matters because it means that when you record a photograph that is basically a collection of lines and curves, you are automatically infusing the image with two major pillars of art theory: harmony and contrast.

And all of this is really just a roundabout way of saying that since people are naturally drawn to artistic beauty, amiable combinations of lines and curves can be very hard to resist—whether these forms compose a logo, a work of art, an automobile or a photographic image.

Try this: Choose an object in your immediate vicinity—the more mundane, the better. Use your viewfinder to search for points of view that turn portions of your chosen subject into compositions of lines, curves and shapes. The photographs you take could include the whole subject or close-up details—the images could be of identifiable subject matter or abstract. This is a good self-teaching exercise that you can do almost anytime, anywhere, with your digital camera. Over time, you might be able to collect an entire series of images such as this—a series that might make an interesting ensemble when shown together...

Graceful associations between straight and curved lines make these images something more than mere photographic records of a theater marque and a boat's prow.

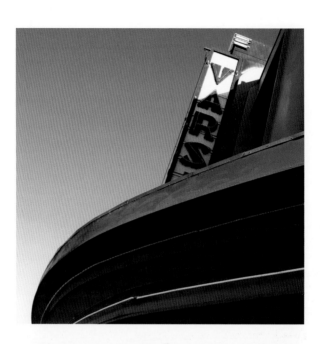

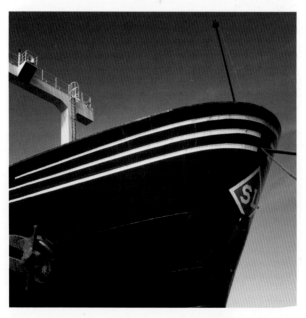

ATTRACTING ATTENTION

People are drawn to images that contain content that they find informative or intriguing on a personal level. There are also certain categories of visual themes that can be applied to images (regardless of the subject matter involved)—themes that can augment or override the "default preferences" of a broad spectrum of viewers by invoking aesthetic, emotional or curiosity-based connections. This chapter focuses on four such categories of attention-getters: color; repetition; visual texture; and the perception of depth. Keep your eyes and mind open to other eye-grabbing visual themes as well: Ask yourself, *What is it about certain images that invariably catch MY attention? What styles of presentation are impossible for ME to ignore?* Take note of these preferences and seek image opportunities that emphasize them—in doing so, you are likely to capture photographs that connect with others who have tastes and interests in common with yours.

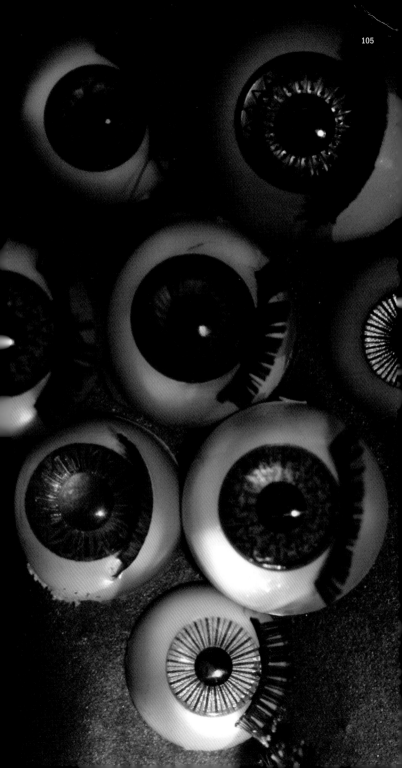

Color informs, influences, attracts and compels through countless visual and emotional channels. It is a basic human instinct to take notice of (and oftentimes, *react to*) colors.

Color can soothe, irritate, calm and invigorate. Color can infuse an image with passion, tranquility, hyper-realism or a sense of the surreal.

Look for—or create—scenes where the main subject is surrounded by colors that enforce its thematic energy, whether joyous, contemplative, active or sedate.

Bright morning light brings out the intense hues in both the sky and the facade of this colorful turn-of-the-last-century building.

If you know a bit of color theory, then you may recognize that the palette in this image is built around two pairs of complementary hues: blue + orange, and red + green—harmonious pairings that are easy on the eyes.

The hues in this photo were quite vibrant, directly from the camera. Still, I made minor enhancements using Photoshop's LEVELS *and* HUE AND SATURATION *controls to put a bit more color-kick in the final image.* SEE PAGES 332 AND 336 FOR MORE ABOUT THESE IMAGE-ENHANCING CONTROLS.

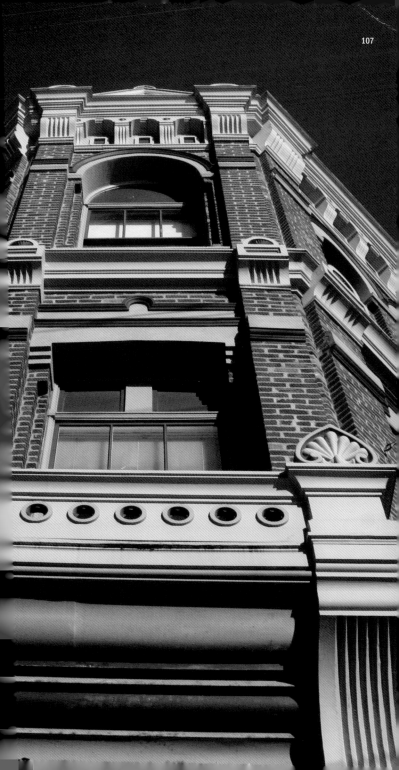

Color: *Seek it out, soak it in, and capture it in its most flattering light.*

If you are unsure about concepts surrounding the effects and uses of color, learn about them in the same way you would any art-related subject: study and observe. *Read about color, ask photographers and artists for advice and take note of how color appears in real life and how it is used in all kinds of visual expression.*

Early morning and ▶ late evening sunlight intensifies color significantly. *The hues in the bark of these colorful madrona trees were at full volume when I came upon them during an early-morning walk.* SEE **TIME OF DAY**, PAGE 172.

Color for color's ▶ ▶ sake—great color-capturing photo-opportunities can often be found right under your nose—don't miss them! SEE **EVERYDAY OBJECTS** AND **EVERYDAY SCENES**, PAGES 198-201.

BEFORE

Photoshop's LEVELS ▶ *and* HUE AND SATURATION *controls were used to give this shot a complete color makeover. The final image was blurred slightly to further enhance the surreal quality of its vibrant presentation.*

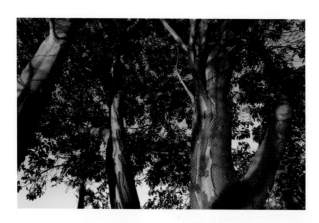

AFTER

It's the digital era: Take advantage!

This photo was imported into Photoshop where all of its colors were desaturated (converted to grays using HUE AND SATURATION controls), except for the green of the speeding car. The effect is eye-catching and gives the car clear visual dominance within the image. SEE PAGE 338 FOR A STEP-BY-STEP DEMONSTRATION OF HOW THIS IMAGE WAS CREATED.

This was a lucky shot (and a good example of old-fashioned opportunism meeting new-fangled technology to achieve an eye-catching result). I was taking pictures of the Victorian-era building in the background when this beautiful 1970s 'Cuda pulled up at the light across the street. When the car drove past I followed it with my camera and snapped this portrait. The resulting image looked good except that the building in the background happened to be an intense blue that fought for attention with the green of the car. Not wanting to waste an otherwise successful shot, I imported the image into Photoshop and began exploring alternatives...

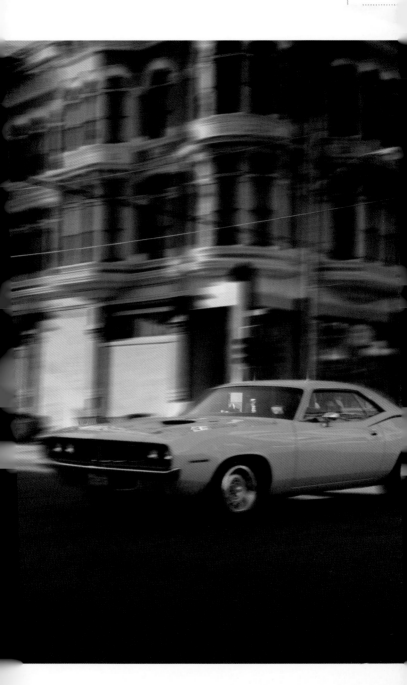

SECTION 1: YOU: ATTRACTING ATTENTION

Use your computer to explore both color and mono-chromatic enhancements for your photos. If you use Photoshop, it's usually best to keep your camera in full-color mode while shooting. That way, you can take advantage of Photoshop's many options when it comes time to convert your images to black and white. Furthermore, this software offers a number of ways of adding subtle tints to images once their overall color has been removed. (The image on the opposite page was converted to grayscale and then given a warm tint using Photoshop.) SEE **GRAYSCALE ALTERNATIVES**, PAGE 340; AND **TINTING**, PAGE 342.

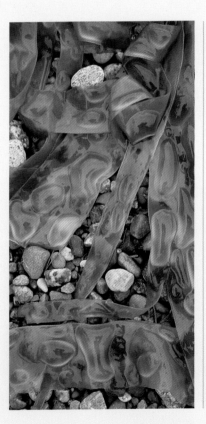

Here, translucent ▶ kelp fronds combine with pebbles under-neath to create an intriguing visual tex-ture. I felt that a monochromatic pres-entation was best for this shot since the colors in the original (left) seemed to draw attention away from the image's textural strengths. SEE **VISUAL TEXTURE**, PAGE 118.

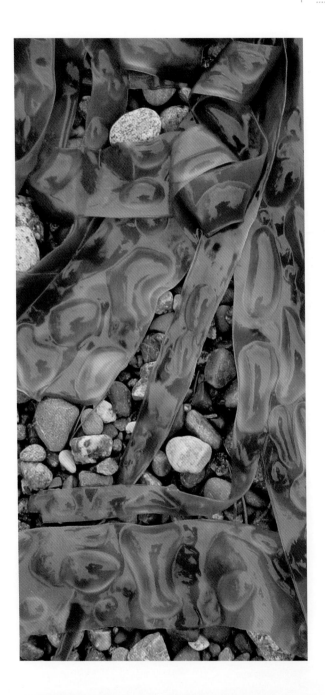

Verbally, people sometimes repeat themselves to attract attention, emphasize a point, or to irritate others. Visual repetition can be used to achieve these very same results.

Most people take a second look when they come across instances where objects are repeated in an intriguing or unlikely manner. Such occurrences appeal to our curious nature by begging questions like: *What's going on here?* and *Who did this?* and, simply, *Why?*

Thematically speaking, repetition can be incorporated into images to convey qualities of conformity, accord and harmony.

An image of a single ▶ doll's eye would not have the same mildly disturbing effect as an entire gathering of them. Surprising instances of repetition attract notice and arouse curiosity.

Instant visual har- ▶ mony is a happy by-product of repeated objects. All that was needed to capture this agreeable composition was a camera and an effective vantage point. Repetition can be disorderly, as in this example, or orderly, as in the following.

A slice of (urban) life. ▶ The duplicated windows in this tight cropping of a downtown apartment infuse this image with a look of static conformity.

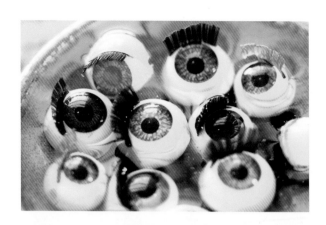

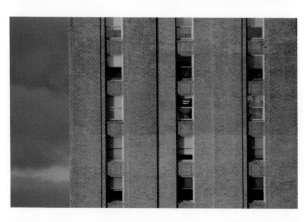

An orderly arrangement of unusual objects = an intriguing image.

Large metal buoys from an earlier era are now used as parking barricades at a seaside park in northwest Washington. Mysterious, half buried and systematically arranged, they have an almost Stonehenge-like presence.

The sun never rose more than a few degrees above the horizon on this cold January day (note the frost in the shadow of the foremost buoy). It was worth enduring numb fingers and frigid ears in exchange for many hours of sunset-like conditions that provided deep blue sky overhead and dramatic shadows all around. It was an extremely productive day of shooting—in addition to this spread, the following pages each contain at least one image taken on this day: 75, 83, 84, 101, 107, 111, 177, 247, 281, 309 and 325. When the conditions are in your favor, don't stop taking pictures unless you really, really have to!

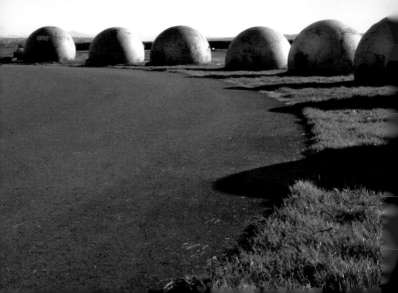

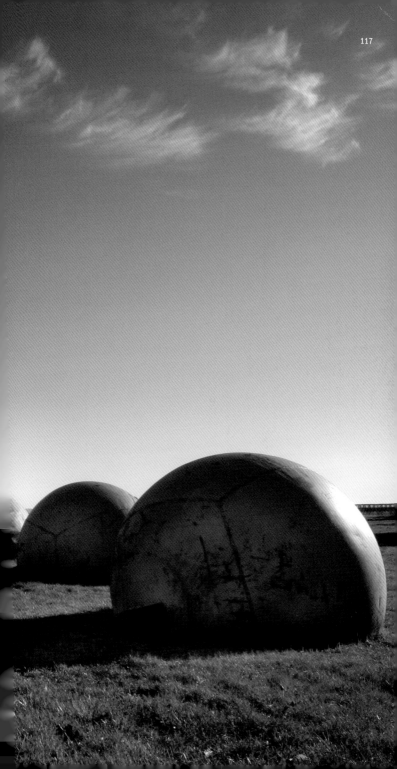

Visual texture can be made up of anything that densely fills all or part of an image. Visual texture usually has no center of attention.

Keep your eyes open to these three kinds of visual texture:

Harmoniously organized—a close-up shot of a canvas bag's weave, for example.

Harmoniously disorganized—such as the blades of grass in a lawn.

Purely chaotic—a rubbish heap, a pile of laundry, certain people's closets…

Visual texture can be featured as a stand-alone image. It can also be used as a backdrop for other elements.

You are probably already adept at keeping your eyes open for photogenic people, places and things. Are you also keeping an eye out for visual textures, instances of repetition and striking combinations of color?

The fissured surface ▶ of a burnt log: endlessly varied and entirely harmonious. SEE **CLOSE-UP**, PAGE 26.

Repetition so ▶ dense it becomes visual texture. SEE **REPETITION**, PAGE 114.

This colorful and ever-evolving mass of discarded bicycle frames sits outside a secondhand bike store near my home. It is an endless source of intriguing photo opportunities.

Here, the plain sur- ▶ face of an intervening beam contrasts nicely with the intense visual texture of the ivy and stonework that surround it. Contrast between plain and textured areas of a scene can emphasize the presence of both.

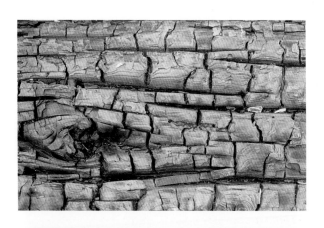

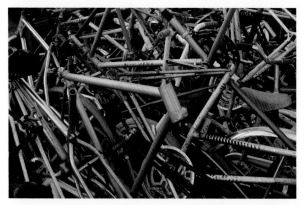

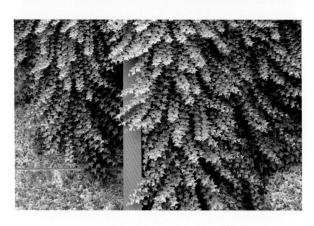

First, a bit of art history: Around 1300 A.D., Giotto di Bondone re-introduced the concept of depth-perception to the mainstream world of art (it seems that the ancient Greeks and Romans had a handle on portraying depth in two dimensions, but somehow their techniques were lost for a few centuries before being revived by Giotto). Conveyances of distance and depth have been employed by artists of two-dimensional media ever since to attract notice to an image, draw a viewer's attention into a composition and add notes of realism.

Take advantage of the intriguing visual and thematic effects that a three-dimensional feel can lend to an image. Consider points of view that amplify the perception of depth whenever you sense that such a presentation could enhance an image's impact.

A rope in the fore-ground ascends toward the ship's bow (and carries the viewer's eye into image with it).

Just as in real life, things in an image that appear to be headed toward the viewer are hard to ignore.

A striking impression of depth is captured by aiming the camera from just above the surface of a game board. The low vantage point also brings dramatic contrasts of near vs. far and big vs. small to the static subject matter.

The pathway leading into the distance seems to invite the viewer to come along...

A set of lines (etched into the concrete platform of a train station platform) carries strong connotations of travel and movement.

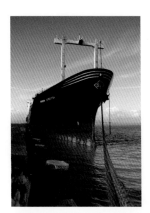

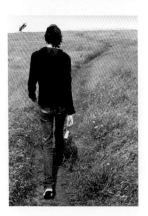

During a beach-side walk, I came across this lone sandal sitting on a large rock. To me, it looked forlorn under the low-hanging clouds; I didn't know whether to feel more sorry for the young person who lost it or for the sandal itself. In any case, I wanted to take a picture of the scene that featured the sandal prominently while hinting at its uncertain future. Eventually, I settled on this low vantage point since it gives the sandal clear visual dominance within the composition; it also grants a large portion of the image's remaining territory to the ominous clouds overhead and adds conveyances of the future through the diminishing perspective of the overall shot.

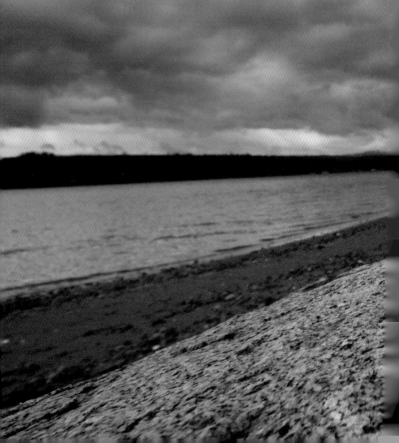

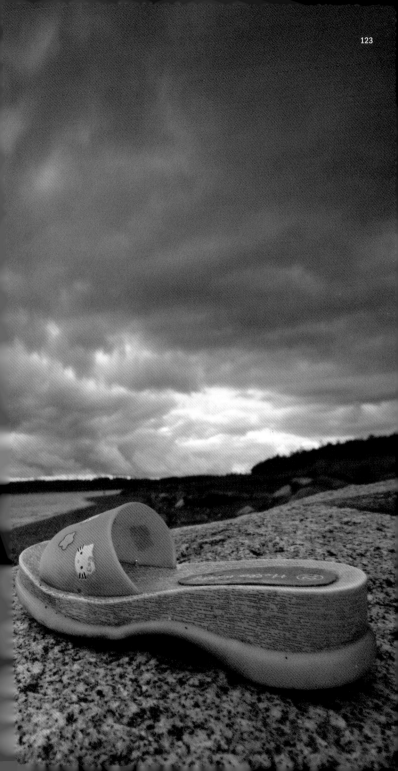

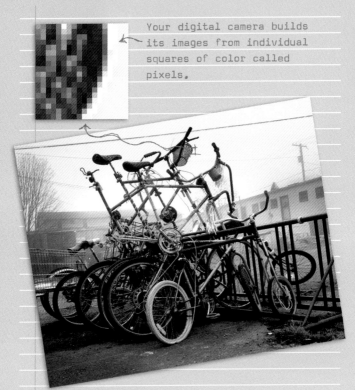

Your digital camera builds its images from individual squares of color called pixels.

Pixels and print.

The number of pixels your particular camera packs into an image is revealed by its megapixel rating. The higher the rating, the more detail your pictures will have and the larger you will be able to print them at high quality. Use this table to give you a general idea of how large you can print your full-frame images given the megapixel rating of your camera.

Mega pixels	High-quality print size (300 ppi)
2.0	4" x 5"
3.2 & 4.0	5" x 7"
5.0	6" x 9"
6.3 & 8.0	8" x 10"
11.1	9" x 14"

The math used to figure out the precise print
size for a given megapixel size can be intimidat-
ing. If you feel like taking it on, you'll find
this info posted within several photo-related
Internet sites. A web search for "pixels and
print size" will yield a number of results.

On the other hand, you can skip the math and
let Photoshop do your image size vs. print size
calculations by following this procedure:
- Open the image in Photoshop at its default
 resolution. Select IMAGE SIZE from the menu.
- Input the numbers circled below. Note that the
 HEIGHT and WIDTH numbers for your image will
 depend on the size of your original.

- Click OK. The image will now be at its maximum
 high quality print size (300 dpi).

Pixels and electronic display.
Onscreen, images can be electronically displayed
at high quality at a mere 72 dpi. If you are
e-mailing an image to a person who has a dial-up
connection, it's best to keep the dimensions of
your 72 dpi image below 640 x 480 pixels to avoid
excessive download times. If your recipient has a
high-speed connection (DSL, cable, etc.), you may
be able to send full-size images at 72 dpi and
higher, though some Internet service providers
(ISPs) place limits on the size of files that
they will allow.

PICTURING PEOPLE

Klaus Kinski (renowned German actor, 1926-1991) once remarked that *"there is no landscape more fantastic than that of the human face."* Most people are irresistibly drawn to aesthetically intriguing and personally relevant images of other people. *When you capture an evocative photograph of a person, you have created an image that is bound to connect with viewers on many levels.* Humans are, by nature, extraordinarily observant of details in other people's faces, expressions, hair style (or lack thereof), body language and attire. As a photographer, take note of the visual and thematic significance of details such as these when you are taking pictures of people. Be aware, also, of the effects that the model's surroundings (and any props that are being used) are having on the shot. When taking pictures of a person or a group of people, look for camera angles and lighting solutions that allow your subject(s) to agreeably connect with their environment; result in a pleasing stylistic and structural presentation; and eliminate secondary elements that contradict either the stylistic or conceptual result you are after.

Take advantage of the fact that when you are photographing a person (as opposed to an object or landscape) you are dealing with a subject with whom you can interact. Communicate with, instruct, talk to, laugh and collaborate with your subject as you take photographs.

Even when the look of a portrait is meant to be very straightforward (such as with these examples), explore all kinds of different expressions and head positions with your subject. Take shots with the model looking at the camera, across the room, toward the floor or off into space. How about closed eyes?

Subtle changes in your model's demeanor or physical posture can make big differences in the images that you are capturing. Take advantage of the free space on your media card and click away. Being able to choose winning shots from *many* candidates is an especially welcome bonus when it comes to catching elusive and photo-worthy expressions and emotional conveyances from your living and breathing subject.

Engage with your model in conversation as you take pictures; this will (hopefully) help them relax and at the same time will give you the opportunity to catch photos of spontaneous smiles, bursts of laughter, moments of pensive thought and a variety of of other actions and expressions. Oftentimes, an unplanned instant of serendipitous expression results in the most rewarding image of a photo session.

As with any subject matter, investigate different points of view and lighting options when you are photographing a person. Consider a variety of backdrop ideas as well. Should the background be plain or busy? Should it add a theme of its own to the photograph? What colors would best complement the skintone and clothing of the model? SEE BACKDROPS AND ATTIRE, PAGE 132.

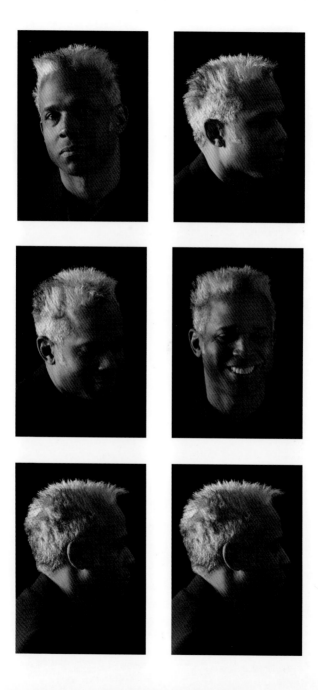

Consider getting outside the studio and taking shots in places that will infuse your portrait with notes of interest and intrigue. When shooting "on location" be mindful of compositional factors such as framing (PAGE 90), value contrast (PAGE 40) and depth of field (PAGE 306) as you look for ways of including your subject's environs in the image. Once you've selected favorites from your session, think about adding digital enhancements such as the tints that have been applied to the photos on this spread. **SEE TINTING, PAGE 342.**

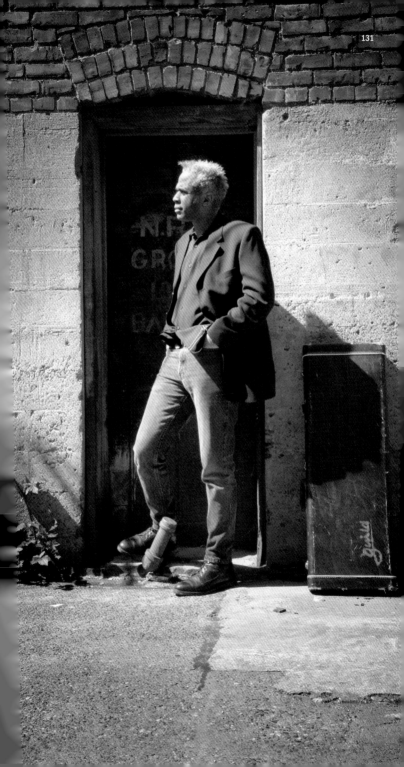

Whenever possible, have your model bring several changes of clothes to a photoshoot. Hold the various items up to different backdrop choices as well as the model's skin. What works best visually? What works best thematically? Should different sets of pictures be taken using different attire/backdrop combinations?

Hint: Attach a few metal clips or clothespins to a wall behind the model so that you can quickly change between different fabric and paper backdrops during the session.

When taking pictures of people, consider the same kinds of variables that you would if you were shooting images of inanimate objects or scenes: composition, backdrop, accessory use, lighting, point of view, depth of field, etc.

For the series of pictures, opposite, the model was asked to bring some fabrics from home for potential backdrop use as well as a variety of clothing options. During the session, several attire/backdrop combinations were explored. Deciding which combo is "right" for portraits such as these depends on the artistic, thematic and stylistic goals you are after.

In this photo, a visually ▶ ◻ active backdrop and shirt combine to create an energetic setting around the model's face and form.

Here, a plain backdrop ◻ ▶ adds a quieting influence and allows the woman's shirt to claim uniqueness as the only decorative element in the scene.

Wearing plain, dark ▶ ◻ clothing for this shot, the model stands out cleanly against the active backdrop.

The featureless back- ◻ ▶ drop and plain attire claim little attention in this photo: The model's smile and at-ease posture are clearly the center of attention.

For a dramatic ▶ ◻ presentation, consider backdrop and clothing choices that put everything but the model's skin tones into near darkness.

And don't forget ◻ ▶ to consider using a prop or two to add thematic notes to an image...

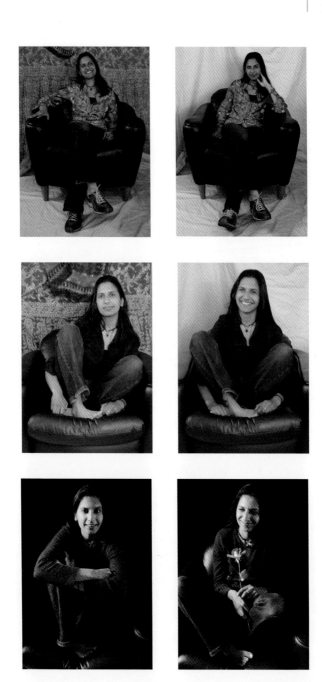

If you are taking portraits to make a thematic or stylistic statement, or to accompany a piece of writing, consider using props to add conceptual meaning and visual interest to your your image.

Props, attire, backdrop, a model's expression and posture can be combined to deliver thematic messages in both subtle and overt ways. Props can complement other visual elements or contrast with them to add a sense of irony, tension or mystery.

When you are going to take a person's portrait, consider asking them to bring an object of personal significance to the photoshoot. Experiment with creative ways of incorporating this object into the photos being taken.

People and props can be combined to artfully ▶ illustrate conceptual messages or to accompany text that explains the image's meaning. Here, a model delicately holds a thorny collection of beheaded rose stems while sitting in a meditative posture. An image such as this might be appropriate within an editorial piece about interpersonal difficulties, for instance—or as an image in an ad for a skin care product. Brainstorm for ideas when it comes to combining models, props, environment and shooting techniques for images that are meant to deliver conceptual messages. Look through magazines, books and web sites for ideas and inspiration. SEE **IMPLYING STORY**, PAGE 244.

Photoshop's HUE AND SATURATION controls were used to give this image a tint that enforced the undercurrent of tense energy evident in its content. SEE **HUE AND SATURATION**, PAGE 336.

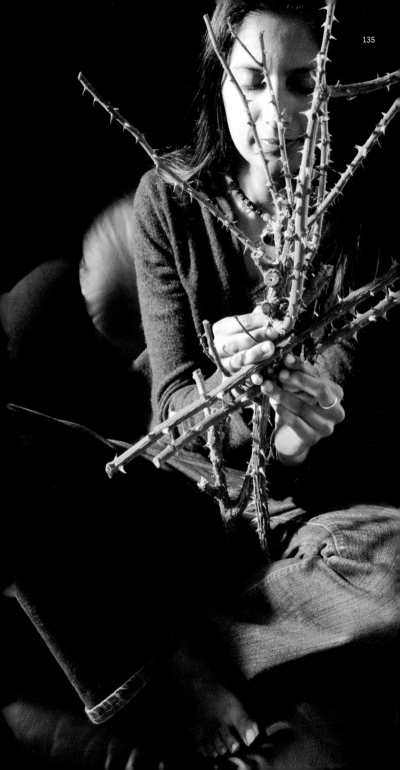

Many people have a tendency to center their subject within the viewfinder or LCD when composing a shot. This is understandable since it's only natural to look directly at people and things that have caught our attention.

However, when it comes to composing a photograph that will have pleasing compositional qualities, it's important to question this natural tendency and consider asymmetric alternatives.

Unless a static presentation is being sought for an image, seek an off-center placement for your model. Asymmetrical compositions give the viewer's eyes and mind more to consider and contemplate than static, symmetrical arrangements. SEE THE COMPOSITION PRIMER BEGINNING ON PAGE 76.

An off-center placement of your center-of-interest can be achieved when the camera is aimed or when the final image is cropped. SEE CROPPING FOR COMPOSITION, PAGE 82.

Be mindful of the model's body language and where they are looking within a scene: Both factors can direct the viewer's attention to other areas of a photograph or to graphic elements that surround the image (if the photo is part of a layout, for instance).

In this scene, clouds ▶ frame the subject and point to her off-center position within the landscape. The open areas around the model enforce thematic and visual conveyances of wide open spaces. SEE **FRAMING,** PAGE 90.

Here, the woman's ▶ gaze and pointing hand hint at the world outside the photo's boundaries while leading the viewer's eye to this very block of descriptive text. The dynamic spacing around the subject encourages these connotations of direction and movement.

The model's off- ▶ center position in this photo grants plenty of room for her gaze to travel within—and beyond—the edges of the image. Conveyances of distance, depth and contemplation are the product of both the image's environment and its composition.

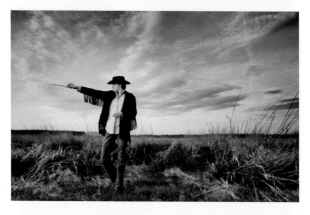

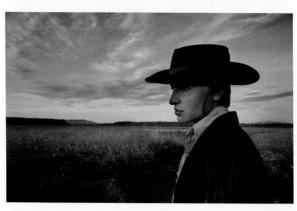

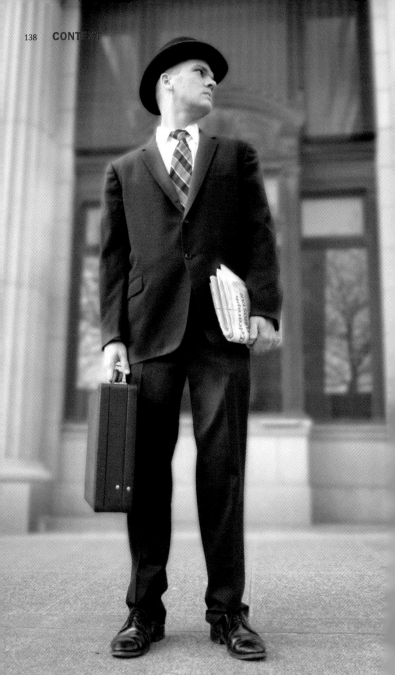

Portraits are context sensitive! Consider your options in relation to the stylistic and communicative result(s) you are after.

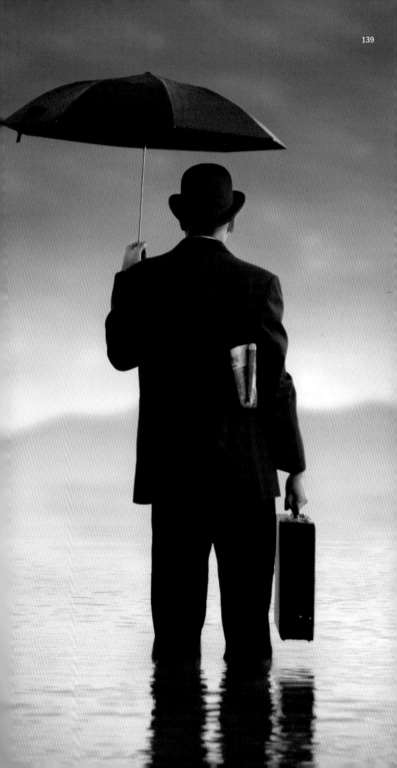

If you have a camera whose depth of field can be manually controlled (a function of more advanced cameras and lenses—not usually available on pocket digital cameras), be sure to experiment with both deep and shallow ranges of focus when you are taking pictures of people. SEE **DEPTH OF FIELD**, PAGE 306.

A deep depth of field (d.o.f.) keeps larger portions of the image in focus and may be preferable when the model's surroundings are compositionally, informationally or thematically essential to the image's presentation. (FYI: The default d.o.f. of most pocket digital cameras is relatively deep.)

On the other hand, a shallow d.o.f. means that only a narrow band of the image's range of view is seen in sharp focus. Many photographers enjoy taking pictures of people using a shallow d.o.f. because it allows them to clearly focus on the model while blurring elements that are both nearer to, and farther from, the camera. This technique can be used to minimize the distracting effects of a model's surroundings.

The deep depth of ▶ field used for this shot keeps most of the background in focus. This effect adds a note of visual texture to the image and takes advantage of the lines on the wall that direct attention to the model's face.

Here, a shallow d.o.f. ▶ blurs the diminishing perspective of the background. The focus (literally and figuratively) is now contained more strongly within the model's face. Which image is "right"? That depends on the stylistic effect that the photographer is seeking.

One of these portraits ▶ ▶ was taken with a deep d.o.f.; the other, shallow. Note the differences between the look and feel of each. If you are using a camera with d.o.f. control, consider your options! Which approach best suits the conditions of the shot and the outcome you are after?

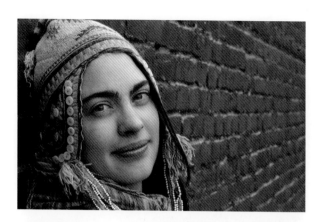

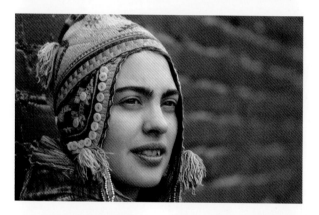

Try this: Think of the person you are photographing as a noun, and what they are doing as a verb. In these terms, a photo of a person *doing something* becomes a complete "visual sentence." And depending on how your image is captured, this pseudo-sentence might be delivered with an exclamation point or whispered within a set of parentheses.

Experiment with the different kinds of visual sentences you can compose while taking pictures of an active subject. Note the different ways in which you can deliver messages of kinetics and movement through your images.

Motion-blur within an image conveys inferences of action and movement, as do the dynamic angles of a photo taken from a skewed perspective. Freeze-frame images of certain postures can also deliver strong or subtle impressions that an action is either happening or imminent. SEE TILT, PAGE 32; **STOPPING TIME**, PAGE 170; CONVEYING ACTION, PAGE 166; AND MOTION BLUR, PAGE 318.

Strength and a sense ▶ of impending movement are both apparent in the posture of the dancer in this photo. From this point of view, the aesthetically complex and intriguing form of her body contrasts nicely with the emptiness surrounding it.

This image—caught ▶ just as the dancer was beginning to fall toward the floor—is infused with a feeling of suspended action. Her body is has been frozen in a moment of beautiful composition. SEE **STOPPING TIME**, PAGE 170.

In this photo, a tilted ▶ frame, blurred figure, off-center composition and flying fabric combine to convey an expressive sense of action.

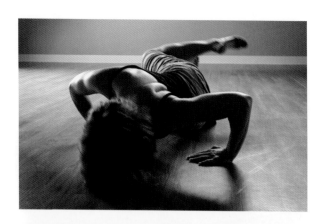

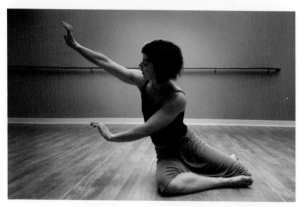

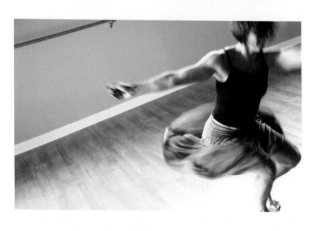

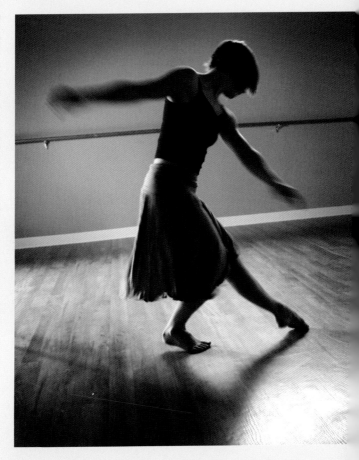

In this scene, the dancer's blurred arms and hands impart a subtle note of movement to an otherwise still setting.

I wanted to capture a sense of both the stillness and action inherent in the dancer's routine during this session. To do this, I used a digital SLR so that the shutter speed could be manually selected. After some trial-and-error, I settled on an exposure of 1/20th sec.
SEE **EXPLORING EXPOSURE**, PAGE 314, AND **MOTION BLUR**, PAGE 318.

Think beyond "say cheese" when taking pictures of a friend or model—especially if you are photographing someone who has a wide range of facial expressions and no fear of the camera.

Once you've caught an eye-catching photo of emotional display, think about using software to digitally amplify the image's look and feel. Explore colorization and tinting options; try out the effects of software filters; investigate cropping alternatives that bring maximum attention to your subject. SEE THE CHAPTER ON **DIGITAL EFFECTS**, BEGINNING ON PAGE 330.

SEE THE CHAPTER ON **DIGITAL EFFECTS**, BEGINNING ON PAGE 330.

Meet my buddy Alex—endlessly animated and without a camera-shy bone in his body.

A "selfie" is one of those images that is taken by aiming the camera at yourself. The guesswork that goes into taking selfies often results in serendipitous photographic surprises.

If you enjoy self-portraits, playing around, and don't mind losing a bit of control in the artistic process, then digital cameras are your perfect ally for this kind of creative venture. Shoot away: Save the good stuff and clear the disk of unsuccessful shots to make room for more attempts.

With a little practice it's possible to hold your picture-taking hand and arm in such a way that it's almost impossible to tell that the image's model is also its photographer. (That's not to imply that it's "wrong" for your arm or hand to show up in a selfie. In fact, the "rules" of photography are largely thrown out the window given the inherently inventive nature of this kind of shooting. If a selfie makes you smile, captures the essence of a fleeting moment or records a meaningful time and place in your life, then it's a keeper.)

Also experiment using mirrors or other reflective surfaces as a means of capturing selfies.

Some selfies ▶
are hard to tell
apart from photos
taken in more
traditional ways.

One of the best ▶
things about selfies is
that they can be
taken just about
anywhere, anytime.

*This image is a
perfect illustration
of the creative
photographer's
credo of keeping a
camera within reach
at all times.*

Go ahead, point that ▶
lens right at your face
and take a flash
photo from point-
blank range. Bend the
rules of photography
to the breaking point
when you are both
the shooter and
the subject!

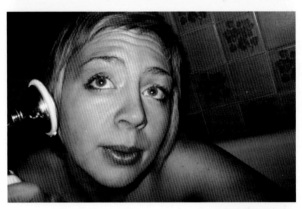

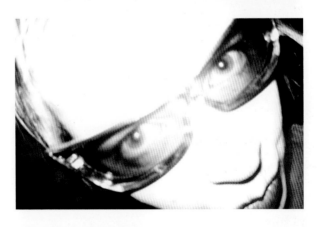

You and the model.

When you start taking portraits of people, a realization occurs: Most of the people you are taking pictures of are reacting to YOU first, and the camera second. A "model" who feels at ease with their photographer will feel encouraged to **relax** and **act naturally** as the photoshoot progresses. On the other hand, if the photographer seems unfriendly, distracted or indecisive about what they want, the model may (understandably) become tense in front of the camera. When this happens, the full potential of the photoshoot will be in jeopardy and the resulting images will likely reflect the prevailing undercurrent of discomfort.

So, in addition to becoming competent with your camera's operation and issues of lighting, composition and theme, there's at least one other set of things a portrait photographer needs to work on in order to capture effective images: **people skills.**

If you've never been in **front** of a camera for a photoshoot, think about giving it a try. Ask a friend or fellow-photographer to take a series of portraits of YOU. Take note of how it feels to have the lifeless eye of a lens pointing at your face and body and try to imagine ways of making this experience more comfortable to the people that you want to photograph.

On the practical side of things, as the photographer, you can improve **your** chances of

being relaxed during a portrait session by making sure all of the technical details of the photoshoot are in order before you begin. If you are working in a studio, set up as much of the shot as you can before the model arrives: have the camera angle somewhat figured out; backdrop in place; lighting ready to go; props on hand; batteries charged and all equipment in working order. This way, when the model shows up, you can use their (and your) time efficiently and concentrate on the more communicative and artful aspects of the process.

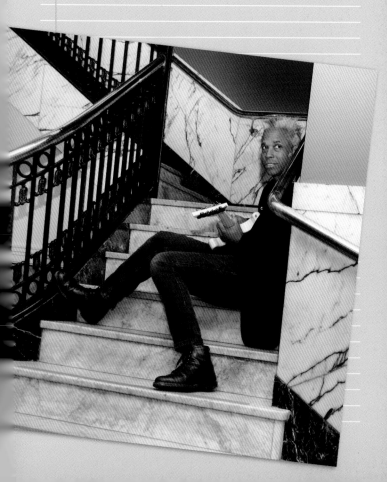

In addition to the usual types of portraits, consider ways of capturing pictures of your subject that mask their identity.

Images such as these could be taken for playful, conceptual or purely aesthetic purposes.

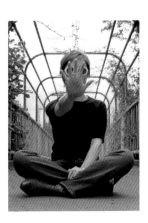

The motivation for this kind of "hidden identity" portrait could also be practical: In advertising and design, it's sometimes considered risky to feature a specific kind of person too clearly in a layout for fear of alienating viewers who do not identify with this particular demographic representative.

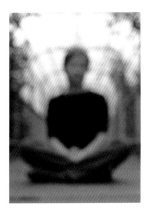

Brainstorm for different ways of using props, graphic elements (digitally added), or the model's hands or posture to hide their identity. How about blurring the subject's entire figure beyond recognition or cropping all but one portion of their body from the image?

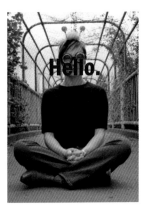

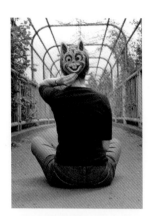
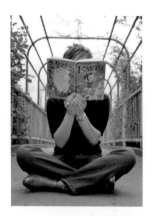
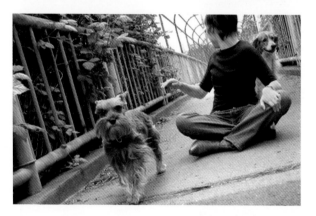
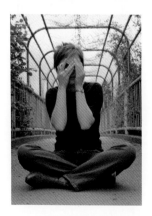
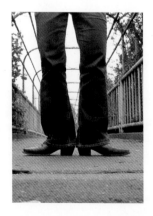

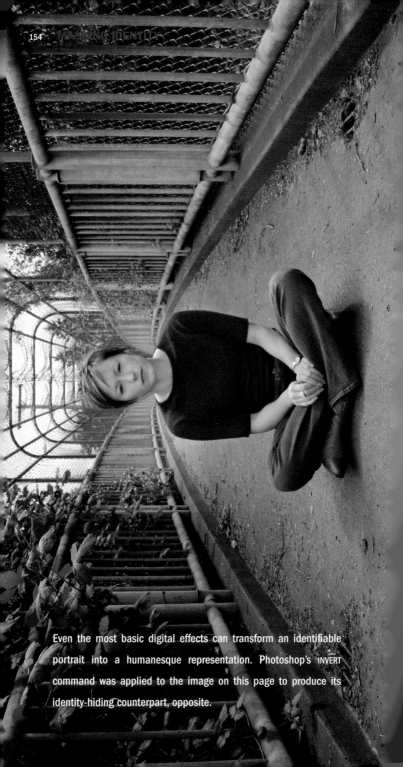

Even the most basic digital effects can transform an identifiable portrait into a humanesque representation. Photoshop's INVERT command was applied to the image on this page to produce its identity-hiding counterpart, opposite.

Once you've caught a successful image of a person or group of people, consider taking the image into new visual territory through digital enhancements.

These effects could be applied to strengthen or alter the existing mood of an image; display its content in a surreal or artful way; electronically layer its subject(s) over another backdrop; remove or add other visual elements to the image; or to pursue an endless number of alternative presentations for the shot.

Save multiple versions of your photograph as you work if you are coming up with more than one potential winner.

See the chapter on Digital Effects (PAGES 330-351) for how-to tips and ideas related to electronic image enhancements.

Photoshop's HUE AND ▶ ◻ SATURATION controls have been used to give this image a deeply saturated, retrospective look. SEE **HUE AND SATURATION,** PAGE 336.

Artistic whims can be explored endlessly ◻ ▶ using software. Here, the colors of the subject's glasses and the balloons he's holding have been amplified while all other hues have been turned to grays. SEE **CUSTOM COLORIZATION,** PAGE 338.

The subject in both ▶ ▶ of these images was removed from its original photographic environment using Photoshop's POLYGON LASSO TOOL. Consider placing your free-floating model over nothing-ness (as in the far sample) or on top of a digitally-generated backdrop (as in the near image. Note: This backdrop was borrowed from the demonstration on page 350). SEE **BACKDROP-LESS,** PAGE 44; **CLIPPING PATHS,** PAGE 346; AND **IMAGE LAYERING DEMO,** PAGE 348.

Next to the face, the hand is probably the most expressive and telling part of a human being.

How about starting your own collection of hand images? Collect hands of workers, artists, friends, children, adults and the elderly.

Take pictures of hands doing things and hands doing nothing.

159

You don't have to include actual people in your photographs to make direct references to humans and human behavior.

Statues, for instance, can be used in place of warm bodies when you want to capture images that make references to human emotions and experiences. People-less people pictures can make powerful (and sometimes ironic or humorous substitutes) for images of the real thing.

Just as you are naturally on the lookout for photo-ops with actual people, keep your eyes open to sights and scenes that feature statues, dolls, mannequins and all kinds of human likenesses. It's not uncommon to find these people substitutes in out-of-the-ordinary places or peculiar situations where real people would never hope to find themselves.

If you work with digital images professionally or as an artistic pastime, a collection of this sort of image makes a strong and versatile asset for all kinds of potential projects.

The face of a moss-covered statue offers solid conveyances of ageless and serene humanity. ▶

I came across these mannequins in an under-contruction window display. Their interaction seemed all too human. The great thing about taking pictures of faux humans is that they hold perfectly still while you search for good camera angles and are never self-conscious. ▶

This close-up of a mannequin's face appears human until you notice that the features you are seeing— even the sparkle in its eye—are painted on. ▶

Be on the lookout for conveyances of humanity that are obvious, oblique, obscure, ironic and humorous. Given the right context, images such as this can make statements about humans and society just as effectively as peopled pictures.

Once again, a collection of images such as these make powerful additions to the visual arsenal of a multi-media designer, writer, illustrator or fine artist. SEE BANKING IMAGES, PAGE 240.

The images on the opposite page make clear references to humans—even though none contain a living subject.

▶ Clothing and accessories naturally carry strong conveyances of culture and humanity. Images that contain this kind of subject matter can be used as inventive substitutes for pictures of people in works of design and illustration.

▶ Keep your eyes open to photo opportunities that include words that refer to people. Human- or gender-based images often come in handy as part of a digital collage or composition. SEE **WORD PLAY**, PAGE 252.

▶ This may look like the grill of an old Land Rover to some, but to others it's the wizened face of an old truck telling stories of its heyday. How about starting a collection of face-like images and showing them together once you have accumulated a good-sized collection?

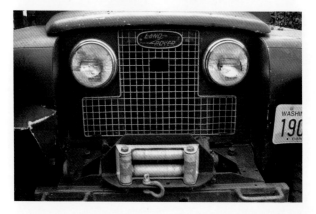

THINKING CREATIVELY

In order to consistently capture great images, a photographer must spend a certain amount of time acquiring photographic know-how and keeping up with developments in camera technology. Herein, however, lies a potential trap—and one that snares many a would-be competent photographer: the temptation to spend time and money accruing technical knowledge and high-end equipment at the expense of hours and energy spent cultivating conceptual instincts and skills. This lengthy chapter focuses on the *conceptual* thinking that comes into play as we consider different ways of using our camera to capture intriguing, attractive and communicative images. If you don't think of yourself as the creative type, take heart: Creativity is like a muscle—it can be built, strengthened and made flexible through use. Regardless of your level of creative fitness, use the concepts presented in the pages ahead to spark new ideas and reinvigorate stale instincts. Cultivate the creativity that makes the photos you take uniquely *yours*.

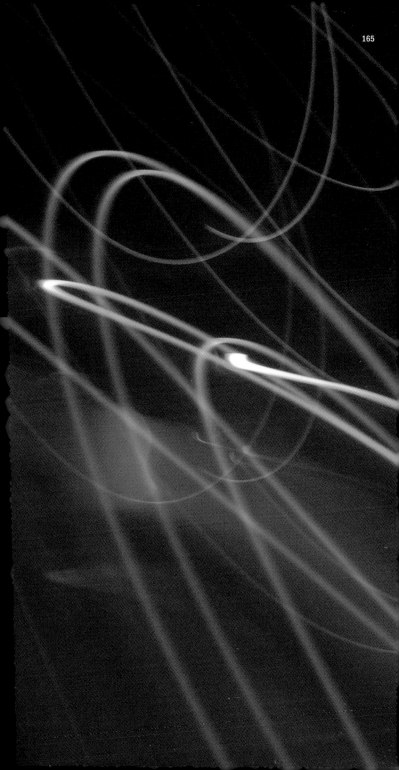

Connotations of action add notes of reality to certain scenes and help engage a viewer's attention.

Experiment with non-traditional picture-taking techniques to capture the essence of movement: Spin, wiggle or jiggle the camera while shooting to add motion-blur to images of stationary subjects; allow (rather than avoid) the blur that sometimes occurs when you photograph fast-moving subjects; shoot under low-light conditions that cause the shutter to stay open longer than "normal" (often resulting in a blurred image). SEE **MOTION BLUR**, PAGE 318.

Motion-blur can add ▶ active connotations to an image—even when the subject is standing perfectly still. *A look of playful dizziness was added to this scene by twisting the camera back and forth as I clicked the shutter.* SEE **SHAKE IT**, PAGE 242.

The blurred vehicles ▶ and glaring lights in this image do a good job of conveying the bustling essence of an airport loading zone—despite the fact that a tightly focused shot would have shown the subjects more clearly.

Following spread: Not a lot is going on in this scene. Still, as a composition, it is far from static—a subtle sense of animation has been achieved on a number of levels: the model's eyes direct attention to the left while the drifting smoke counteracts with rightward movement; the street sign at the top of the image points up and out and provides playful tension with the aim of model's gaze; a tilted cropping adds a dynamic undertone to the overall image. Look for opportunities to incorporate directional cues such as these in the scenes you capture, whenever connotations of movement could add to the impact and presentation of an image. ▼

Certain movements ▶ and moments are naturally ripe with conveyances of *action*. Capturing moments such as these can result in images that are infused with a sort of visual kinetic energy borrowed from their frozen subject. SEE **STOP-PING TIME**, PAGE 170, AND **CONTINUOUS SHOOTING**, PAGE 316.

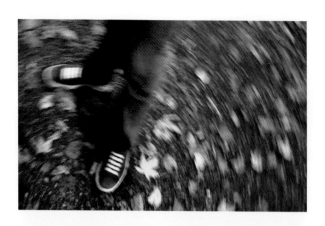

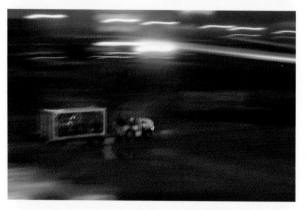

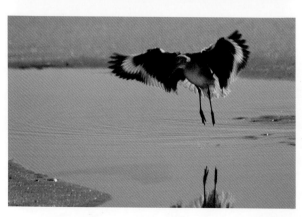

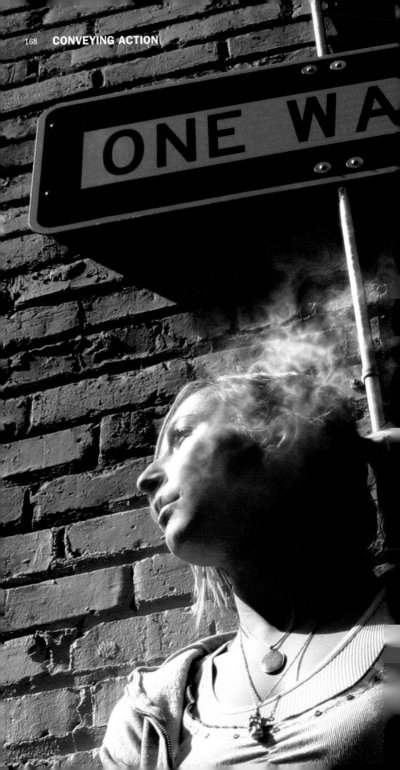

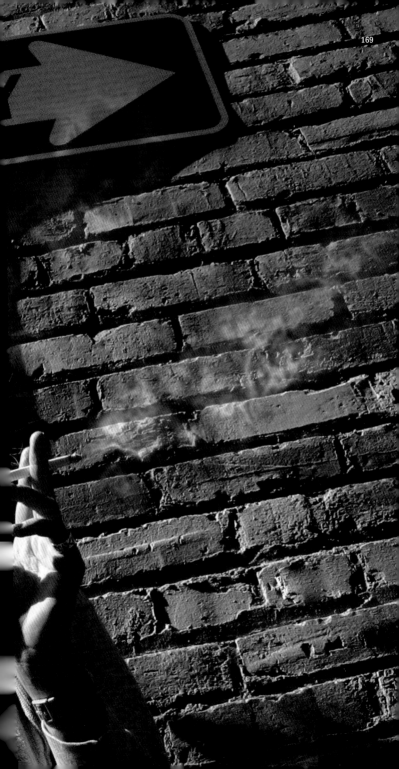

Certain photographs appeal to our sense of curiosity—and our attraction to beauty—by capturing images in a way that the eyes and mind cannot.

Through photography, we are able to see and study what the naked eye can only glimpse.

The eye cannot predict exactly what the camera will record when shooting a fast-moving subject. Therefore, if your camera has a CONTINUOUS-SHOOTING mode, use it when taking photos such as these so you can select the best image(s) from a string of tightly-spaced shots afterwards. SEE CONTINUOUS SHOOTING, PAGE 316.

Experiment with all kinds of subject matter that moves too quickly for the eye to follow: people and animals in action; moving vehicles or toys; water, smoke or fire (SEE **PLAY WITH FIRE**, PAGES 236-239).

You don't necessarily need high-end equipment to capture intriguing stop-action images. I took both of these photos using a pocket digital camera in bright conditions. Bright light causes the camera's shutter to open and close very quickly (in order to avoid taking in excess light)—thus freezing the movements of all but the fastest subjects.

A burst from your camera's flash can also be used to freeze action (though the lighting in the image will not be as natural as that in a non-flash image). SEE **ON-CAMERA FLASH**, PAGE 294.

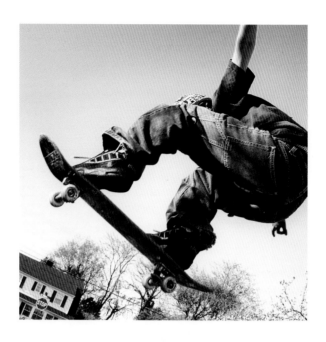

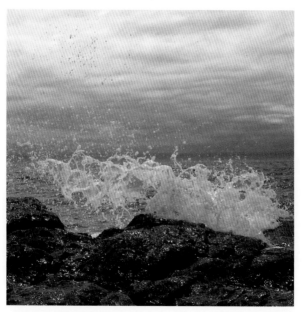

As stated at the beginning of this chapter, a good photo is all about knowing *where* to stand. *When* you stand there is also an important factor to consider when deciding how to best capture a subject or scene.

Light changes, minute by minute. It is said that when Monet was working on his famous series of haystack paintings he would switch to a different canvas every hour or so as the light changed.

The spectrum of color available from the sun is at its richest just after sunrise and before sunset. Another bonus of morning and evening light is the striking effect of the deep shadows being cast.

The colors in ▶
the sky and water on this cold November morning seemed almost supernatural in their richness. They reminded me of the palettes used in the dramatic paintings of N.C. Wyeth and Maxfield Parrish.

An unseen structure ▶
casts a bold, ominous shadow on the face of this empty building. Time of day can play an essential role in determining the thematic and compositional impact of a scene.

Caught in a moment ▶
of ballet-like synchronism, the backs of these rooftop workers soak up the last of the day's light. The sky's deep hue is reflected throughout the scene by the waterproofing goo beneath their feet. A good example of a serendipitous moment captured at an ideal point in time.

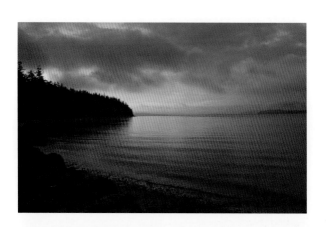

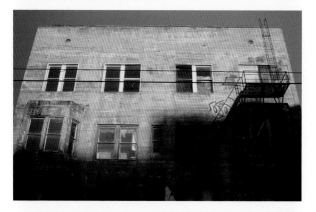

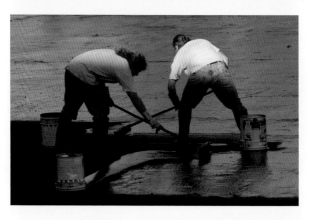

A group of pigeons haloed by the last of the day's light. You never know when subject matter and time of day will converge favorably: Have a camera nearby as often as possible so that you can catch these moments when they occur. (This image was opportunistically captured from my office window late one summer evening, using a telephoto lens.)

I chanced upon this scene while on my way to ▶ ▣
*take pictures elsewhere. The sun had just risen
and was casting light on a turn-of-the-century
statue while throwing shadows on the stairs
behind it. The lighting conditions were changing
by the minute, and since I didn't want to miss out
on the very favorable contrast between the stat-
ue and the steps, I took this photo from the mid-
dle of the street as I walked toward them both.*

For the next few minutes, the lighting could ▣ ▶
*hardly have been better if it were set up in a
studio. I continued taking pictures from close
range—it would have been unwise to remain
standing in the street much longer—seeking a
viewpoint that put the statue in good contrast
with the mid-value sky above. The sun slipped
behind a building just a few moments after this
shot was taken.*

At first I was disheartened at the loss of the ▶ ▣
*direct sunlight, but then realized that if I
changed my vantage point, the (now dark) stat-
ue could be made to stand out against a sky
that was growing brighter by the minute. This
shot, and the one at upper right—though com-
pletely different from each other—were taken
just a couple of minutes apart.*

Before leaving, I spent a little while longer look- ▣ ▶
*ing for other interesting viewpoints and found
one more that I liked. Here, the statue is seen in
silhouette against the sky and framed neatly by
the same row of buildings that it has been fac-
ing for the past 100 years.*

Go with the flow as lighting conditions change;
be resourceful and keep searching for vantage-
points that make the most of what's available.

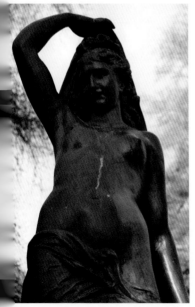

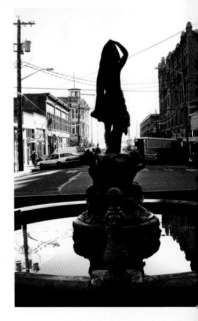

Many camera owners wait for the sun to come out of the clouds before taking their camera out of the bag.

Waiting around for the sun? Don't. There is plenty of picture-taking potential under cloudy, stormy, snowy, and foggy skies.

Take a look at the image of the sandal on pages 122-123—such clouds overhead! Without their ominous presence, the scene would hardly have been as dramatic.

Fog can be especially rewarding to work with. Foggy conditions enhance the perception of depth by toning-down elements that are not near the camera. It can also lend a ghostly dimension to an otherwise mundane subject or scene.

The images of the concrete skate park on pages 206-209 were taken on a morning of dense fog. The fog not only softened the backdrop behind the concrete forms of the skate park, it also wetted every surface—adding rich reflections and deepening contrasts throughout the setting.

Be on the lookout for ▶ the kind of unique photos that can be captured when the weather is up-for-grabs. Here, the sun is caught splaying its rays though the tumultuous clouds hanging over a distant island. The bay is just beginning to show the effects of the oncoming wind.

I try to think of bad ▶ weather as a good photo opportunity. Here, early-morning fog neatly separates the lightpost in the foreground from the building behind it. "Good" weather would have denied me the intriguing presentation of this scene.

Snow changes every- ▶ thing: Cover your ears and put on your gloves—it's picture-taking time! A tip: Leave your camera in the unheated trunk of your car when driving somewhere cold to take pictures. This will will help keep the lens from fogging when you are ready to shoot outside.

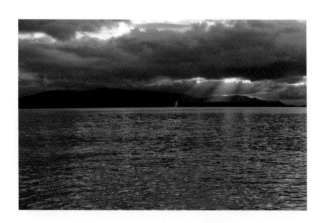

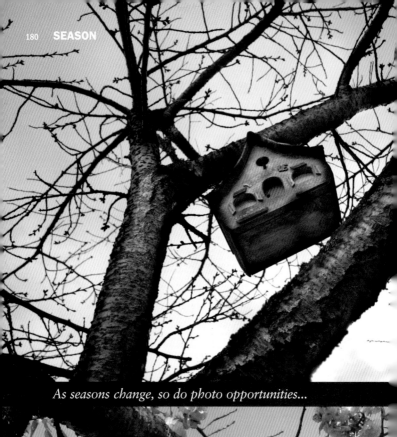

As seasons change, so do photo opportunities...

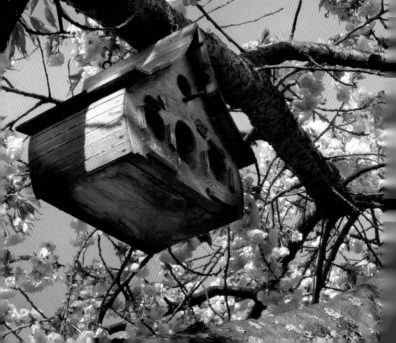

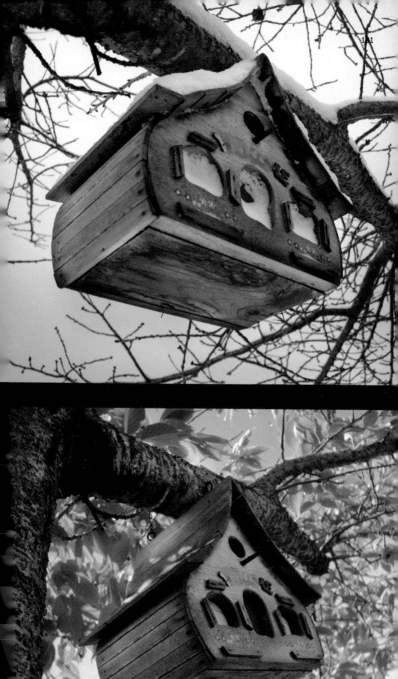

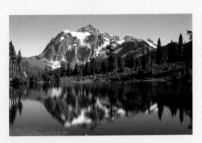

Yeah, whatever. A nice enough shot, but even as I was taking it I knew that it was going to be just like the million others that had been taken from this very same viewpoint before.

It seems almost obligatory to take photos of certain mountains, lakes and old barns from the same well-worn vantage points used by countless other photographers. And these viewpoints *are* good (hence their popularity), so go ahead and take that status-quo shot (if you feel that you must), and then start playing around with some *more original* options...

How about stepping back from that "ideal" viewpoint and including something in the foreground? A properly chosen foreground element will give the viewer more clues to the scene's context while adding a sense of depth to the image.

After you take the "normal" landscape shot, why not try something radical? This impressionistic image was taken by sweeping the camera back and forth while shooting. *I took this photo right after the one featured at the top of page 179.* SEE **SHAKE IT**, PAGE 242.

And be sure not to miss the leaves for the forest. When considering grand, "postcard shots" of scenic views, don't forget to look for the tiny photo opportunities that might be at your feet or right next to your elbow.

A perfectly acceptable shot of fields and an old highway could have been taken by standing upright from this vantage point. Instead, I decided to lay on my belly and take the shot from ground-level—thus turning the gravel on the roadway into pseudo-boulders. When you find yourself looking at a "perfectly acceptable" shot, ask yourself if perhaps there's a way to capture something more intriguing by drastically changing your vantage point.

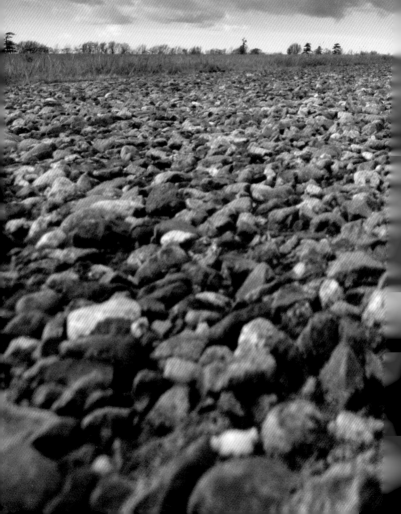

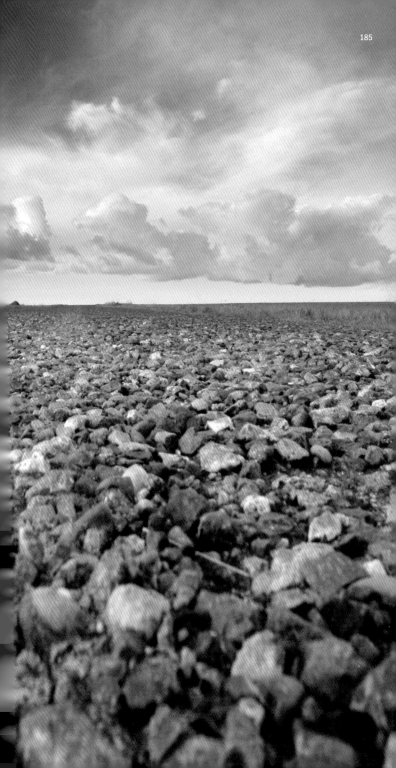

As they say, wherever you go, there you are. And, so long as you're there, why not take a 360° panoramic series of shots to record your whereabouts?

Shots can be taken individually as you systematically turn your body in a circle, or fired off using the camera's CONTINUOUS-SHOOTING MODE as you freely spin.

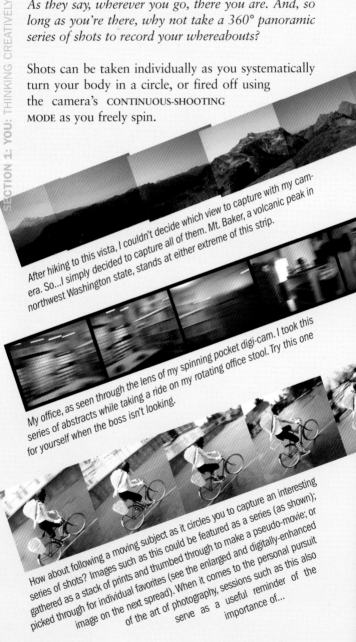

After hiking to this vista, I couldn't decide which view to capture with my camera. So...I simply decided to capture all of them. Mt. Baker, a volcanic peak in northwest Washington state, stands at either extreme of this strip.

My office, as seen through the lens of my spinning pocket digi-cam. I took this series of abstracts while taking a ride on my rotating office stool. Try this one for yourself when the boss isn't looking.

How about following a moving subject as it circles you to capture an interesting series of shots? Images such as this could be featured as a series (as shown); or gathered as a stack of prints and thumbed through to make a pseudo-movie; or picked through for individual favorites (see the enlarged and digitally-enhanced image on the next spread). When it comes to the personal pursuit of the art of photography, sessions such as this also serve as a useful reminder of the importance of...

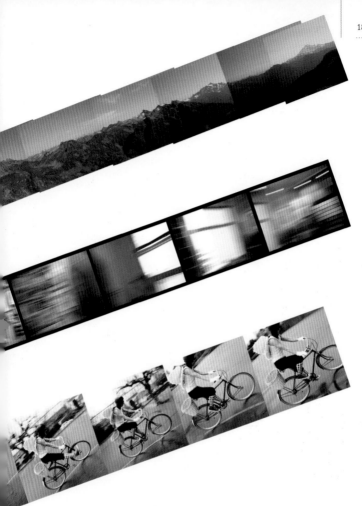

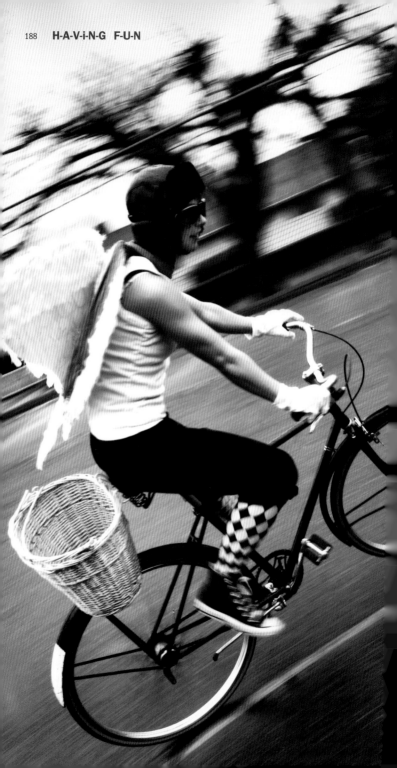

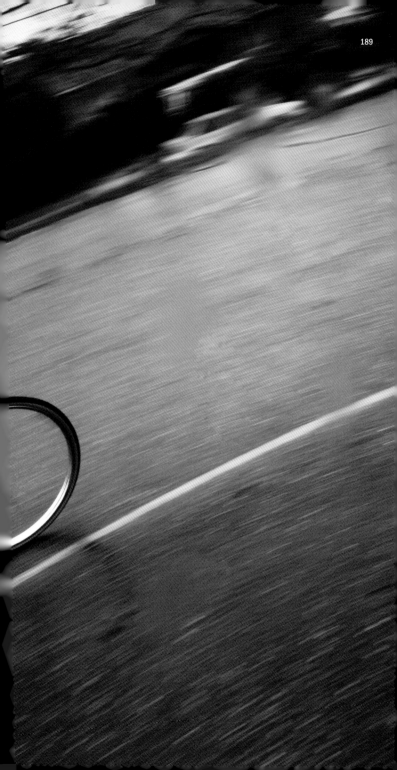

Many books about photography (including this one) suggest that you avoid letting secondary elements in your image distract the viewer from the main subject.

But then again, rules are made to be broken...aren't they?

Consider capturing certain images that have layers of visual matter and thematic meaning—even if this means that the viewer's eye will be challenged to find the featured subject (if there is one).

Look for interesting conceptual agreements or juxtapositions between the primary subject and the visual elements that camouflage its presence. SEE JUXTAPOSITION, PAGE 248.

Images like this have potential as an accompaniment for a short story, poem, magazine article, personal web site, brochure or advertisement.

The frame of an old ▶ 10-speed bicycle seems to be growing from the same ground as the plants surrounding it. Scenes that catch our attention in real life often make intriguing photos as well.

Here, a rusted ▶ barbed-wire fence provides thematic and visual contrast against the geometric dome of the church in the background. Artists sometimes use photographic juxtapositions such as this to deliver conceptual messages.

Photos can reveal ▶ things that only the observant and the lucky see in the actual world. *In other seasons, leaves completely hide this birdhouse from view. Its secret location is revealed every fall—but only to those who look closely.* SEE **VISUAL TEXTURE**, PAGE 118.

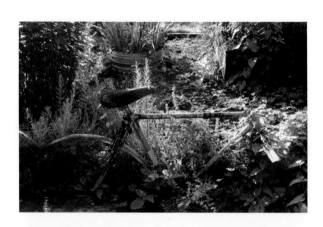

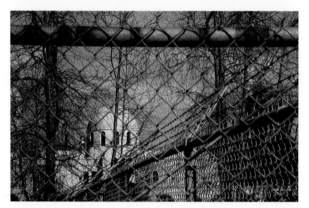

To many, the trail of wear, aging and decay that follows life is every bit as beautiful as the tail that follows a comet.

Most photographers instinctively look for "beautiful" subject matter for their photographs: attractive people, vibrant sunsets, elegant floral arrangements, spectacular architecture, etc.

But then again, isn't beauty supposed to depend on the eye of the beholder? And who's to say that *your* eyes have to see beauty in the same way as other people's? Expand your perception and definition of beauty: Join the ranks of those who find intriguing subject matter in the less-than-pristine.

The end of the road for a colorful convertible VW—if only we could see what its headlights have seen.

Expand the scope of your image-potential-radar to include scenes that reflect life as it is, not necessarily as it ought to be.

Intriguing compositions can be built from just about anything.

If you are assembling a library of images for personal/professional art projects, consider devoting a wing to bizarre and unsightly subject matter. After all, you never know when an image of a dead halibut, for example, might be just the thing needed to accompany a piece of writing, or as a layer within a digital composition.

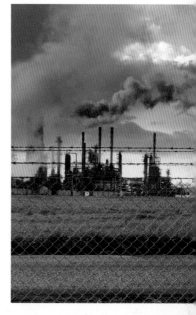

A deserted parking garage; its cold floor covered by a windblown skiff of light snow.

Frigid, deserted, desolate, beautiful.

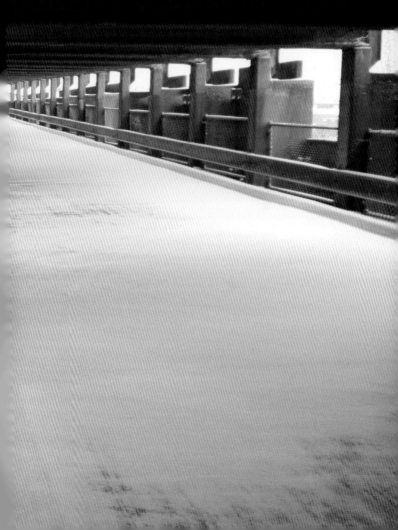

COLLECT CLOUDS

Capture and
collect clouds: All
you need is a digital
camera and a hard drive.

Clouds are an endless source of variation
and beauty. Oftentimes, a good photograph of clouds
depends less on what the sky is doing and more on your
willingness to stop whatever you are doing in order to
capture the image.

You are carrying a digital camera with you at all times,
aren't you? What are the clouds doing today? Is
anything photo-worthy going on up there?

Graphic designers and digital
artists can always find uses for
cloud images. They can be
used as a main
subject, back-
drop or layer
within all kinds
of digital
compositions.

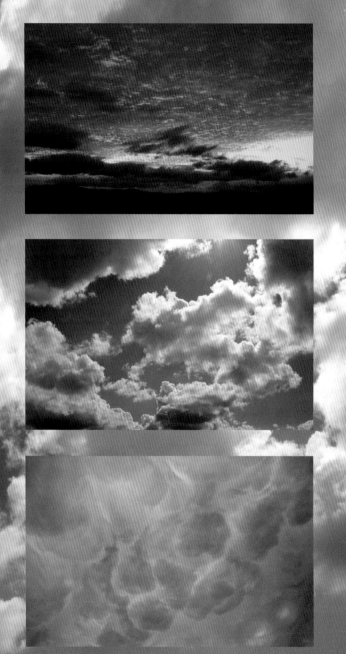

There's something about images of everyday objects that connects easily with viewers. Everyday objects can be comforting, familiar and surprisingly photo-friendly.

Learning to see picturesque details in everyday scenes (as well as in the objects that embellish them) is like discovering a new universe of photo opportunities. SEE CLOSE-UP, PAGES 26-29, AND UGLY IS BEAUTIFUL, PAGES 192-195.

When an image of a familiar object is captured in a way that is unique and visually pleasing, it has the potential to trigger a revelation in anyone who sees it: The viewer may be fascinated to discover that an object of such beauty has been sitting right under their nose all this time.

As with any subject, explore points of view when taking pictures of commonplace items: Just because your subject matter is mundane, it doesn't mean your vantage point needs to be status quo. SEE EXPLORING POINTS OF VIEW, PAGE 20.

A discarded juice bottle set against a backdrop of blue sky. Who would have thought that an empty beverage container would lend itself so agreeably to a graceful photographic composition?

Intriguing reflections, intense color, a steep shadow and a starburst from the morning sun. Even a half-empty cup of coffee can give the eye plenty to enjoy if the conditions are just right.

I was drawn to the reflection of the table's bright hue in the sides of these table-top shakers. Their well-worn tops also caught the light (and my attention) favorably.

Backlit by the July sun, a ring of bubbles is strikingly illuminated inside a sweating bottle of cold ale. Strive to be observant and appreciative of the extraordinary potential of everyday occurrences and subject matter.

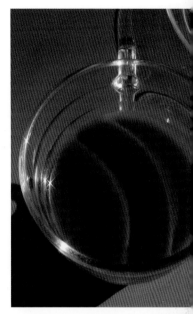

With eyes wide open, the day becomes a stream of photo opportunities...

An icon of rural backyards everywhere: a birdhouse waiting for visitors. SEE **INTENTIONAL EMPTY SPACE,** PAGE 96.

While waiting for a friend's flight to arrive, I spent an hour in an air-port stairwell taking pictures. The subject matter was limited, but the potential for interesting com-positions was endless. ANOTHER TYPE OF SHOT FROM THIS IMPROVISED PHOTO SESSION IS FEATURED ON THE **ABSTRACTION** SPREAD, PAGES 230-233.

A portrait of freshly cooked bacon strips? The kitchen as an impro-vised photo studio? Why not? There is plenty of commercial and communicative potential for pho-tos of commonplace subjects. A stockpile of such images could be used for all kinds of projects.

Color, form and texture— it's all here. *When it comes to stalking and capturing images of ordinary life, cafes and restaurants are among my favorite hunting grounds. I almost always take my camera to dinner with me.*

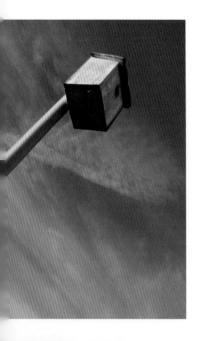
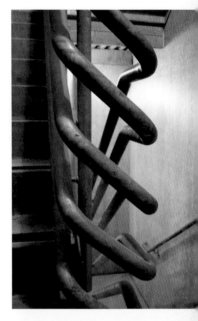

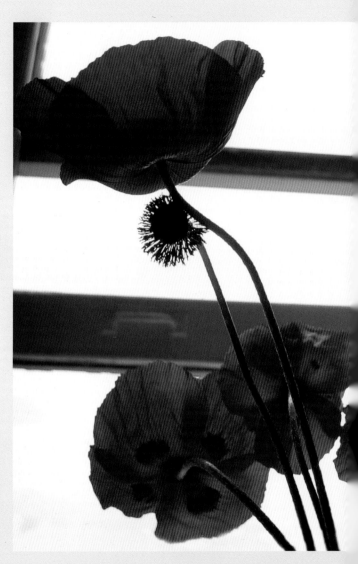

A story with a lesson: *These flowers were given to me by a client at the conclusion of a project. Poppies are a favorite of mine and I could hardly wait until the client had left my office before taking pictures of their blooms. After a week or so, the flowers began to fall apart (as captive poppies will do) and I was just about to throw them out when it occurred to me that there still might be some photo potential in the*

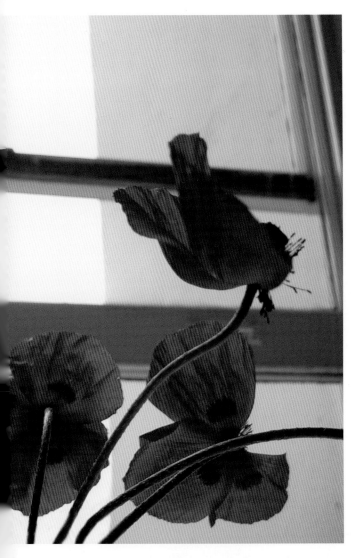

decaying petals and stems. After snapping a few shots (and liking the results) I decided to keep the flowers on hand—and take pictures of them—until they were fully dead and dried. The next spread features shots taken during the entire span of the poppies' tenure in my office window. The lesson for me was this: Think beyond the obvious uses for subject matter of all kinds.

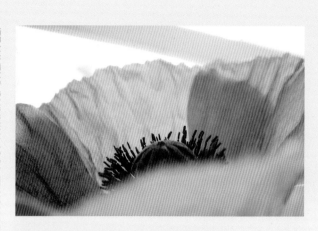

Here's a simple exercise that you can do to further develop your eye for aesthetics and your technical picture-taking skills: Take yourself on a photography field trip. Go to a place where there is at least moderate image-taking potential and spend an hour or so there taking photos from all different angles and vantage points. Investigate points of view and shooting techniques that are both ordinary and unconventional. Frame your subject matter in the most interesting and aesthetically pleasing compositional arrangements that you can. Don't worry about so-called mistakes and failures—you will be able to sort through photos later on in search of favorites and pleasant surprises. Repeat this kind of exercise often. Explore a variety of environments, weather and lighting conditions. Consider asking an experienced photographer or artist to critique your shots.

I took these pictures (and the two on the following spread) on a foggy morning at a deserted skate park near my home.

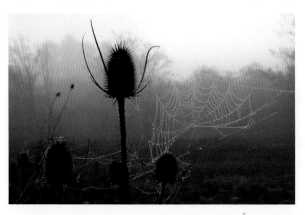

Here's a macro-variation of the previously described creativity- and skill-sharpening exercise: Choose a simple object and take at least a hundred shots of it. Explore the effects of light and shadow. Experiment with focus, points of view and an unsteady camera. *My own favorites from this series are shown on the next spread.*

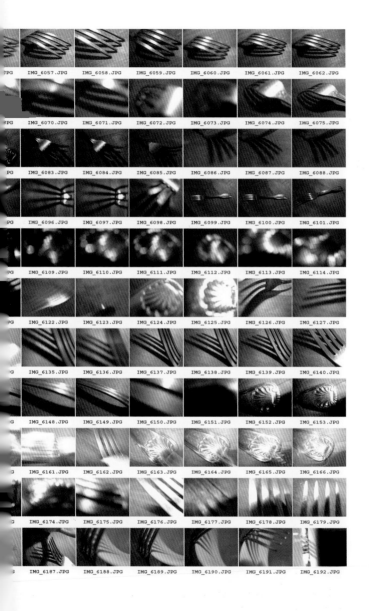

IMG_6057.JPG IMG_6058.JPG IMG_6059.JPG IMG_6060.JPG IMG_6061.JPG IMG_6062.JPG

IMG_6070.JPG IMG_6071.JPG IMG_6072.JPG IMG_6073.JPG IMG_6074.JPG IMG_6075.JPG

IMG_6083.JPG IMG_6084.JPG IMG_6085.JPG IMG_6086.JPG IMG_6087.JPG IMG_6088.JPG

IMG_6096.JPG IMG_6097.JPG IMG_6098.JPG IMG_6099.JPG IMG_6100.JPG IMG_6101.JPG

IMG_6109.JPG IMG_6110.JPG IMG_6111.JPG IMG_6112.JPG IMG_6113.JPG IMG_6114.JPG

IMG_6122.JPG IMG_6123.JPG IMG_6124.JPG IMG_6125.JPG IMG_6126.JPG IMG_6127.JPG

IMG_6135.JPG IMG_6136.JPG IMG_6137.JPG IMG_6138.JPG IMG_6139.JPG IMG_6140.JPG

IMG_6148.JPG IMG_6149.JPG IMG_6150.JPG IMG_6151.JPG IMG_6152.JPG IMG_6153.JPG

IMG_6161.JPG IMG_6162.JPG IMG_6163.JPG IMG_6164.JPG IMG_6165.JPG IMG_6166.JPG

IMG_6174.JPG IMG_6175.JPG IMG_6176.JPG IMG_6177.JPG IMG_6178.JPG IMG_6179.JPG

IMG_6187.JPG IMG_6188.JPG IMG_6189.JPG IMG_6190.JPG IMG_6191.JPG IMG_6192.JPG

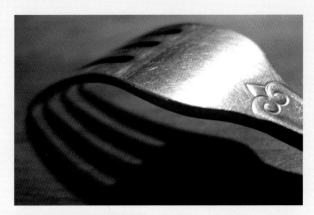

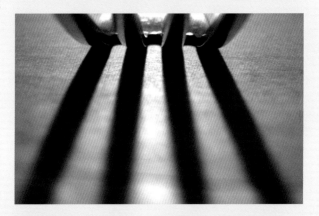

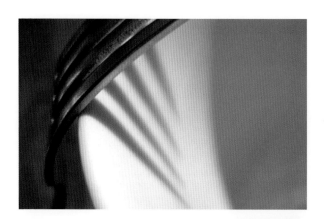

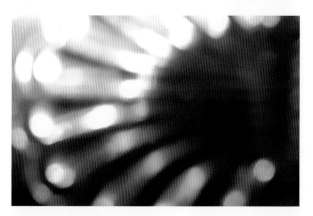

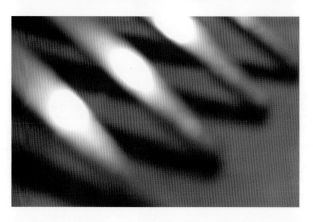

Revolutionary Fun.

If digital cameras have started a revolution in photography, it's not because they take better pictures than cameras that use film. And it's not because digi-cams are really any easier to use than film cameras. The thing that **does** make digital photography revolutionary is the fact that it is a forgiving medium that encourages artistic risk-taking and exploration. When using a digital camera, unsuccessful photos can be erased without paying a cent for film or processing; the photographer can play, experiment and investigate all kinds of new shooting techniques without worrying about the dollar-penalties associated with "wasting film." And, as an additional bonus, digital photography is an instant gratification medium:

Photos can be reviewed
as soon as they are
taken; downloaded for quick sorting
and digital enhancement; and the camera's disk
can be cleared by pushing a button or two for
the next round of picture-taking. Take advan-
tage of the many perks of digital photography!

E-x-p-l-o-r-e
E-x-p-e-r-i-m-e-n-t
-&-
P-l-a-y
-!-!-!-

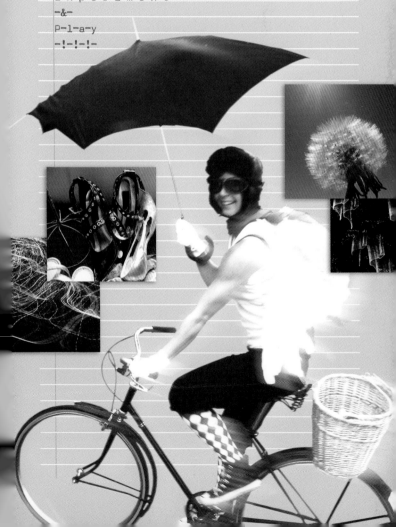

Keep your camera with you as much as possible so that you can capture images of offbeat and out-of-the-ordinary scenes whenever and wherever they present themselves.

Remember: YOU are your camera's best viewfinder. Teach yourself to walk through life with eyes that are open to photo opportunities of all sorts.

A water meter has ▶ been transformed into a monster in a cage by an anonymous graffiti artist— *I came upon this character while cutting through an alley on my way to work.*

I was relaxing on the ▶ *front porch when I spied this tiny jumping spider (not much larger than a grain of rice) catching its dinner. I was happy to find that the close-up setting on my pocket digital camera was able capture the charming moment in detail.*

I saw this case of ad- ▶ *hoc political commentary during the early days of the Iraq war. Shortly after, the sign had been "fixed" (a B had been reinserted before the word LESS). Real life photo opportunities can be fleeting and rarely repeat themselves; catch them when you can.*

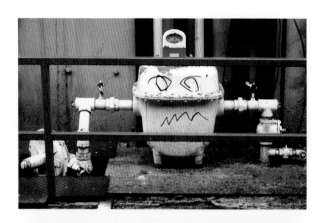

Another story with a(nother) lesson:

A fuse had blown in the coffee shop where I was reading, and its restroom had been lit with a row of candles. When I chanced upon this serene and shrine-like setting, I was happy to discover that my pocket digi-cam was right where it was supposed to be: in my pocket.

You never know where and when and how beauty will present itself. Be prepared.

When a camera detects a low-light situation such as this, it automatically selects a relatively long exposure so enough light can be taken in to capture an image of the scene. In the case of this candle-lit room, I discovered that the exposure was too long for a normal hand-held shot—the slight shaking of my hands resulted in an undesirable amount of motion-blur in the photos. After some experimentation, I found a way of bracing the camera against the wall firmly enough to eliminate all but a trace of blur within the photographs being taken. (I allowed for this slight "defect" since its softening effect on the image seemed to agree with the quietude of the scene itself.) SEE **STEADYING THE CAMERA**, PAGE 274.

Most photographers use their camera to capture images of nature just as it is found.

How about rearranging reality in some way to create a work of environmental art? And then, once you are done with your creation, how about taking a series of pictures to record your effort?

Take a look at a book or a web site about the environmental sculptures and photographs of Andy Goldsworthy. The resourcefulness, ingenuity and artistry evident in Goldsworthy's art speaks volumes about the creative process (as well as providing endless ideas of how we might use our time when we find ourselves on a beach, in the woods, or in a field with some time on—and a camera in—our hands).

Think of this kind of activity as artistic cross-training. And just as athletes keep their minds fresh and their bodies in shape by taking part in a wide variety of activities, a photographer's creativity can be vitalized and expanded when it is applied to a broad spectrum of artistic ventures.

Also consider applying this reality-altering exercise on a smaller scale using the items found on your desk or in a drawer.

We came to this ▶ beach at low tide and found a scattering of weathered yellow bricks mixed in with the natural stones. After collecting several armloads of bricks we decided to build a pathway that connected the jumbled rockery with the smoothly rippled expanse of sand beyond. The semi-precise arrangement of weathered bricks contrasted nicely against its surroundings and pointed neatly to the islands beyond.

Once the improvised sculpture was finished, the camera was retrieved from its bag and I took a number of shots from a variety of viewpoints. The glare of the late afternoon sun provided an attractive bed of light for the bricks as they receded into the distance.

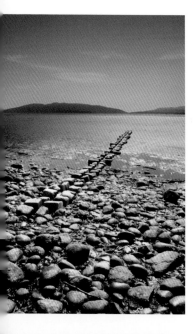

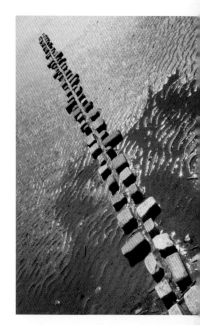

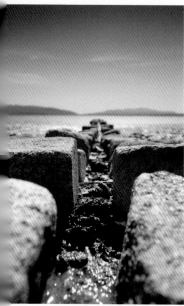

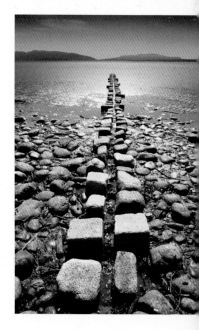

Shadows can infuse a photo with all kinds of aesthetic bonus materi-al: *form-boosting shading; interesting shapes and visual texture; compositional framing; areas of dramatic darkness.*

Teach yourself to notice not only photo-worthy people, animals and things, but the shadows they cast as well.

Shadows can transform ▶ the ordinary into the artful. This rack of drying dinnerware has been given an aesthetic boost from the shadows cast by a set of nearby blinds.

An eye-catching effect ▶ achieved with a studio light and a set of lace curtains. Here, the model's face is covered with an intricate, tattoo-like design by the shadows being cast. Experiment with the effects that can occur when shadows meet the human form.

In this scene, shadows ▶ cast by the early morning sun embellish the floor, seat-cushions and table top with ornate forms borrowed from elsewhere.

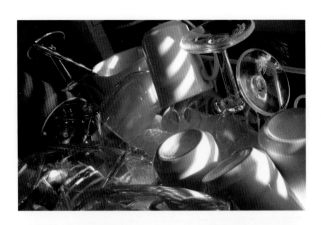

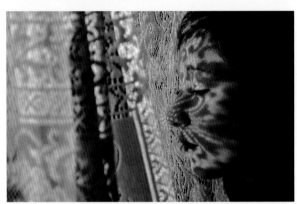

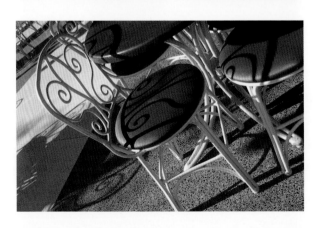

Consider making a shadow the main subject of an image.

The default settings in our minds dictate that we pay less attention to shadows than we do to whatever is casting them (after all, evolution seems to have weeded out those of us who, for instance, were more interested in the shadow of a saber-toothed tiger than the tiger itself). Make an effort to train your eyes and head to notice shadows—they can be quite photogenic and are hardly ever camera-shy.

The next time you have some free time on a sunny day, consider visiting a place where there are plenty of people and their shadows. And, instead of people-watching (or in addition to it), watch shadows. Use your camera to capture images of shadows being cast by all kinds of people and things against all sorts of surfaces.

A shadow can tell us ▶ about things that are not even in a photograph. This ultra-long shadow of a pick-up truck existed for a only a few moments before the sun went down. A lucky catch for me since I just happened to be walking by at the time.

Shadow figures. ▶ Capturing shadows, rather than people, is one way of taking pictures of humans without dealing with issues of identity. SEE **MASKING IDENTITY,** PAGES 152-155.

Consider using a ▶ subject's shadow to provide visual clues about its shape and identity. In this image, a bottle's shadow reveals definite clues about its form and the material it is made from.

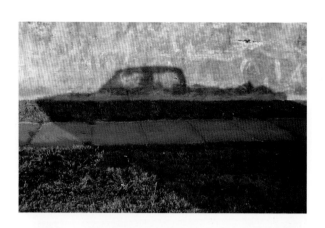

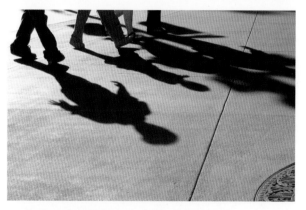

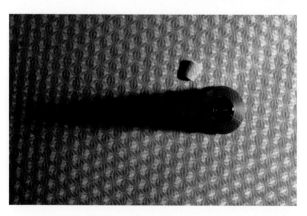

Here's a shooting technique that is especially suited to those who enjoy surprises and have a taste for abstract images: Jiggle, wiggle, shake and sweep your camera in front of different kinds of light sources.

Tip: It's a good idea to have your camera's wrist- or neck-strap in place when engaged in this sort of free-wheeling shooting technique.

Images such as this could be featured as they are or as backdrops or layers within digital compositions. SEE **ABSTRACTION**, PAGES 230-233; **VISUAL TEXTURE**, PAGE 118; AND **IMAGE LAYERING DEMO**, PAGE 348.

Take advantage of one of digital photography's greatest perks: the ability to freely experiment with your camera without worrying about film-processing costs.

Instant abstraction: ▶ ▶ Randomly jiggle your camera while aiming at a light-source (left) or lit surface (right). Take lots of shots—you're almost sure to find something interesting on your disk afterward.

An unsteady hand, a ▶ pocket digital camera and a chandelier combine forces to create an abstract, otherworldly image.

In this case, the light ▶ moved while the camera held still. I captured this image of an exploding firework using a digital SLR and a telephoto lens. I chose a shutter-speed that allowed for a certain amount of motion blur in the shot. SEE **CONTINUOUS SHOOTING**, PAGE 316, AND **CONVEYING ACTION**, PAGE 166.

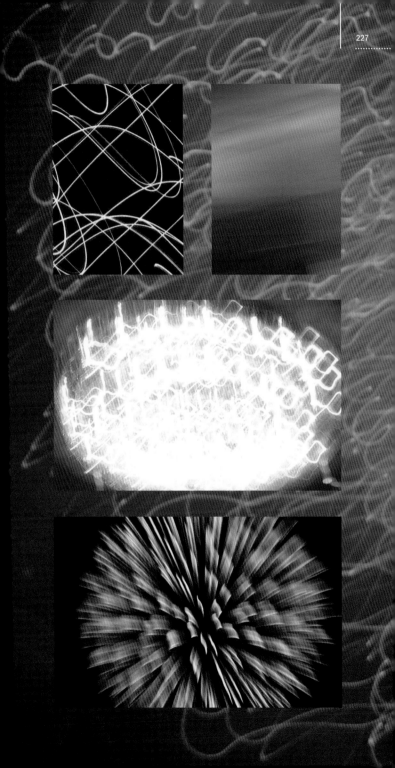

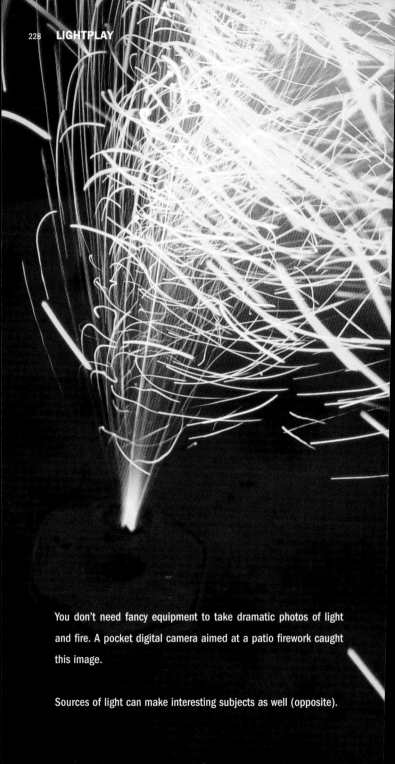

You don't need fancy equipment to take dramatic photos of light and fire. A pocket digital camera aimed at a patio firework caught this image.

Sources of light can make interesting subjects as well (opposite).

Digital photography is an ideal medium for anyone who enjoys creating abstract visuals. Why? Because digital cameras provide endless possibilities when it comes to the exploration of viewpoints, shooting variables and compositional options. Plus, digital images can be easily linked to a software environment where further effects can be applied and considered.

And while traditional cameras have always been outstanding tools for the creation of abstract images, digital cameras expand this creative potential by taking away the dollar penalties previously associated with a trigger-happy shutter finger.

Intriguing abstract images can be gleaned from all or part of just about any subject: people, animals, buildings, water, light, everyday objects. Explore, experiment!

Let your personal tastes and ever-evolving instincts for composition and aesthetics tell you what makes for a good abstract image. Take a look at other people's non-realistic photos for inspiration and ideas. Investigate works of abstract painting, sculpture and design.

There is vast potential ▶ ◼ in many architectural details for abstract and semi-abstract images.

A swimmer-less ◼ ▶ *swimming pool, as seen from a 9th floor hotel balcony.*

A feeling of late- ▶ evening urban bustle is caught in this abstract nighttime cityscape. SEE **LIGHT-PLAY**, PAGES 226-229, AND **SHAKE IT**, PAGE 242.

This richly colored ▶ organic composition was captured by aiming the camera through a cup of ice water.

Photos such as this could be used within layered digital works of art, as accompaniments to text, or as stand-alone images.

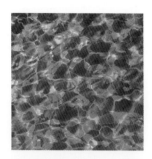
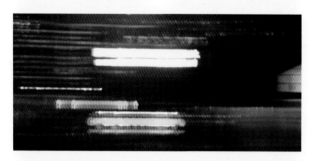
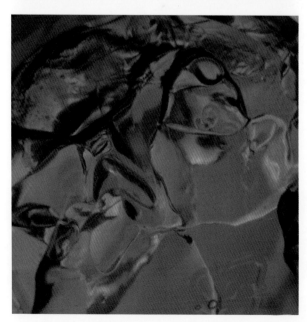

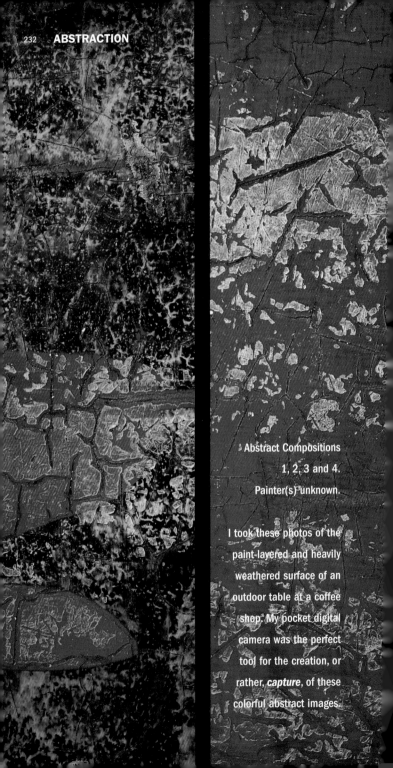

Abstract Compositions
1, 2, 3 and 4.
Painter(s) unknown.

I took these photos of the
paint-layered and heavily
weathered surface of an
outdoor table at a coffee
shop. My pocket digital
camera was the perfect
tool for the creation, or
rather, *capture*, of these
colorful abstract images.

If you are comfortable using other artistic media, here's a project idea to consider: Make a piece of art using whatever media you wish (or use something that you've created in the past). Then, use your digital camera to take close-up shots from portions of the original artwork. Shoot from interesting angles and seek eye-catching mini-compositions. Experiment with lighting effects and different degrees of focus.

The images at right are close-ups taken from the piece of art shown above. For this set of photographs, the camera was intentionally swept over the surface of the ink painting as the shutter was clicked to achieve abstract connotations of movement. The final images were converted to a monochrome color scheme to further differentiate them from their original source. SEE **SHAKE IT,** PAGE 242, AND **TINTING,** PAGE 342.

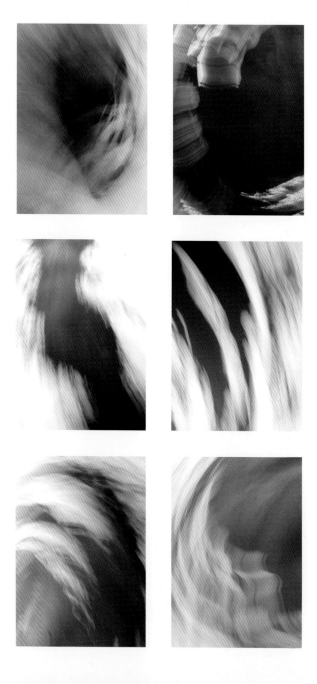

Go ahead: Play with fire.

Fantastic abstract images can be captured simply by pointing the camera at some flames and clicking away.

Fire moves very quickly: Take advantage of your camera's CONTINUOUS SHOOTING mode to capture fleeting moments of beauty. SEE **CONTINUOUS SHOOTING**, PAGE 316.

Take pictures of fire all by itself. Or, take pictures of objects *on fire*.

And naturally, be careful not to expose your camera—or yourself—to excess heat when taking pictures of fire.

Fire is fast: These photos were taken using the extremely quick shutter speeds available from a digital SLR. The camera's CONTINUOUS SHOOTING mode was used so that favorites could be chosen later on from sets of closely spaced shots.

I selected the five images at right from a group of over four hundred shots. Can you imagine holding down the shutter of a film-eating camera with such abandon? Digital media greatly reduces the monetary risk of artistic explorations such as this.

The photos at right were captured using the advanced functions of a digital SLR. This interesting abstraction (left), on the other hand, was taken by simply leaning over a campfire and snapping a shot with a pocket digital camera.

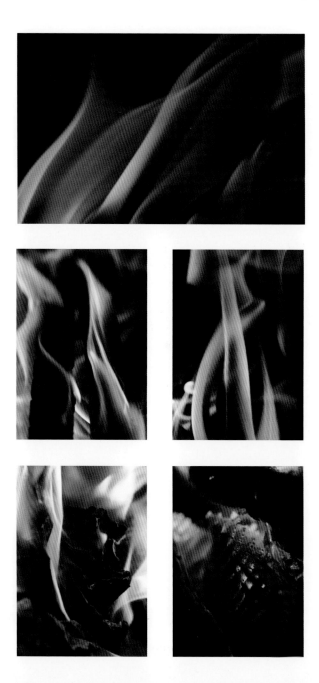

Take advantage of the unique post-shooting strengths of digital media: Import your images into a cyber environment for further enhancement, exploration and experimentation. SEE THE SECTION ON **DIGITAL EFFECTS** BEGINNING ON PAGE 330.

This abstract image was created by stacking six different fire images in Photoshop and using the DIFFERENCE command between layers.

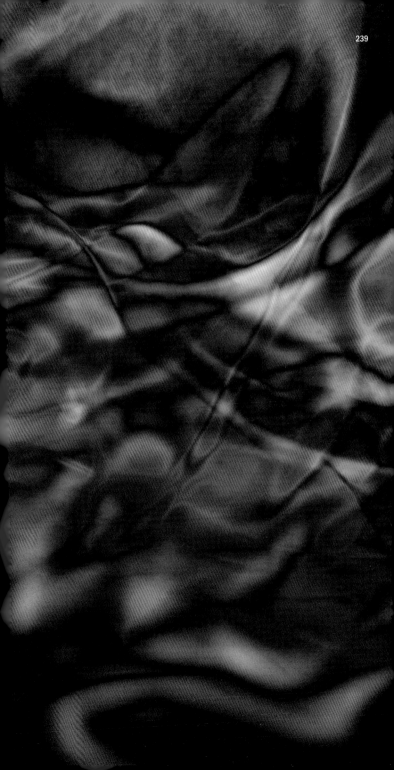

Start your own visual savings account.
Now that you are using your digital camera
to collect all kinds of shots of everyday
objects, strange abstractions, visual
metaphors, portraits of friends and photos
of visual texture, what are you going to do
with all of these images? How about setting up
your own cyber savings account of photographs?

**Take advantage of yet another perk of
digital media: the ability to archive images
electronically—without filling bookcases and
drawers with albums and prints.**

Organize your photos using a program such as
Apple's iPhoto, or simply place your image
documents in folders according to content. A
well-organized collection can be a bit of a
pain to establish and maintain, but you will
thank yourself for taking the trouble when it
comes time to search for a certain photo or a
particular type of image for a project.

If you are a graphic designer or an artist
who uses digital images, then an image-bank
of this sort (and a well-organized one at
that) is a virtual necessity. A strong col-
lection of photos streamlines and enhances the
creative process of anyone who uses images
for communicative purposes.

Practicality.

A savings account of digital images will make
it that much easier to access photos for all
kinds of projects: framing and display; screen
savers; desktop images; works of fine art;
professional design and illustration projects;
a rotating digital display; portfolio samples;
slide shows; gifts; last minute gift-cards.

iPhoto and similar
programs do a great
job of helping you
store and organize
your digital
images.

Most of the time, photographers try to avoid the blur that happens when the camera moves or shakes while the shutter is open. This kind of blur often shows up in images that were taken under low-light conditions (dim light causes the camera to default to longer exposures in order to take in enough light to record images properly).

Avoiding blur, however, is just one of those "rules" of photography that begs to be broken for the sake of pursuing visually intriguing or conceptually meaningful photos.

So... go for it! Move, shake, twist and jiggle your camera while shooting. Keep your eyes and mind open to pleasant surprises and creative effects that tickle your fancy. And why not? You have nothing to lose but a little bit of free disk space.

Out-of-the-ordinary photos such as these have excellent potential as stand-alone images; as backdrops for text or other design elements; and as accompanying images for all kinds of written material. SEE **LIGHTPLAY**, PAGES 226-229 AND **ABSTRACTION**, PAGES 230-233.

Zoom: ▶ ◼
The camera was moved sharply toward a freshly-bloomed peony to achieve this effect.

Shake well: ◼ ▶
The lone chair in this image takes on other-worldly qualities when seen through the lens of a vigorously-shaken camera.

Do the twist: ▶ ◼
This abstract composition was captured by twisting the camera back and forth while aiming down a concrete stairwell.

Randomosity: ◼ ▶
Trees, sunlight, and a wildly shaken camera combine to create an interesting marbled impression. *I keep a large collection of images like this in my computer for use in design and art projects of all kinds.*

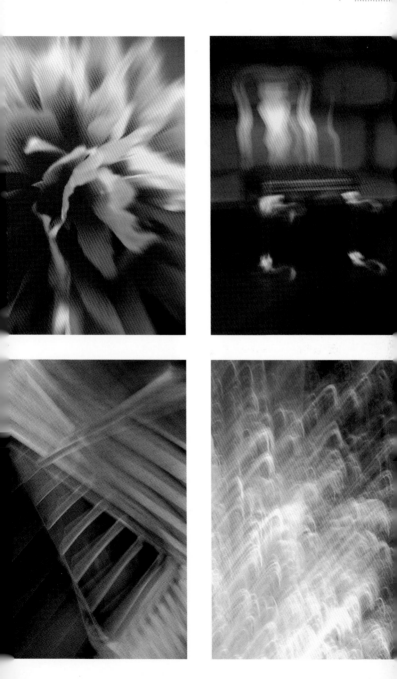

Curiosity draws people to photographs that contain suggestions of a larger story or message.

Playful obscurity invites investigation and prompts the viewer to take a second look—to ask, *What's going on here?*

Create or capture scenes that convey hints of mystery and the possibility of an interesting story. SEE **REPETITION**, PAGE 114, AND **ALTERING REALITY**, PAGE 220.

From time to time, ▶ *I go on buying binges at secondhand stores in search of interesting props. I enjoyed using the heads of these eyeless dolls as subjects—together, they seem to be sharing a dark secret...* SEE **HUE AND SATURATION**, PAGE 336.

One of the more ▶ *intriguing highway signs I've seen: Is this a cautionary sign or a promise of joyful abandonment just around the bend? I waited until a truck was passing before taking the shot to add a sense of context and movement to the image.*

Huh? ▶ Advertisements often feature images with peculiar content to engage viewers' attention and to deliver their message in a unique way.

FOR
1½ MI

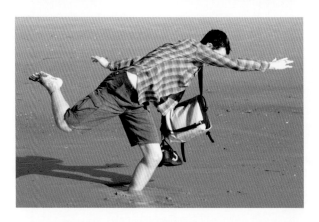

Certain scenes and objects are ripe with visual metaphor. Sometimes the metaphor is obvious; sometimes accompanying text is required to specify the implied message.

Build your own image library of visual metaphors—especially if you are a graphic designer or fine artist who could make good use of a stockpile of conceptual prompts.

Train your brain to be a metaphor-hunter—and keep your camera nearby at all times so that you can capture visual metaphors whenever and wherever you find them.

A sturdy chain, an escalator into darkness, a crack in the wall. Each of these images is charged with metaphor potential—it's just a matter of putting them into a context that connects their visual content with a relevant theme. Ads, posters, brochures, book covers, stories, articles and web sites often use visual metaphors as a means of communicating ideas.

Juxtaposition occurs when colors, shapes or ideas are combined in unexpected ways.

Juxtaposition is often used in design, advertising and fine art to send and enforce thematic messages. Juxtaposition can inject an image with attention-getting notes of intrigue, humor, irony or sarcasm.

Visually speaking, un-alike elements can be juxtaposed to infuse an image with compositional energy or tension (lines vs. curves, light vs. dark, colorful vs. plain).

Is this juxtaposition of ▶ trees and smokestacks a statement of industry's threat to nature, or is it an example of industry and nature in peaceful coexistence? Juxtaposition is often context-sensitive—this image could be used to illustrate either viewpoint.

Juxtaposition can be ▶ used for purely aesthetic purposes. The precise grid of mirrored windows in this photo provides stark visual contrast against the organic form of a palm tree in the foreground.

Juxtaposition can be ▶ purely thematic. This photo opportunity caught my eye because the typographic question of thirst seems to be denied by the steel grid in front of it.

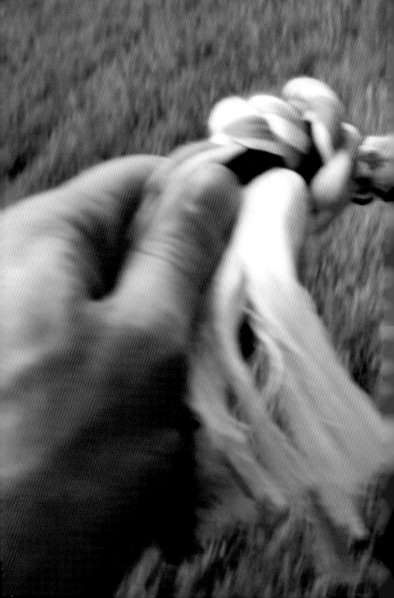

INVOLVE THE VIEWER

It's hard to ignore images that make you feel as though you are a part of the action. Look for ways of taking pictures that make the viewer a virtual participant in the scene.

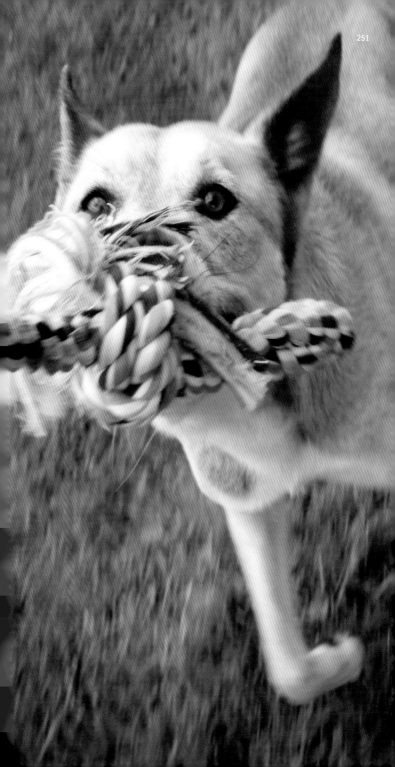

Words can make excellent subjects for photos. Words are not only infused with meaning of their own, they can also take on humorous or ironic thematic twists—depending on the context in which they are seen.

Keep your eyes open to words and sentences that exist within an environment that enforces—or subverts—their intended message.

Messages that make ▶ ▪ sober sense in one context may cause titters when seen on their own. *(I found this particular warning stenciled on the back of an old train car.)*

Type itself is an end- ▪ ▶ less source of beauty: Use your camera to capture interesting images of letterforms.

Does this mean ▶ we're supposed to pay *here*... or *up there*?

A concrete message, ▶ ▪ printed on concrete. Message and presentation are one in this image.

Words for words' ▪ ▶ sake: A neon "open" sign gives this photo a hint of context and the sense of being inside.

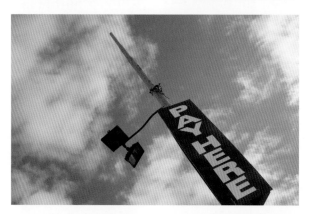

Creativity and Resourcefulness
+
Camera Competency
+
A Basic Understanding of Light & Shadow
=
Great Pictures

The bulk of this book is centered on creative (right-brain) aspects of picture-taking. Still, no book on photography would be complete without addressing certain left-brain fundamentals. This section provides an overview of light, shadow and a few essential camera functions. You'll notice that the information presented in this section is offered differently than is usually the case with photography books (technical charts and diagrams being conspicuously absent here). In this book, the reader is mainly encouraged to expand their technical know-how in the same way they hone their creative instincts: through hands-on exploration, investigation and play. *Consult the glossary beginning on page 352 if you are unsure about any of the technical terms used in this chapter.*

section

Light, Camera

LIGHT

When we look at something, what we are really seeing is the light that is reflecting off its various surfaces. It is light, and light alone, that we see with our eyes, and it's light's effects that we record with our cameras. The examples on the pages ahead are lit from a variety of single, multiple, natural, colored, direct and reflected sources of light. Use these images to fuel your own exploration of the virtually endless ways of capturing the effects of light as it illuminates the subjects and scenes you photograph.

Lights, diffusion, reflection.
Most of the studio-type shots featured in this
book were taken using either natural light or
the equipment shown on this spread.

A work lamp with a 500-watt
quartz bulb was used to light
the majority of studio shots
for this book. Positives:
**Inexpensive, bright, and
adjustable.** Drawbacks: HOT
(BE CAREFUL! Don't put any-
thing flammable near the lens
of these lights!); **not as
bright** as a true photographic
light unit.

When necessary, one
or more circular
metallic **reflectors**
were used to bounce
light into a scene.
This reflector came
with interchangeable
white, silver and
gold covers.

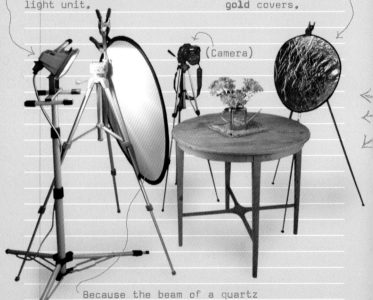

(Camera)

Because the beam of a quartz
bulb is very intense, its light
almost always needs to be **diffused.**
Here, the light's beam has been
softened by placing a **diffusion
panel** between the light and subject.

A **photographer's umbrella** was also used when diffused light was needed for a shot. The umbrella was clipped to a light which was aimed at its reflective inner-surface. Note: Sometimes it works to simply bounce light off a wall or ceiling to achieve a similar effect.

You may have noticed that the camera is not the only thing on these pages that's supported by a **tripod**. Use spare tripods (secondhand stores can be a good source for these) as stands for both diffusion and reflector panels. By clipping these panels to tripods, their position can be easily **set** and **changed** as lighting options are explored.

Now **and later**.

If you are new to photography, consider budget-sensitive equipment such as the the items featured on this spread. If you become more serious about your photographic pursuits, then you might want to consider more advanced and versatile lighting equipment. Ask professionals for advice and check out online photography forums for ideas.

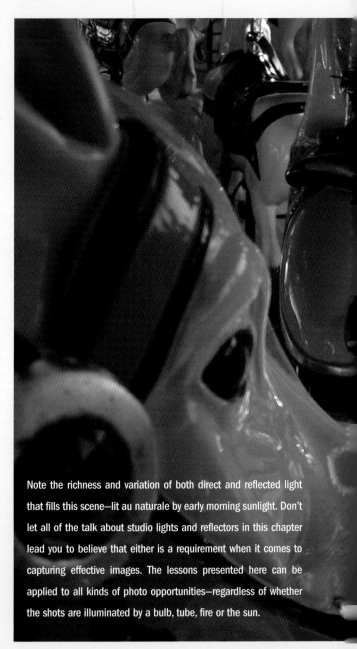

Note the richness and variation of both direct and reflected light that fills this scene—lit au naturale by early morning sunlight. Don't let all of the talk about studio lights and reflectors in this chapter lead you to believe that either is a requirement when it comes to capturing effective images. The lessons presented here can be applied to all kinds of photo opportunities—regardless of whether the shots are illuminated by a bulb, tube, fire or the sun.

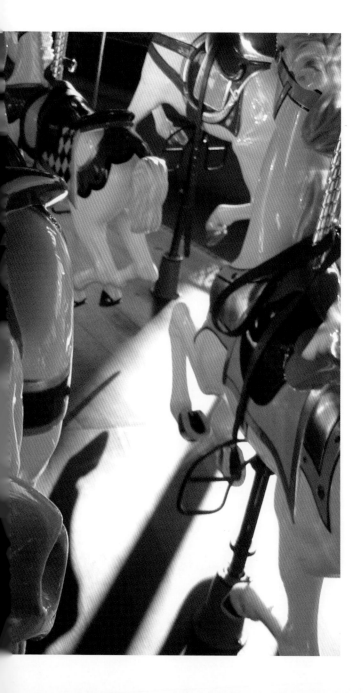

Whether you plan to take pictures in a studio environment or not, a basic understanding of studio lighting will help you work effectively with all kinds of lighting conditions—both controlled and naturally occurring.

Each of the scenes on this spread were lit by one 500-watt quartz bulb (SEE PAGE 258 FOR MORE ABOUT THE LIGHTS AND REFLECTORS USED IN THIS CHAPTER). Aside from a small amount of ambient light in the shadows, the only things lit in these photos are the surfaces that are in the direct path of the light.

Single-source lighting can result in a dramatic—though sometimes harsh—final result. This effect suits some subjects and themes, but in most cases, it is desirable to add some reflected light and/or the light from a secondary source to soften the contrast between areas of light and shadow. *Compare these images with those on the next spread where reflected light has been added.*

It is up to the photographer to decide what the "right" lighting is for a subject or scene. *How much detail needs to be included in the image? What sort of mood is being sought? How can light be used to give the best possible answers to these questions?*

Dark, hard-edged ▶ and long-reaching shadows are cast by the low placement of a quartz bulb aimed from the right. The effect suits the rough-and-ready look of the toy cars.

Most of the shadows in ▶ this photo appear "dead" (without detail). The harshness of their presentation seems contrary to the inviting and tranquil look of the image's content and presentation. Compare the shadow areas in this example with the more enlivened ones on the next spread.

Here, strong light ▶ is cast directly on the model's face from the right. The dramatic look of this image is perhaps better suited to contemporary works of advertising and design than its more traditional counterpart shown on the following spread.

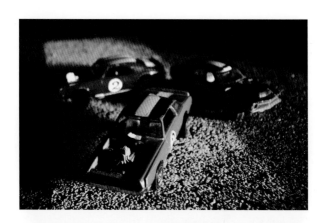

SECTION 2: LIGHTS, CAMERA: LIGHTS

In this series, a reflector has been used to bounce the quartz bulb's light into shadow areas of each scene. The reflector was placed out of frame and carefully angled to bounce light into previously dark areas. SEE PAGE 258 FOR MORE INFO ABOUT THE REFLECTORS USED FOR THIS SERIES.

Compare these shots with those on the previous page. Note how the addition of reflected light has brought more detail to the shadow areas, and how the distinction between light and dark is now less pronounced throughout each image.

When aiming reflected light into a setting, keep checking through the camera's viewfinder to assess its effect. You may want to secure your camera to a tripod in the meantime so that your viewpoint will not change as you adjust the overall lighting for the shot. SEE **STEADYING THE CAMERA**, PAGE 274, AND **MAKING A SCENE**, PAGES 70-73.

You don't need to use specialty reflector panels to add reflected light to a subject or scene—many ordinary items will do: a sheet of paper or fabric; a book with a colored cover (see the next spread for more on reflecting colored light); a nearby wall; the ceiling.

Placing a reflector to ▶ the right of the subjects casts light into the previously dark shadow areas. The result is a more congenial presentation than before. Is this appropriate for the given subject matter? That all depends on the look and feel being sought.

No "dead" shadows ▶ here—reflected light has brought detail to areas that may have appeared gloomy before. Now the image and content seem to be in better agreement—a gentle light evenly pervades this setting.

In this image, a ▶ reflector has been used to bounce light onto the near side of the model's face. Compare this image with the previous version: The drama of before has been exchanged for greater detail and a more portrait-like presentation.

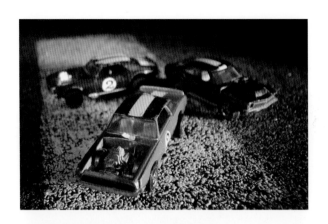

Left: The globe has been lit from one direction with no reflected light. Right: Three different colors of reflected light have been bounced onto the globe.

A silver reflector, ▶ placed out of frame to the left, casts cool (slightly bluish) light onto the globe and the rocks beneath. The effect could be described as "text-book," or analytical.

Photographers often use simple white reflectors to bounce light into a scene. If a "cooler" effect is desired, a silver reflector can be used. If a "warmer" ambience is desired, a gold reflector is often employed.

Cool light is inclined to enforce analytical, matter-of-fact themes. Warm light tends to add notes of comfort and safety to an image. When an image is infused with light from a colored reflector, it tends to look less realistic and more artistic—especially if the colored hue is pronounced or unnatural. Different colors convey different moods. When reflecting colored light onto a subject or into a scene, consider its thematic and aesthetic effect. Select a hue that amplifies the desired look and feel of the image.

Here, a gold reflector is ▶ used (note the warm hue of the stones beneath the globe). Though only subtly different than the scene before, the look is now noticeably more inviting and comfortable.

This scene gets its ▶ reflected light from a sheet of glossy red paper. Less natural than gold, silver or white, colored hues can be used to impart artistic, dreamlike, futuristic or fantastic notes to an image.

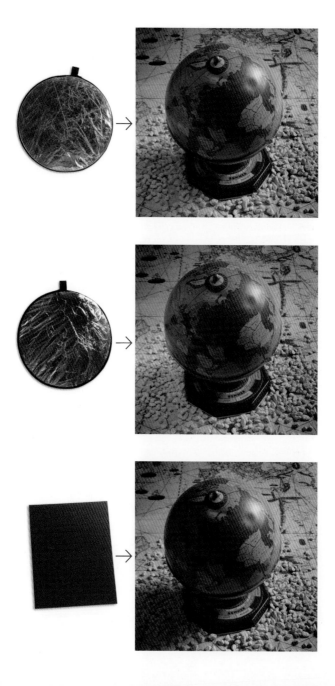

Whenever possible, thoroughly explore lighting options before deciding which set-up illuminates your subject or scene to its best thematic and visual effect. The images on this spread demonstrate some of the variables in lighting direction a photographer might explore when deciding how to present a subject most effectively.

Seek a lighting configuration that shows off the form of your subject; one that casts shadows that are neither too dark nor too light (a judgment call depending on the effect you are after); and one that gives visual dominance to the main element(s) of your composition (SEE **VISUAL HIERARCHY,** PAGE 94).

When looking for an effective lighting arrangement, be patient—this is often a time-consuming (and sometimes frustrating) process. Snap pictures whenever you achieve a successful set-up, and then experiment with other lighting configurations—after all, you're not paying for film costs and the best solutions are often those that arise after you *thought* you had a clear winner.

SEE PAGE 288 FOR ANOTHER DEMON-STRATION OF LIGHT, MULTI-LIGHT AND REFLECTOR EXPLORATION.

Light is bounced off ▶ ◻ the ceiling directly above the figure. A clean and sharp image, though not particularly dramatic.

Here, light is aimed ◻ ▶ from next to the camera. More stark than beautiful; more contemporary than classic.

Light is aimed at the ▶ ◻ side of the figure and away from the backdrop. The strikingly lit subject now stands out boldly against its surroundings.

Drama is heightened ◻ ▶ by the extreme angle of this side-lighting arrangement. Note that no reflected light has been added.

Light is aimed at the ▶ ◻ backdrop rather than the figure. The result is meditative and mysterious.

How about trying ◻ ▶ something completely different? Here, a candle provides the only source of illumination for the scene.

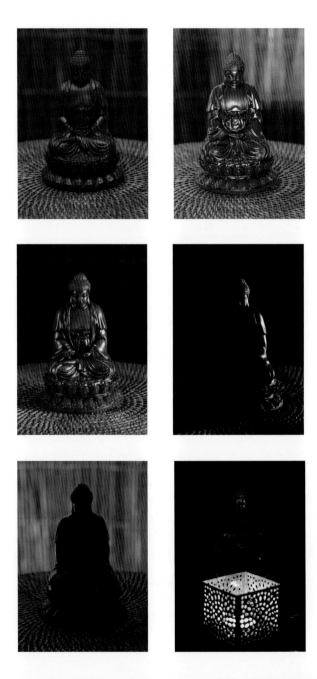

One light plus a reflector is often adequate to effectively illuminate a studio shot. Additional lights may be called for if a subject is too large for one light to adequately cover, or if reflectors cannot redirect light to certain areas of a scene.

When using two lights, try aiming one at the subject and one at the backdrop; see what happens when one light is aimed directly at one side of the subject while another is aimed toward the other side; experiment with different levels of diffusion for each light (SEE DIFFUSED LIGHT, PAGE 272); change the hue being cast by one or both lights by applying a colored gel or a piece of colored glass to the light(s); try employing different types of lights—consider using a spotlight or even a flashlight as a secondary source of light (SEE THE TOPMOST IMAGE ON PAGE 53 FOR AN EXAMPLE OF FLASHLIGHT USE).

As with any lighting set-up, explore options thoroughly before settling on a favorite. Pay attention to the shadows being cast (*Too light? Too dark? Getting in the way of other subjects?*) and the degree to which the main subject stands out from its backdrop and other elements in the scene.

One light is shone ▶ ◻ directly at the backdrop while a diffused light is aimed from from the right of the subject. A solution that shows off the bike's form nicely and neatly separates it from the backdrop.

Same set up as ◻ ▶ before, except that a note of drama has been added by placing an orange gel over the backdrop light. *I swept water onto the floor to add reflections and a measure of richness to this set of images.*

One light is aimed ▶ ◻ directly at the backdrop, and the other at the floor in front of the subject. Direct light casts harsher shadows than reflected or diffused light. Note the contrast between the relatively "soft" look of the motorcycle and its starkly lit backdrop.

And why not explore a few off-beat solutions ◻ ▶ while you've got your camera out of its bag? Here, a light itself has been given center stage. SEE **DEPTH OF FIELD**, PAGE 306.

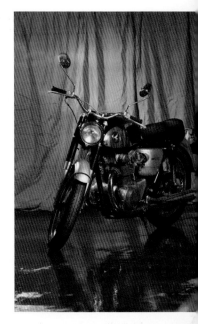
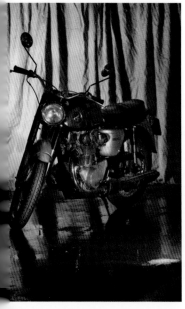
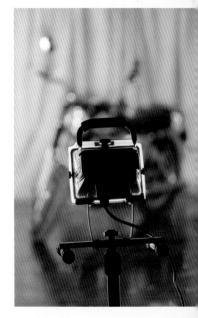

Light that is aimed straight at a subject is known as *direct* light.

Light that is shone through a diffusion panel is called *diffused* light. Light that is bounced off a reflective panel or a photographer's umbrella is also considered diffused. SEE AFFORDABLE LIGHT, PAGE 258, FOR EXAMPLES OF A DIFFUSION PANEL, REFLECTOR AND A PHOTOGRAPHER'S UMBRELLA.

Diffusion lessens the contrast between lit and unlit areas of a scene—softening the edges of shadows and decreasing the strength of highlights throughout the image.

A comparison between the effects of direct and diffused light are featured on this spread. Look closely at each of the samples: The differences between them are subtle but significant. Each of the images could be considered "right" or "wrong"—it all depends on the look and feel being sought.

Direct light. Here, a ▶ single 500-watt quartz bulb has been aimed directly at the subjects. Notice the stark shadows on the front of the wooden crate.

In this shot, a ▶ diffusion panel was positioned near the light. The shadows are noticeably softer in this image than before.

And here, the ▶ diffusion panel was positioned farther from the light source and nearer to the subjects. The resulting shadows are now quite subtle.

Avoiding blur.

The amount of time that a shutter has to be
open to capture a specific image depends on
several factors: the type of lens being used;
the quality and quantity of light bouncing off
the subject; the camera's aperture setting; the
relative stillness of the subject; and the
stillness of the camera itself.

Most digital cameras do a good job of automati-
cally evaluating the amount of exposure that
will be needed to properly capture a shot.
Sometimes, however, this means that the shutter
will need to be open for longer than it is pos-
sible to hold the camera perfectly still. When
this happens, the result is usually a blurred
image. To achieve a crisp shot under conditions
such as these, the photographer needs to find a
way of steadying the camera.

'Pods.

Tripods are the most common devices used to
steady cameras and they come in all kinds of
sizes and configurations. Sturdy, highly
adjustable models are often used in the studio;
lighter versions are designed to be collapsed
and carried; mini-
tripods are small
enough for tabletop
use with a pocket
camera.

A **monopod** (not shown)
is like a single
collapsible leg from
a tripod that has a

mini-tripod

camera mount on top. Monopods
are not as stable as their three-legged
cousins, but they do provide a footing
that enables the camera to capture
shots that would be impossible without
some sort of steadying device. The
extremely portable nature of monopods
makes them a favorite of many photog-
raphers who do a lot of shooting on-
the-go.

Improvisation.
If you find yourself in a situa-
tion where you want to take a
low-light, non-flash picture,
and have no tripod or monopod
on hand, try methods such
as these to capture a sharp
image: **Brace** the camera and
your shooting hand against
a wall or sturdy object
as you take the picture;
press your elbows down
on a table as you hold
and aim the camera;
set the camera on
something solid like
a rock, table, book
or drinking glass
and use the cam-
era's **delayed shooting function.**
(This will avoid any shaking that
might occur if the shutter button
is manually pressed as the
picture is taken.)

lightweight tripod

Unless you are using special equipment, your low-light images are likely to come out as blurred, abstract representations. Take heart: This is not necessarily a bad thing. The semi-abstract look of this kind of semi-accidental shot often works nicely to convey the essence of darkness and late hours.

Nighttime is a great time to explore non-traditional photography techniques. It can be difficult to predict what the outcome of low-light shooting will be, so review your images on the camera's LCD as you work and keep your eyes and mind open to unexpected and pleasant surprises.

Also, learn to see the potential of imperfect photos taken under difficult conditions such as these: Image-enhancement software might be able to save the day (or night).

Cameras vary in their ability to capture low-light images. If you are unsure about what yours can and cannot do, check out the manual to see if certain settings can be utilized to maximize its capabilities and/or to achieve special nighttime effects. SEE **ABSTRACTION**, PAGES 230-233; **LIGHTPLAY**, PAGES 226-229; AND **SHAKE IT**, PAGE 242.

The photographic ▶ "imperfections" that occur in dim light can work to your advantage—resulting in photographs of intriguing obscurity. Amplify contrast and colors using software if your nighttime images need a post-shooting tune-up.

I enjoy using the ▶ "nightshot" mode on my old Sony pocket digital camera. The resulting images are similar to the view through a pair of night-vision goggles and convey a gritty quality of after-hours voyeurism.

I chanced upon this ▶ contemplative scene while waiting for a stage performance to begin. The shot was taken under conditions of very low light using a digital camera with a "fast lens"—one that is able to take in light very efficiently. FOR MORE INFORMATION ON LENSES, SEE PAGE 322.

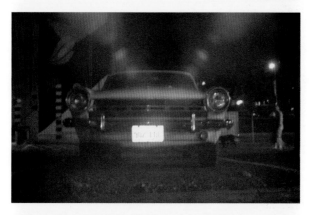

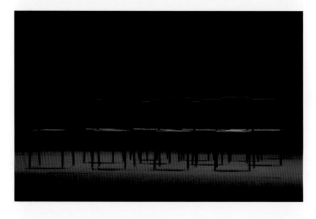

Most of the time, photographers use light that comes from in front, or the side, of the subject they are shooting.

Be sure to consider backlighting alternatives as well when you are looking for distinctive ways of lighting images of people, places or things—the results can be refreshingly unique.

Backlighting is any lighting arrangement that puts the subject between the camera and the light source.

When using backlight as the primary source of illumination for a scene, you may need to reflect or shine a small amount of light onto the front of your subject as well—unless you want the subject to appear as a silhouette.

Keep your eyes open to examples of backlighting in the photographs you see. Mentally catalog the visual effects of these images so that you can apply them to your own backlit shots in the future.

I chanced upon this ▶ dramatic example of backlighting at an Italian restaurant. An unseen candle shines through a bottle of olive oil while casting direct light on the wall behind.

Natural backlighting: ▶ The embroidered flowers within the folds of these lace curtains are illuminated from outside the window. The resulting effect is subdued and contemplative—the viewer seems to be placed inside the room from which the picture was taken.

Here, a quartz light ▶ was aimed at the back of a thin sheet of handmade paper hung behind a stack of jars. The lighting in this scene does little to reveal the jars' contents—images such as this can be used as "visual bait" for a text that gives more information. SEE **IMPLYING STORY**, PAGE 244.

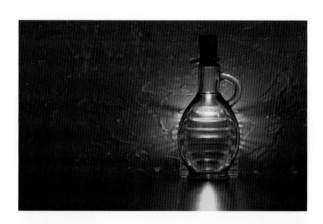

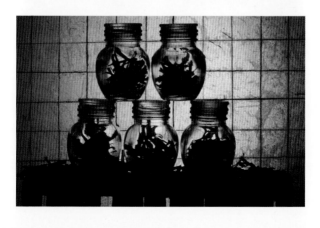

Backlighting on a larger scale: The beautifully complex form of this oceanside tree is put into silhouette by the evening sky.

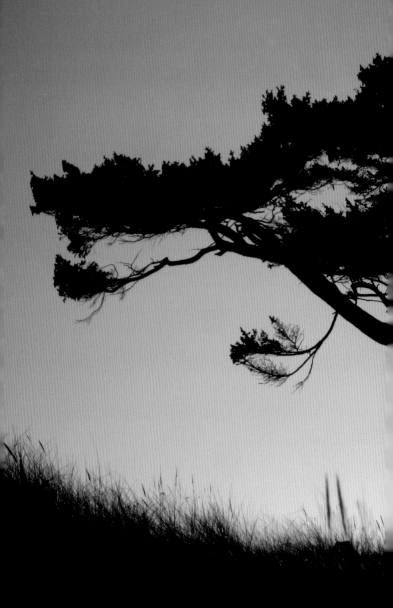

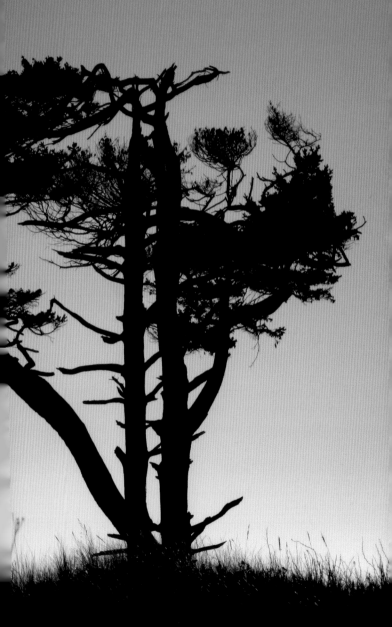

If you have access to a light table, you might want to investigate its potential as a photographic light.

Experiment by placing transparent, translucent and opaque objects on the light table. See what happens when the light table is the only source of illumination for your subject. Explore the effects of simultaneously using a light table beneath your subject, and a regular source of light above it.

Sometimes a photographer or artist needs to capture an image of a complex ▶ subject without any shadows or background present. "Knock-out" images such as this are often seen as graphic elements in designs or layered digital compositions. It would be very difficult to digitally remove the background and shadows from a subject as complex as this decayed leaf if the original photo was taken using a traditional overhead light. To make the job of background and shadow removal *much* easier, the leaf was lit from beneath using a light table and from above with an ordinary incandescent light.

These halogen bulbs were placed on top of a textured glass block, which was then set on a light table. The light table provided the only source of illumina- ▶ tion for these subjects—the highly reflective surfaces of the bulbs themselves distributed the light throughout the scene. The effect is modern and eye-catching and only took a few minutes to set up.

Note: If the light table you are using has fluorescent tubes, you might want to adjust the WHITE BALANCE setting on your camera to compensate for the cool hue cast by this type of light. SEE **WHITE BALANCE,** PAGE 320.

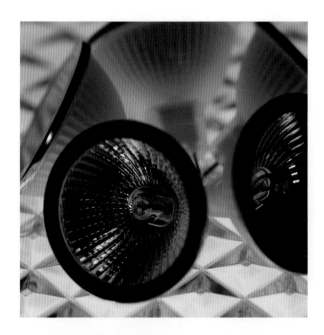

SECTION 2: LIGHTS, CAMERA: LIGHTS

An excellent and versatile way to add light to a scene or subject (especially if it is a tiny one) is to use a flashlight or a keychain-style (piezoelectric) light. These light-sources are cheap, portable and a lot of fun to experiment with.

Flashlights can be used as the only source of light in a scene—as with each of the examples on this spread. They can also be used in addition to other lights to fill in dark areas of a setting or to add accent highlights to a subject (SEE THE IMAGE OF THE WASP ON PAGES 28-29; NOTE THE BLUE HIGHLIGHTS ON ITS WINGS).

The light produced by most flash-lights is relatively weak; you will probably need to secure your camera to something solid when shooting—otherwise your photos might be blurred. SEE STEADYING THE CAMERA, PAGE 274.

An intriguing composi- ▶ tion of form and light is created simply by aiming a keychain light from surface-level at an old metal spring. I used a tripod to steady the camera for this low-light shot.

This old spring (and the weathered sheet of painted metal beneath it) both came from a secondhand building materials store. I get a lot of my props at outlets such as this: The goods are inex-pensive and they come with a built-in history of wear-and-tear.

A tiny flashlight was aimed through the middle of the small metal spring to pro- ▶ ▢ duce this effect. A digital SLR fitted with a macro lens captured the micro-detail of this tiny subject. FOR MORE ABOUT MACRO LENSES, SEE PAGE 323.

This contemporary-looking effect was achieved using a technique known as "paint- ▢ ▶ ing with light." To paint with light, you need a subject, a flashlight, a camera whose aperture and shutter speed can be manually controlled, and a tripod. Aim the cam-era, atop a tripod, at the subject; darken the room; close the aperture as far as possible (its highest f-stop number) and set the exposure for about 10 seconds. Now press the shutter button and then use the flashlight to freely illuminate the subject/scene until the shutter closes. The results—though impossible to accu-rately predict—often contain beautiful surprises. Review your images as you work and make adjustments to the exposure time and your flashlight technique until you start seeing results you like.

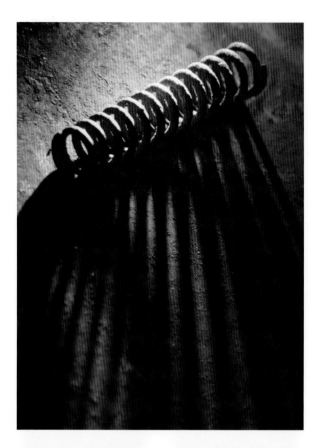

A flashlight can be used to put tiny subject matter into a spotlight that matches its scale.

Try this exercise sometime: Choose a favorite small subject such as a toy or keepsake and set it up in a room where you can shut off the lights. Secure your camera to something solid so that it will hold perfectly still while shooting and aim it at your subject (make sure that the flash on your camera is turned off so that it won't automatically fire under these low-light conditions). Use a flashlight as a mini-spotlight to illuminate the subject—try varying the height and angle of the light to see how it affects the scene. To avoid shaking the camera when the shutter is pressed, you may want to use your camera's timer mode when shooting (this also gives you a few seconds after pressing the trigger to fine-tune the aim of your flashlight). SEE **FLASHLIGHTS**, PAGE 284, AND **STEADYING THE CAMERA**, PAGE 274.

A friend's glass-mounted collection of bugs made perfect models for my own mini-spotlight series.

Here, the spotlight is ▶ shone from beneath the glass to highlight the beautifully translucent wings of one subject.

In this photo, the ▶ flashlight is aimed from a low angle to spotlight the featured insect and cast dramatic shadows all around.

Extreme light, extreme ▶ shadows. Here, a striking effect is achieved by directing the flashlight's beam harshly upon the central subject—intentionally overexposing the insect's shell while casting a gigantic shadow on the sheet of paper below. SEE **INTENTIONAL OVEREXPOSURE,** PAGE 312.

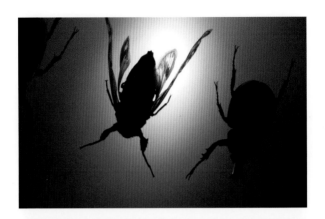

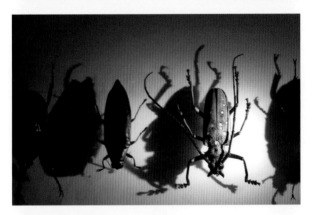

When setting up the lighting for a shot, be prepared to spend ample time exploring options before you settle on a favorite solution. *A subject is not ready to be photographed until it is properly lit.*

This spread demonstrates some of the lighting and reflection variables a photographer might explore while preparing to photograph a scene.

If the lighting for a shot is complicated, you may want to take photos of the set-up itself while you work. You can then refer to these images later on if you want to return to an earlier light/reflector configuration.

Indirect, ambient light coming from many ▶ ☐ directions results in a "flat" image. This effect is not usually your best bet, but might be appropriate if the final result is meant to be low-key or intentionally bland.

A direct source of light, aimed at the ☐ ▶ subjects from above, adds dimension and drama to the scene.

Lowering the light source lengthens the shad- ▶ ☐ ows dramatically. Light is bounced onto the subjects from an (unseen) white reflector placed to the left of the scene. The reflected light helps define the shape of the jacks and softens the shadows slightly.

The center-of-interest is moved forward by con- ☐ ▶ centrating the light in the foreground. An artistic touch is added by reflecting light from a sheet of red paper onto the subjects.

The blue hue cast by a keychain light (aimed ▶ ☐ from near the camera) further amplifies the artistic effect of the image. The unseen sheet of colored paper continues to provide red accents from the left.

A bold effect is created by removing the ☐ ▶ reflector and aiming a single source of light directly at the subjects.

Here, another low angle of light is explored; ▶ ☐ this time with the red reflector back in place. This is a strong effect that presents the jacks in a clear and striking manner.

This image was "painted with light" to achieve ☐ ▶ a contemporary effect unlike any of the others. SEE **FLASHLIGHTS**, PAGE 284, FOR MORE ON THIS TECHNIQUE OF LIGHTING A SCENE. ALSO SEE **INTENTIONAL OVEREXPOSURE**, PAGE 312.

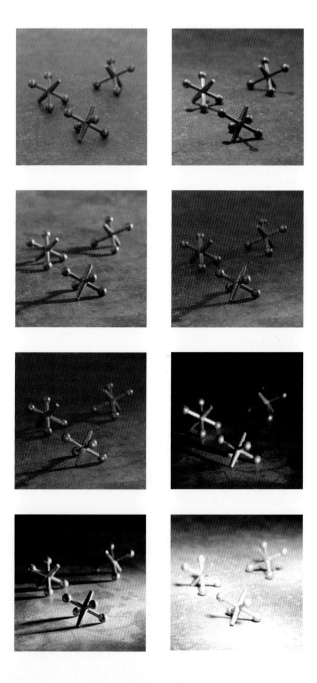

It is almost always best to avoid the kind of "flat" lighting seen in this photograph. Here, one light was aimed from next to the camera, and the other was directed from behind the egg. Together, the two lights cancel out most of the form-defining shadows that could have given this image the feeling of dimension and depth it lacks.

Go on, try it for yourself. Place an egg on a white sheet of paper and take its portrait. Use whatever light and reflector sources you have at your disposal. Be patient and learn some lessons about illumination and form as you experiment with solutions—lessons that can be applied to all kinds of real-world subjects and scenes.

An off-topic suggestion: Play with your props once you are done tak-
ing the pictures you were supposed to take. Often, this is when the
really interesting photos are taken.

This image of a smashed egg also serves as a reminder to collect
your own stockpile of visual metaphors for use in various projects
(commercial or otherwise). SEE **BEYOND THE OBVIOUS,** PAGE 202-205, AND
METAPHOR, PAGE 246.

Your on-camera flash can be a useful—though limited—picture taking aid.

In reality, most experienced photographers rarely use their on-camera flash. One reason for this is that the color of light added by the flash is rarely in-sync with the prevailing light in a scene—flash images tend to have an unnatural look. (Hint: One way to compensate for this color-related issue is to convert your flash images to monochromatic color schemes—as seen in the samples on this spread. SEE GRAYSCALE ALTERNATIVES, PAGE 340.)

Another downfall of on-camera flash units is that the flash itself is positioned near the lens and is aimed straight at whatever you are shooting. This tends to overexpose the main subject, cast harsh shadows, and eliminate the naturally occurring shadows that would otherwise describe the subject's form. When experienced photographers take flash photos, they generally use an auxiliary flash unit whose head can be aimed at the ceiling or a wall. This "bounce-flash" technique eliminates or reduces the problems described above.

Still, all of this does not mean that your on-camera flash needs to go to waste. This spread and the next suggest a few practical uses for it.

Fill-in flash. *When I first tried to photograph this decaying seaside post, the subject came out as a dark silhouette. This is because the camera was automatically selecting an exposure that would properly record the bright sky in the background (at the expense of the darker forms in the foreground).*

By using the on-camera flash, I was able to illuminate the post without affecting the appearance of the sky or water behind it.

If you are a fan of visual texture, your on-camera flash can be a useful tool. The near-image of these fenced-in brambles was taken without flash. The far image (taken with the flash turned on) shows what can happen when the flash is used at close range in dim light. In this case, the intensity of the flash caused the camera to restrict its intake of light—thus, only the brambles within range of the flash were lit. The result was an intriguing, "flattened" visual texture.

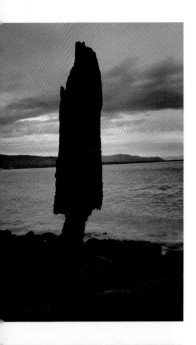
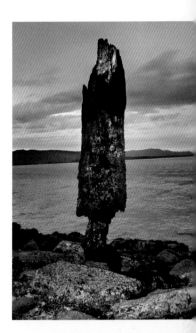
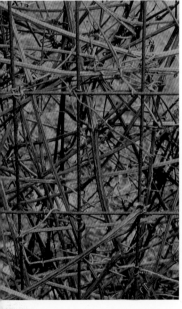
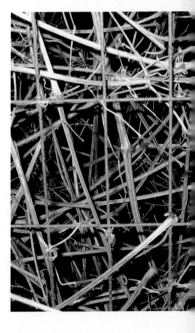

Your camera's flash can be used to freeze time in spectacular ways. Here, a dart has just passed through a water balloon whose pink remnants can still be seen inside the disintegrating ball of liquid (which, amazingly, has not yet completely lost the shape of the balloon). This image was captured by selecting a fast shutter speed (1/8000 of a sec.) on a digital SLR and using the on-camera flash.

This chapter concludes where it began: with natural light.

Don't let the potential complexity and expense of photographic lighting equipment overshadow the fact that many of the best photos are taken using exactly whatever light is available.

Keep your eyes and mind open to beautiful convergences of light and subject, whether they occur naturally or are studio-derived.

Opposite: Two unplanned images that were each lit using available window light. One was shot from inside a window; the other, from outside.

A cozy portrait of ▶ early morning stillness: Light from the newly risen sun is just able to make it through the thick and translucent arms of a window plant.

Who knows what the ▶ story is in this scene—I chanced upon this devil's head on the dashboard of an old VW van parked at a trailhead. The light and reflections throughout the scene could not have been more perfectly composed and varied if they had been planned in a studio.

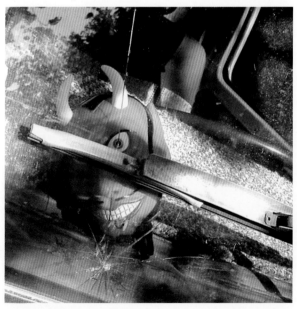

CAMERA VARIABLES

Photography is an amazing blend of art and science: The best photographers are usually those who have taken the time to sharpen both their creative instincts *and* technical know-how. If you are a creative type and feel intimidated by your camera's workings, don't despair! Review the instruction manual that applies to your specific camera to learn what each of its functions do. Then, apply what you read through practice and hands-on photo sessions. Before long, an understanding of your camera's full range of functions and capabilities will become second nature. And the more you know about your camera's operation, the better able you will be at capturing images that meet and exceed your expectations. This chapter provides a series of demonstrations and prompts designed to encourage exploration of your digital camera's functions. *Note: Most pocket digital cameras offer a limited degree of manual control over such things such as aperture setting and shutter speed. Therefore, much of the content in this chapter is demonstrated using the manual functions offered by a digital SLR with plenty of manual controls. Even so, the information and lessons presented here are relevant to photography as a whole, and can be applied in various degrees to digital cameras of all kinds.*

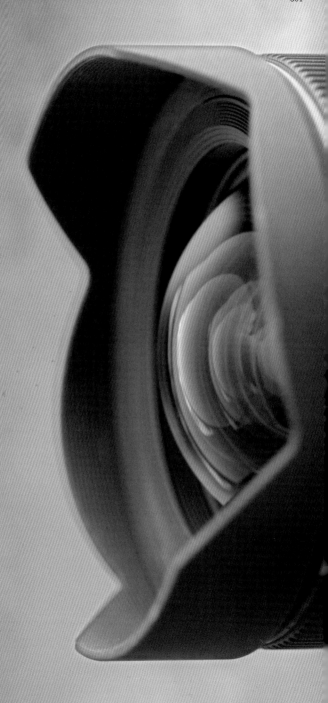

Unless you are *trying* to take a blurred photograph for thematic or artistic reasons, you've got to learn how to get things in focus before clicking the shutter.

Most of the time, the camera's AUTO FOCUS function does a good job of bringing images into crisp focus. If the camera is having trouble focusing, it is usually a matter of there being too little light for the camera's sensors to properly function, or because you are holding the camera too near its subject.

Low light situations can often be handled by steadying the camera (SEE **STEADYING THE CAMERA,** PAGE 274). Learning to properly use the CLOSE UP setting on your camera (most are equipped with this feature) will solve the majority of your too-near-the-subject issues.

Take a look inside your camera's user manual for tips on getting the sharpest focus from your particular model. It is important to practice taking pictures under a variety of conditions so that when a great shot presents itself, you'll be able to quickly bring your subject or scene into proper focus.

...but then again, who says that every shot needs to be *in* focus? The primary goal of any creative visual media is to communicate. And if a blurred image of your subject conveys an idea or message better than a crisp presentation—then by all means, let the image be blurred.

Blur can be used to turn the realistic into the abstract, convey motion or imply distress. Subtle blur (softfocus) can be used to add notes of tenderness and comfort to a subject or scene.

If your camera is equipped with a MANUAL FOCUS mode, then you will be able to manually blur images according to the effect you are after. If you camera is in permanent AUTO FOCUS mode (as are many pocket digital cameras), you can still achieve images that are blurred by using one or more of these methods:

· Press and hold the shutter button halfway down while aiming at a subject that is significantly nearer to—or farther from—the camera than your actual subject. After focus has been obtained on this temporary subject, re-aim the camera at your real subject and finish depressing the shutter.

· Intentionally move your camera while shooting. SEE **SHAKE IT**, PAGE 242.

· Take pictures under low light conditions without a tripod—this is almost guaranteed to produce a blurred result (sometimes desirable, sometimes not).

There is a point near the camera at which objects come into focus. The measurement from this point, all the way to the point where things begin to fall out of focus (sometimes infinitely far away) is known as a shot's *depth of field*.

Depth of field (d.o.f.) is determined by lens-type, the aperture setting that has been selected, and how far away the subject is. Some lens/aperture combinations result in a shallow d.o.f.—others deep. The d.o.f. of most advanced digital cameras can be manually controlled (the degree to which depends on the lens that is being used). Control over d.o.f. is a good reason to consider upgrading to something more advanced once you've gotten a handle on the basics (few pocket digi-cams offer more than incidental control over their d.o.f.).

The samples on this spread provide a simple demonstration of the effects of manually adjusting the d.o.f. while taking a series of shots.

Look at photos in galleries, magazines, advertisements and web sites. Notice how a shallow depth of field is often used to confine the focus to certain essentials. Look for samples of a deep d.o.f. as well. Take note of which effect seems to work best in support of what type of message and stylistic result.

These samples demonstrate how changing a camera's depth of field affects its view of a scene.

In technical terms, the "f-stop" number (displayed to the right of the images, opposite) reveals how far open the camera's aperture* was manually set for each shot. The lower the number, the wider the aperture opening, and the shallower the depth of field.

Conversely, reducing the aperture opening (represented by a higher f-stop number) increases the lens's depth of field. This narrower aperture opening also means that the amount of light getting to the camera's image-sensor is reduced. Therefore, when shooting with a deep d.o.f., more light or longer exposures may be needed to properly capture the image.

*The adjustable iris-like opening inside the lens.

F 2.8

The photos on this page were each taken using a digital SLR fitted with a 100mm macro lens. Changes to depth of field affect different types of lenses to varying degrees. SEE **LENSES**, PAGE 322.

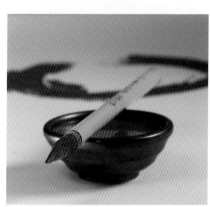

F 11

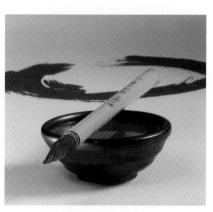

F 32

Another depth of field demonstration: this one conducted outdoors.

Digital cameras make ideal photographic learning tools since you can review your images on the spot and make adjustments to your technique accordingly.

The lens is focused on the grass in the foreground using a shallow depth of field. As a result, the lighthouse in the background is a barely distinguishable blur. ▶

Here, the d.o.f. has been increased. More of the grass in the foreground has been brought into focus and the lighthouse is now recognizable. This shot is a fairly good representation of the way the human eye would view the scene. ▶

Here, the camera's primary focus is still on the grass, and the lens' maximum d.o.f. can almost, but not quite, bring the lighthouse into focus. *Note: If I had wanted a shot where everything was in sharp focus, I could have moved the camera back a few feet so that the grass in the foreground was not so near to the camera's lens.* ▶

The f-stop setting used for this image is the same as it was for the above example. The only difference is that the primary focus is now on the lighthouse rather than the grass. Using a camera with manual depth of field control puts a great deal of artistic control in the hands of the photographer. ▶

F 2.8

The photos on this
page were each taken
using a digital SLR fit-
ted with a
70-300mm
telephoto lens.
SEE **LENSES,** PAGE 322.

F 11

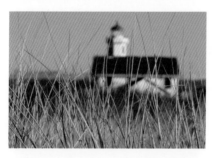

F 36

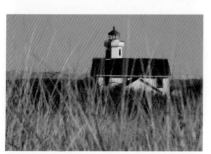

F 36

Most mid-level (and above) digital cameras have an AUTOMATIC EXPOSURE BRACKETING feature that can be used to instruct the camera to take a rapid set of three shots: One will be exposed at what is expected to be the correct level; one will be darker; and one lighter.

Since no camera (or photographer) can always guess what the right amount of exposure for a particular shot will be, bracketing is sometimes necessary to ensure success.

Bracketing is especially useful when there are both very dark and very light areas in a scene. Such extremes are beyond the capabilities of most cameras to accurately capture (an accurate reading of one extreme will usually be made at the expense of the other). Learn to recognize conditions such as these and, if possible, auto-bracket your shots so that you don't miss out on a good photo opportunity.

Note: Most pocket digital cameras do not have an AUTOMATIC EXPOSURE BRACKETING feature. Many do, however, offer manual control over the relative brightness of their images. You can "manually bracket" with this type of camera by taking a set of shots using various brightness settings.

A tough scenario for any camera's light-reading sensors: an extremely bright sky combined with dark foreground areas. In cases like this, it's a good idea to use the camera's AUTOMATIC EXPOSURE BRACKETING feature (if it is so equipped). That way, you stand a better chance of getting at least one shot that is properly exposed.

In this series of bracketed shots, the first image is over-exposed (note the lack of detail in the "burned-out" areas of the clouds).

The next shot, though better than the first, still shows evidence of overexposure.

Finally, the darkest of the three shots captures the sky as it should be—though now, the foreground is a bit lifeless compared to before. Fortunately, the best of both worlds can be had with a little help from the computer... (SEE **DIGITAL BRACKETING,** PAGE 344).

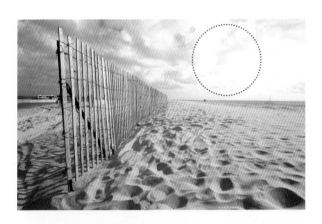

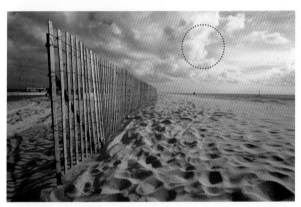

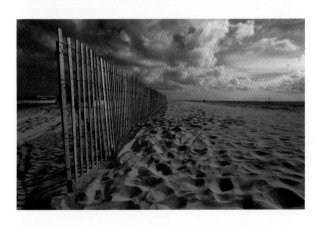

Though purists may grimace, modern images often contain areas of intentional overexposure as a matter of style and a means of thematic delivery.

Overexposure is another of those artistic judgment calls. It's up to the photographer to decide when this kind of image abuse is appropriate for the sake of visual impact—and when it should be outlawed in favor of a more P.C. (photographically correct) presentation.

Photoshop's LEVELS and CURVES controls can also be used give an an overexposed look to an image, whether the original was overexposed or not. SEE LEVELS ADJUSTMENTS, PAGE 332, AND CURVES CONTROL, PAGE 334.

Decay, emptiness and ▶ abandonment all seem to be thematically at work in this scene; so why not degrade (overexpose) the image itself to enforce these connotations?

An ominous and enor- ▶ mous slab of concrete rises out of shallow surf. Its massive presence (and mysterious purpose) seem to be heightened by the overwhelming glare that surrounds it.

Here, overexposure ▶ enhances the hardcore industrial look of a burly set of bolts.

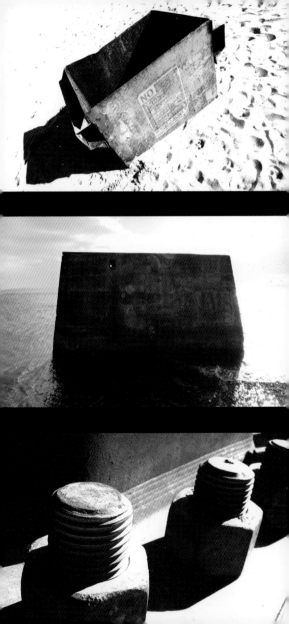

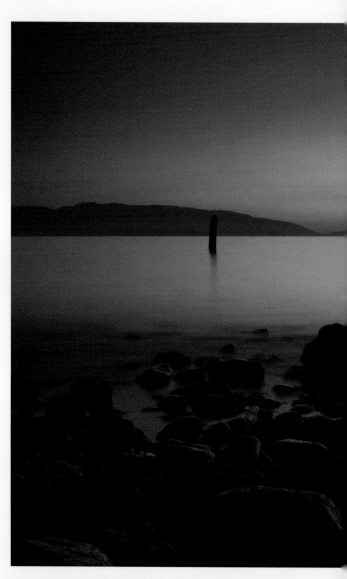

This scene was captured in near-darkness following sunset. I set the digital SLR on a low tripod and left the shutter open for a full 30 seconds. This allowed the lens to take in enough light to capture the scene and turned the choppy action of the waves into a surreal mist. Shots like this require the capabilities of an advanced digital camera and a basic understanding of its manual controls. For

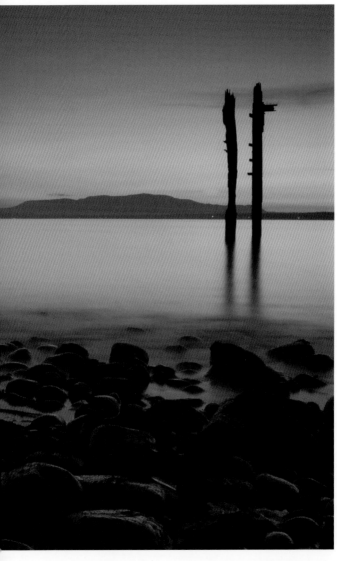

most creative-minded people, an excellent way to learn about the functions of their advanced cameras (shutter, aperture, flash, etc.) is through hands-on use. A suggestion—review the manual to find out what the buttons do, and then start shooting. Experiment freely with the full range of your camera's controls under a variety of conditions.

Nearly all high-end digital cameras have a CONTINUOUS SHOOTING mode. Many pocket digi-cams offer this feature as well.

This mode is ideal for taking photos of subjects that are moving too quickly for the eye to follow since it directs the camera to take a series of shots in rapid succession. You can review your accumulated set of images for favorites after you are finished taking pictures.

Shooting pictures in this mode can eat up large amounts of disk space relatively quickly: A large-capacity media card will help keep you from having to change cards or quit shooting in the middle of the action.

Once again, digital media grants an unprecedented measure of fearlessness to artistic exploration such as this—few photographers who use film have the courage to incur the film processing costs associated with such rapid-fire shooting.

The quickness of the dancer's movements throughout this session meant that it would be impossible to predict the exact outcome of each shot. Therefore, I selected the camera's CONTINUOUS SHOOTING mode so that I could take a steady stream of photographs during her routine. Out of the 1000 or so images that I ended up taking, I found 50 that I liked enough to keep. A success rate such as this (about 5%) is not untypical for this kind of catch-what-you-can shooting.

Note: I wanted these images to contain just enough motion blur to convey a sense of the model's movements. To gain this effect, I set the shutter speed of the digital SLR at 1/15th of a second. Longer exposures would have meant more blur; shorter exposures, less.

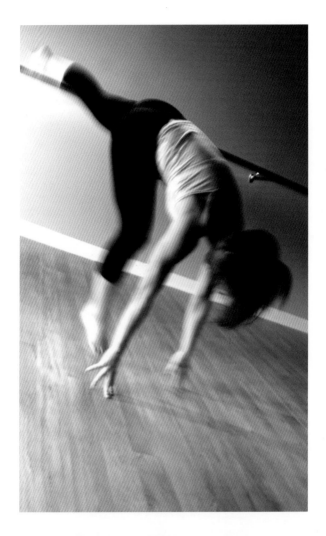

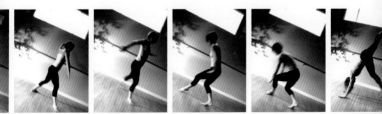

If you want to include some motion-blur in a shot of a moving subject, try one of these three techniques.

1. As the subject passes, follow it with the camera (called *panning*). You can freeze your subject against a blurred backdrop if you follow the speed of the passing subject as you pan.

Note: Each of these motion-blur techniques requires that the camera's exposure time is not so fast that it freezes all action (SEE **STOPPING TIME,** PAGE 170). With a digital SLR, this may mean selecting a shutter speed that is longer than 1/8th of a second. With a pocket digi-cam, you might need to shoot under relatively dim light so the camera will automatically select a slow shutter speed.

2. Hold the camera steady and snap a picture as the subject passes by. Naturally, this transfers the emphasis in visual detail from the subject to the backdrop. This can be an effective shooting technique if the backdrop is the real center of attention (a cityscape, for example) and the moving subject is being included for stylistic purposes.

3. Pan the camera at a faster or slower speed than the moving subject. This will cause both the subject and the backdrop to blur. More impressionistic than realistic, this technique can result in artful and communicative images.

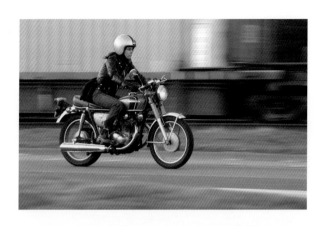

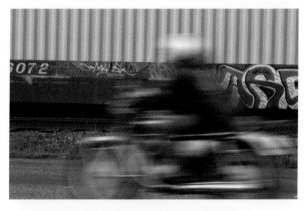

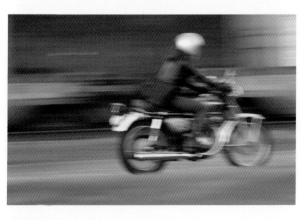

If you came across a zebra standing under a blue spot-light, you would almost certainly see the animal as a regular zebra, not as a completely new species of hoofed mammal. This, in spite of the fact that the zebra's colors have been shifted to blue and black by the light.

An obvious point, but also a useful demonstration of how our eyes and mind automatically combine to try to tell us what the actual colors are in the things we see.

Your camera, on the other hand, has no way of knowing anything about the light being cast on a subject. Oftentimes, this is okay, such as when you want to record a scene just as it is (ambient light and all). Other times, however, you may want to select one of your camera's WHITE BALANCE settings—one that corresponds to the prevailing light conditions. This feature (available on most digi-cams) shifts the balance of colors that the camera records so that they will appear normal when the images are viewed. An example: If the zebra mentioned earlier was photographed using CUSTOM WHITE BALANCE* control, this feature could have instructed the camera to ignore the blue light being cast and to record the scene as the eye would view it under natural light.

Also, consider using white balance controls to intentionally and creatively alter the the colors of a scene.

**The CUSTOM WHITE BALANCE control allows you to point the camera at a particular hue and tell it to use this as a reference point for true white. Try it out for yourself under a variety of lighting scenarios. Consult the user's manual if you need help figuring out how to use your camera's white balance controls.*

Opposite: These photos were each taken using light from the same 500-watt quartz bulb. The WHITE BALANCE setting was changed for each shot (the labels correspond to the various settings used). The custom setting captured the colors most accurately, but also seemed to present the scene in a relatively cold light—contrary to what you might expect given the subject matter. Which WHITE BALANCE setting do you think best suits the presentation of this image?

TIPS & TRICKS

Lenses: a semi-technical rundown.
The majority of photos in this book were taken
with a pocket digital camera. When a more
advanced camera was needed for a particular
shot, a **digital SLR** was used along with one of
the four lenses shown on this spread. Here is
a brief description of each lens and its
strengths.

FYI: This set of numbers
refers to the range of a
lens's focal length. Lower
numbers mean a wider field
of view and a lower degree
of magnification. Higher
numbers = greater magnifica-
tion and a narrower field
of view.

These numbers represent
the lens's range of max-
imum aperture openings.
A lens's ability to take
in light and its depth
of field capabilities
are determined by its
max. aperture opening.
See Depth of field,
page 306.

Standard zoom. 18–55mm, **f**/3.5–5.6: Great **all-
around lens.** Capable of taking fairly wide-
angle shots as well as moderate zooms.

Macro. 100mm, f2.8: Specially designed to focus at small distances for exceptional **close-up** shots. At f2.8, this lens is good under low light conditions and has extremely fine depth of field control. This d.o.f. finesse also means that macro lenses work well for **portraits** since they can focus sharply on a subject while blurring the backdrop. A fun lens!

Wide angle. 12-24mm, f4.5-5.6: Not quite a fish-eye lens, but close. This lens captures a very **wide view** of things and has the ability to keep entire scenes in focus. Good for taking indoor shots in spaces that are too confining for the narrower field of view of other lenses; also excellent for sweeping landscape shots and portraits that include the subject's surroundings.

Telephoto. 70-300mm, f4-5.6: A mid-level telephoto lens such as this is great to have on hand when a standard zoom lens cannot satisfactorily **magnify** a distant subject. Far more powerful telephotos are available, though their prices are also highly magnified.

An advantage offered by most digital SLRs is that their lenses can be changed. Extra lenses grant extra options when it comes to the kinds of images that you will be able to compose and capture with your camera.

When I head out for a planned photo session, I almost always bring my digital SLR's standard lens along with a wide-angle and a telephoto. This way, I will be able to take advantage of many different kinds of photo opportunities, both expected and otherwise.

If you find yourself getting serious about photography, and are looking for more capabilities than those offered by your pocket digital camera, consider buying a digital SLR with an extra lens or two. Ask for the advice of experienced photographers when considering equipment upgrades such as these.

Swapping lenses while in the middle of a photoshoot is one of those skills worth practicing beforehand in the relatively controlled environment of your home or office. Being able to quickly (and safely) change lenses in the middle of a photoshoot can mean the difference between capturing a fleeting image opportunity and missing it altogether.

Early morning sunlight ▶ illuminates the historic barracks at Fort Casey in northwest Washington state.

I took this photo with my digital SLR's standard 18-55mm lens.

Standing in the same ▶ spot as before, I switched to a wide-angle lens (12-24mm) to capture more of the overall scene. This is a favorite lens of mine—especially when going after sweeping views of the earth and/or sky.

...and then I swapped ▶ lenses for a telephoto unit (70-300mm) to capture a composition made up of porch seats and architectural details. This shot was taken from the same position as before, with the lens zoomed to about half its maximum level.

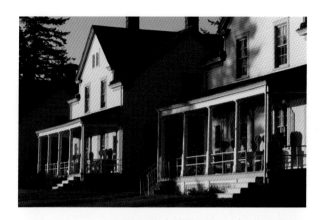

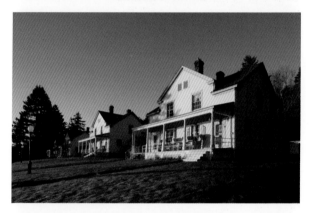

Intriguing optical effects can be achieved using low-tech alternatives to specialty lenses and digital after-effects.

Collect a small arsenal of pseudo "lenses" and explore their reality-altering potential. Investigate the effects of your camera's zoom and focus functions as you shoot through these alt-lenses. Save examples of your shots as a reminders of the kinds of effects you can apply to certain photo opportunities in the future.

In addition to the ideas shown here, try taking pictures through shards of colored glass, drinking glasses, eyeglasses, sunglasses, magnifying glasses, bubble wrap, discarded lenses from old cameras, marbles, binoculars.

The photos on the facing page were taken by aiming a pocket digi-cam at this mask through a variety of cheap, improvised "lenses."

Molded glass
container cover

Kaleidoscope

Peephole

Toy eyepiece

Leaning towers.

Keystoning is the **slanting, exaggerated per-spective effect** seen in the top image. Most lenses will cause keystoning when shooting upward at tall buildings, etc. Sometimes this is okay—especially in contemporary media where image "imperfections" are toler-ated as long as they work toward a desired style of presentation.

Software to the rescue.

If a perception of accuracy outweighs sty-listic ideals for a particular shot, you can "fix" the image using Photoshop's **DISTORT** function (ironically named in this case). This example shows how the handles around the image have been individually moved to warp the image in such a way that its ver-tical lines run parallel with the framing of the photo.

Done.

The final image was cropped from the adjusted Photoshop document. Now, the subject's verti-cal lines are parallel with the sides of the image.

Note: Keystoning such as this can often be avoided in the first place by using a wide-angle lens and finding a way to shoot the subject from a vantage point that is near its vertical center (from a nearby rooftop or the balcony of another building, for instance).

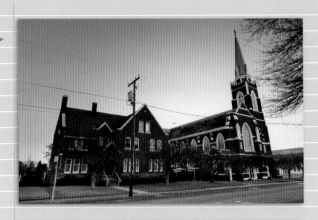

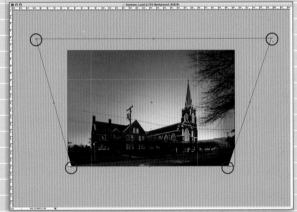

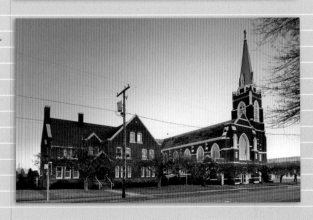

It takes a triad of components to produce eye-catching and aesthetically sound images using digital cameras and software: *creativity, camera competence, and software savvy*. Having addressed the first two elements of this trio already, this chapter sets out to exhibit a core set of software techniques that can be applied to improve the appearance and thematic impact of just about any picture you take.

Photoshop is used to demonstrate the topics in this chapter since it is perhaps the most widely used and versatile program in use today. If you already know how to use Photoshop, then you should be able to easily follow the demonstrations. If you do not know how to use image-oriented software (Photoshop or a similar program), it's time to think about learning. Why? Because software is to digital images as the darkroom is to film. Nearly all images depend on competent post-shooting handling to achieve their full potential.

section:

Digital Effects

Shooting conditions, camera settings and a camera's capabilities do not always come together in a way that produces images with a pleasing degree of contrast and visual "snap." Fortunately, dull images can often be rescued by using Photoshop's LEVELS controls. *In fact, just about any photo can benefit from some degree of* LEVELS *adjustment.*

LEVELS adjustments can also be used to create intriguing visual effects.

If you are an adept Photoshop user, these operations will probably be familiar to you. If not, they are easy to learn. If you need help, consult an experienced Photoshop user, the manual, or any of the numerous books or online sources that show how to use the functions of this remarkable image-enhancement program.

In its original form, this photo ▶ appears dingy and its colors seem muted. When the LEVELS panel is opened, gaps are evident at both ends of its histogram (circled). This means that the image does not contain areas that are either white or black. In most cases, it is desirable to see the histogram tapering out as it reaches each extreme (indicating that the values* in the image span the entire range of light to dark).

To expand the image's range of values to its fullest potential, the sliders ▶ at either end of the dark/light spectrum are moved to the point where the graph shows activity. This causes the computer to redistribute the image's values from pure black to true white. The middle slider, though not used in this example, can be used to weigh the overall appearance of the image toward a lighter or darker presentation.

More drastic slider movements can ▶ be used to create more artful, less realistic results. Also experiment with the channel menu at the top of this panel—this pull-down menu allows the levels of individual colors to be independently adjusted.

Value = the relative lightness or darkness of a color or shade compared to a scale of white to black.

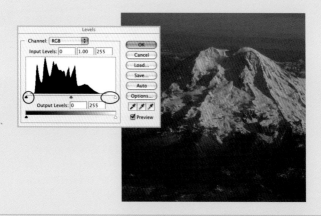

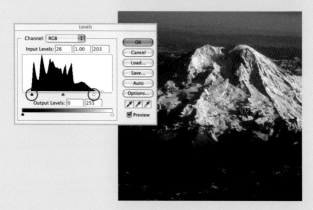

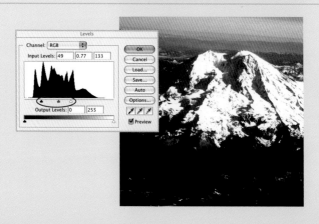

SECTION 3: DIGITAL EFFECTS

The appearance of this photo (first featured on page 141) is quite true to the actual conditions under which it was shot. The image displays a pleasing degree of value contrast throughout.

CURVES controls can be used to transition the emphasis of an image's values toward lighter or darker hues. Used more radically, these same controls can be applied to attain all kinds of far-flung visual effects.

CURVES and LEVELS controls are largely interchangeable. Many Photoshop users find that it is most efficient to first maximize an image's contrast using LEVELS controls (as demonstrated on the previous spread), and then applying CURVES controls to fine-tune the image's dark vs. light qualities.

To achieve a brighter presentation, ▶ a point has been added to the image's CURVES line. The point was then moved to create a new curve that results in a brighter presentation of the image. *It's easy to become acquainted with the workings of the* CURVES *control. Just click on the default line (top panel, opposite) to establish a new point and then move the cursor around until you see a result that you like.*

Here, both the top point (representing the image's highlights) and the bottom point (dark areas) have been moved inward to restrict the range of values in the image. The curve has also been reconfigured to intentionally "overexpose" lighter areas of the image while deeply saturating darker areas. The result, though not as true-to-life as the original, is striking and colorful.

Explore the effects of crazy modifi- ▶ cations within the CURVES panel. *Each of these examples demonstrates changes to the "master" channel within the* CURVES *panel. This channel affects overall relationships between the colors and values within an image. Adjustments to individual colors can be made by pulling down the "channels" menu at the top of the* CURVES *window.*

▲ BEFORE AFTER ▼

The photo used at the ▶ beginning of the color chapter was fairly vibrant when it was originally shot. However, since it was to be the flagship image for a chapter on color, its hues needed to be enhanced to their fullest (natural-looking) potential. HUE AND SATURATION controls are ideal for this kind of of color makeover.

Be sure to take advantage of your computer's UNDO and SAVE commands as you fearlessly explore all kinds of interesting color effects. Take chances; note your successes as well as your "failures"—something that does not work well for one image might result in an eye-catching transformation when applied to another.

The sliders with- ▶ in the master editing channel of the HUE AND SATURATION (H&S) panel can be used to apply global changes to an image. In this case, however, the master control has been left alone. Instead, the panel's pull-down menu has been used to select specific hues so that the saturation of each could be adjusted independently. *Notice the subtle but significant difference in the visual "pop" of the adjusted image (right) and the original (above).*

H&S controls can also be used to ▶ create unusual color effects. Here, the saturation of the red channel has been reduced to zero—this converts all red hues to grays. At the same time, the saturation of yellow hues have been amped to bring out colors in this range. The blue channel has been completely altered: Its color has been shifted to a green tone using the HUE control and the intensity of the resulting color was then muted by lowering its SATURATION value. Modifications such as these can quickly change a true-to-life image to something out of the ordinary.

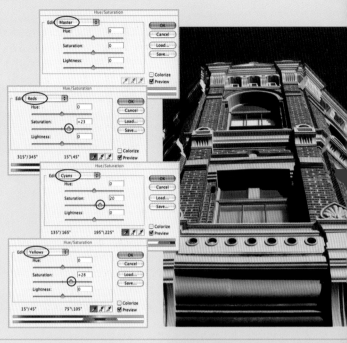

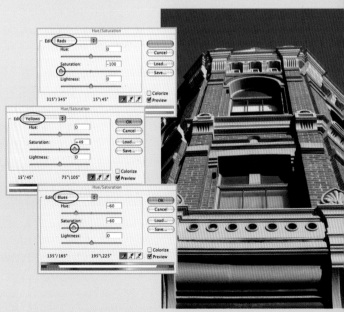

Adjustments within Photoshop can be made to blur the line between photo and illustration—to create images that are more artistic than realistic. SEE DIGITAL EXPLORATION..., PAGE 350, FOR A WIDE RANGE OF SAMPLES.

To create the image featured on page 110, the three controls featured on the previous pages were used: LEVELS, CURVES and HUE AND SATURATION (H&S). *Adjustment layers* were used to apply these effects (note the LAYERS palette below). Using adjustment layers—versus applying adjustments directly to an image via a pull-down menu—gives you the opportunity to revisit each adjustment since the controls in each layer can be reopened and readjusted.

Use *masks* to control the strength of an adjustment layer. Note how each of these masks (circled) have been painted with varying degrees of darkness to control the strength and distribution of their effects.* A clipping path was used to define the shape of the car in the H&S layer so that its color-cancelling effects would affect everything *except* the car.

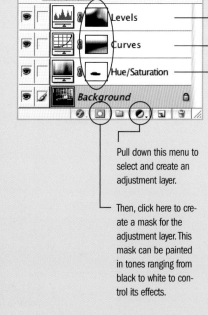

Pull down this menu to select and create an adjustment layer.

Then, click here to create a mask for the adjustment layer. This mask can be painted in tones ranging from black to white to control its effects.

*White areas of a mask allow the layer to function at full strength. Darker shades limit the mask's effects.

Right: The original image.

Below: Contrast is strengthened using LEVELS; the tone of the image is deepened using CURVES; and the colors in everything but the car are converted to grays using HUE AND SATURATION controls.

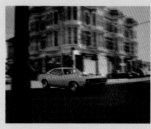

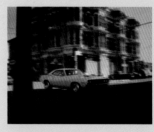

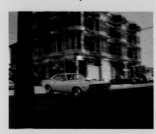

At the bottom of this page, the colorful image of the wasp featured on pages 28-29 has been converted to black and white using Photoshop's GRAYSCALE command. This method of converting a color image to black and white often works just fine, but before you settle on this technique, be sure to see if the image's grayscale potential could be better achieved by individually selecting one of its RGB components (as demonstrated on the facing page).

When an image comes from your digital camera, its color data is distributed in three channels: Red, Green, and Blue. Each of these channels can be viewed alone as a black-and-white image by selecting it in Photoshop's CHANNELS palette. Oftentimes, one of these channels will offer a black and white version of the image that is superior to the computer's default grayscale interpretation.

Notice the dramatic differences between each channel's presentation of a grayscale version of this image (right). If you want to use one of these RGB channels as the basis of a grayscale conversion, select the channel and *then* use the GRAYSCALE command. This will cause the computer to use only the selected channel's content to create a black-and-white rendering of the image.

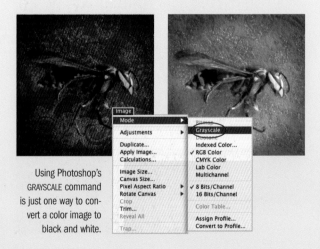

Using Photoshop's GRAYSCALE command is just one way to convert a color image to black and white.

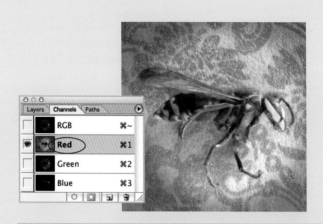

In addition to considering a black-and-white presentation for an image, you may want to think about tinting the image to give it a warm tone, a cool cast, or to transform it into an image made up of monochromatic hues.

In this set of examples, the colorful image from page 53 has been treated using the HUE AND SATURATION controls to limit its palette.

This technique can be particularly useful to commercial artists and designers who wish to use non-color images for stylistic or budgetary reasons.

In this example, the photo has been ▶ converted to an untinted black-and-white image using the HUE AND SATURATION control—a conversion technique that is worth considering in addition to those demonstrated on the previous spread.

Here, the image has been given a ▶ warm cast by activating the "colorize" button in the H&S panel and selecting this set of HUE AND SATURATION values (this particular formula was used to tint most of the monochromatic images in this book). Varying these sliders will result in different hues and strengths of the tints being applied. Experiment until you find a look that fits the presentation you are after.

To create this monochromatic version, the HUE has been shifted to an ▶ orange tone and the SATURATION has been increased. When applying this kind of effect, seek colors that complement and amplify the thematic look and feel of the image.

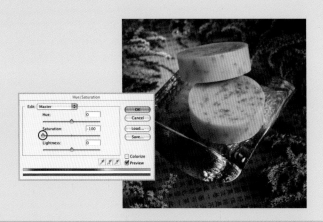

Even the BRACKETING feature of an advanced camera cannot overcome certain lighting challenges. In these cases, Photoshop's layer and masking capabilities can be used to replace poorly exposed areas of one photo with properly exposed areas of another. SEE **BRACKETING**, PAGE 310.

Hint: Since this technique requires stacking two or more images in Photoshop, use a tripod when you are shooting a scene that you think might cause this kind of exposure difficulties. That way, your images will line up exactly when you layer them in Photoshop.

The top two images, opposite, ▶ were taken using a digital SLR's BRACKETING feature. The foreground in the upper image looks good but the sky contains burned-out areas of overexposure.

The sky in this exposure looks ▶ fine, though now the foreground appears dull. Neither image is perfect as is, so Photoshop has been used to combine the better parts of each to create an attractive composite (below, opposite).

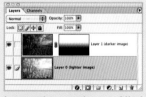

The repair process is initi- ▶ ated by placing the darker image in a layer above the lighter version. A mask was then applied to the top layer. This mask was filled with a gradation that created a seamless transition between the sky of the darker exposure and the foreground of the lighter exposure. The result: a well-balanced image throughout. When using this method, you may need to use selection and painting tools to create more complex masking layers (AS SEEN IN THE DEMONSTRATION ON PAGE 338).

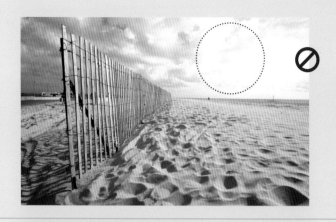

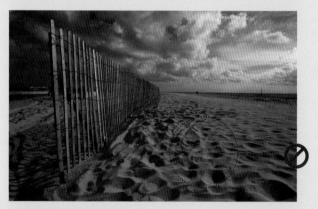

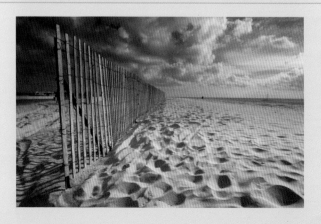

Clipping paths can be used to define regions of a photo where adjustments need to be made or to remove elements from a photo entirely.

The POLYGON LASSO TOOL (demonstrated here) is often the best bet when it comes to manually creating a clipping path around a complex form within an image.

In this demonstration, a clipping path has been drawn around the motorcycle and its rider from page 319. Once selected, the knock-out image has been set against the page *sans* backdrop.

It can be tricky getting the mouse ▶ to follow the outline of a free-form shape using the regular LASSO TOOL. Instead, try zooming in and using the POLYGON LASSO TOOL—this allows you to follow complex shapes using a series of straight and easily controlled lines. Try to aim the tool just inside the edges of the object you are selecting so that you will be able to soften the outline later on by feathering it.

Once a subject has been complete- ▶ ly outlined using the POLYGON LASSO TOOL, adjustments and masks can be applied to the selected area. Here, a layer mask has been applied in preparation for removing the subject from its original backdrop.

Hint: Lasso small areas at a time and combine them by holding down the shift key each time you start a new selection. This keeps you from having to redo the entire selection if you make a mistake.

Before copying the extracted image and pasting it onto ▶ this colored background, the edges of the mask were feathered 2 pixels. Such feathering subtly softens the transition between a pasted image and its backdrop (without it, there would be a harsh, bitmapped line between the overlaying image and its backdrop). The airbrush tool was used to add hints of a faux shadow beneath the motorcycle.

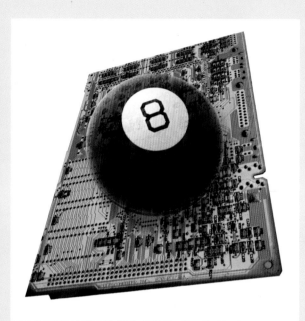

Mastery of Photoshop's advanced controls is not necessary for the creation of intriguing and artful images. The combination of an 8-ball and a colorful circuit board featured on page 57 was created using just five basic Photoshop controls: DISTORT, INVERT, HUE AND SATURATION, and LEVELS.

If you are familiar with these controls, you will be able to easily follow this demonstration and apply its ideas to images of your own. If you are new to Photoshop, or have not yet learned how to take advantage of features such as these, consider taking the time to learn how to use them. If you are a hands-on learner (as many designers and artists are), import photos of your own into Photoshop and experiment by applying controls such as these—as well as any others that interest you—to your image.

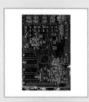

1. The original photo of a circuit board is opened in Photoshop.

2. The entire image is selected and put into faux perspective using the DISTORT controls.

3. The image is INVERTED to create a negative version of the circuit board. A clipping path has also been drawn around the circuit board and a mask has been applied to remove the small amount of background that showed at the bottom of the board.

4. HUE AND SATURATION controls are used to alter the photograph's hues. Take advantage of your computer's capabilities: experiment and play around with controls such as these until you see a result that you like.

5. LEVELS controls are used to strengthen the contrast among the colors and values in the image for greater visual impact.

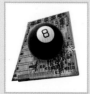

6 and 7. An 8-Ball—removed from a photo via POLYGON LASSO TOOL—is placed over the circuit board and a blue DROP SHADOW is applied beneath the ball. A layer-mask with a semi-opaque area at the top was applied to the ball to create the translucent effect between parts of the ball and the circuit board (as seen on the opposite page).

◀ POSTERIZE an image to simplify its colors and give it a more graphic presentation.

▼ INVERT! Images of people, places and things take on a whole new look when seen in negative form.

Explore all kinds of alternate visual universes using Photoshop's filters and effects.

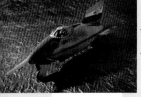

Here, a sampling of effects has been applied to the rocket ship first featured on page 61.

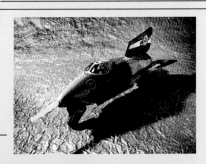

▲ Transform images into pseudo-paintings with artistic filters such as Photoshop's FRESCO.

◀ The TWIRL filter can be used to turn just about any image into an interesting abstraction.

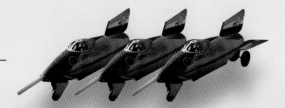

◼ Create a clipping path to separate your subject from its backdrop and then clone away...

▶ This pop art effect was achieved by applying the COLOR HALFTONE filter and placing the resulting image in a layer above an untreated original (using the SOFT LIGHT command between layers).

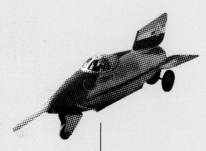

▶ The NEON filter was used to create this flattened sci-fi effect. A DROP SHADOW was applied to add a sense of dimension between the image and the page below.

◼ Photoshop's powerful LIQUEFY controls can be used to do all kinds of crazy things to an image. Try them out on a picture of a toy, person or pet.

Glossary
and Index

Ambient light. The naturally occurring illumination existing within a scene.

Aperture. The adjustable iris-like opening inside a lens that controls how much light reaches the image sensor. Some cameras allow for manual control of the aperture opening—others handle its functions automatically. Aperture affects both exposure and depth of field.

Auto focus. A feature that allows the camera to automatically focus on a subject. Most digital cameras use either infrared light or ultrasound to measure the distance to the subject and adjust the lens's focus accordingly.

Backlighting. A lighting arrangement where the subject is between the camera and the light source.

Bracketing. A technique of taking a set of photos—each shot at a slightly different exposure—to help ensure that at least one is properly exposed. Full-featured digital cameras usually offer an AUTOMATIC BRACKETING feature.

Channel. One segment of the three spectral components in which digital cameras record their images. The three channels of a digitally recorded image are red, green and blue.

Clipping path. A Photoshop term for the selection line drawn around a specific portion of an image.

CMYK. Abbreviation for Cyan, Magenta, Yellow and Black. For most printing purposes, images need to be converted from their native RGB mode to CMYK via software.

Continuous shooting mode. A feature of many digital cameras that allows them to take a steady stream of shots while the shutter button is held down.

Crop. To select only a desired portion of an image for display.

Curves. A highly adjustable Photoshop control that allows the user to control the distribution of values and hues within an image.

Depth of field. The zone in which the camera sees things as being in focus. Objects outside this zone (both nearer to and farther from the camera) appear out of focus. Depth of field is the product of several factors: the focal length of the lens being used; the distance to the object being focused on; and the aperture opening (a narrower opening means a deeper depth of field; a wider opening means a shallower depth of field).

Desaturate. The removal of all color hues from an image. Desaturation results in a black-and-white image.

Diffusion panel. A translucent sheet of fabric or paper that is placed between a light source and the subject to soften the light's effect.

Exposure. The amount of light that reaches the image-sensor to create an image.

Exposure compensation. A semi-automated feature of most digital cameras that allows the user to lighten or darken the images they are taking by selecting a value from

+2 (brighter) through -2 (darker).

Framing. A visual term used to describe when certain elements of a composition enclose others.

Grayscale image. Another term for a desaturated (black-and-white) image.

Histogram. A graphic read-out that displays the brightness and contrast levels within an image. Photoshop's LEVELS control features a histogram. Many cameras also offer a histogram view of their images through the LCD.

Hue. Another term for color.

Hue and saturation. A control within Photoshop that allows for adjustments to the color, intensity and brightness qualities of a specific hue—or all hues globally—within an image.

Keystoning. The effect that occurs when a lens causes lines within an image (lines that should be parallel) to converge.

Knock-out. An image whose subject matter's background has been removed (via a clipping path, in the case of digital images).

Lasso tools. A family of tools within Photoshop that are used to manually draw clipping paths.

LCD. Liquid Crystal Display. A panel on the back of most digital cameras that can be used as a viewfinder, to review images, and to control menu items.

Levels. A control within Photoshop that allows adjustments to be made

to an image's range of values and color balance.

Light table. A rectangular box or tabletop enclosure equipped with lights that shine from beneath a frosted glass surface.

Macro lens. A lens specifically designed to take close-up photos. Most macro lenses have a magnification ratio of 1:1 or greater.

Megapixel. One million pixels. The size and quality of most digital camera's image-capture capabilities are measured in megapixels.

Monochromatic. An image or scene that is composed of values of one hue.

Monopod. A single leg (usually telescopic) with a camera-mount at the top. Used for steadying the camera.

On-camera flash. The on-board flash unit built into a camera.

Overexposure. The effect that occurs when cells of the image sensor receive so much light that the corresponding areas of the image are pure white.

Pixel. A single cell within the complex grid of individual hues that make up an image captured by a digital camera.

Reflector. Anything used to bounce light into shadow areas of a scene. Also the name of a photographic aid (usually a flexible disk of reflective fabric) used for these purposes.

Resolution. The level of detail recorded by a digital camera. Also the level

of detail present in an on-screen or printed image.

RGB. Red, green and blue: The three colors with which digital cameras and computer monitors build their images. Images in RGB format can be converted to other color models (such as CMYK) using software.

Saturation. The intensity of a hue. Highly saturated colors are at their most intense. Colors with low levels of saturation appear muted.

Shutter speed. The duration of time during which the shutter is open (and thereby allowing light to reach the image-sensor) during a shot.

SLR. Single Lens Reflex. A camera whose viewfinder sees through the same lens that will be sending light to the image-sensor. The lenses on most SLRs are interchangeable.

Standard zoom lens. A versatile lens that has a field of view comparable to the human eye's central viewing area. This lens is also capable of moderate image magnification.

Tangent. The visual meeting point between two lines or surfaces.

Telephoto lens. A relatively compact lens capable of a wide range of telescopic magnifications.

Tint. A hue that has been applied to a grayscale image to give it a monochromatic color scheme.

Tripod. A three-legged camera steadying device. The legs of most tripods are telescopic and can be compacted for ease of transport.

Underexposure. The effect that occurs when cells of the image-sensor have not received enough light to fully portray the corresponding areas of an image.

Value. The relative lightness or darkness of a color or shade compared to a scale of white to black.

Viewfinder. The small optical window on many cameras that is used to compose shots.

Visual hierarchy. The varying degrees of importance and visual attraction among elements of a composition.

Visual texture. A dense repetition of elements that form anything from an organized pattern to a free-form, chaotic assemblage.

White balance. The way in which a camera measures and records prevailing light so that whites—as well as all other colors—appear normal to the eye of the viewer.

Wide angle lens. A lens with a broad field of view.

MORE GREAT IDEAS FROM

COLOR INDEX

BY JIM KRAUSE

ISBN 1-58180-236-6, VINYL PB, 360 PAGES, #32011-K

MAKE THE COLORS IN YOUR DESIGN POP OFF THE PAGE! OVER 1,100 EYE-CATCHING COLOR COMBINATIONS AND FORMULAS HELP YOU SOLVE DESIGN DILEMMAS BY MIXING AND MATCHING A SEEMINGLY ENDLESS ARRAY OF POSSIBILITIES! COLOR INDEX IS PERFECT FOR PROFESSIONALS, AMATEURS, AND ALL STUDENTS OF VISUAL MEDIA.

IDEA INDEX

BY JIM KRAUSE

ISBN 1-58180-046-0, VINYL PB, 312 PAGES, #31635-K

WHEN DEADLINES ARE LOOMING, THIS IS THE GUIDE YOU'LL WANT ON HAND WHEN YOU'RE LOOKING TO CREATE KNOCK-THEIR-SOCKS-OFF DESIGNS FOR GRAPHICS AND TYPE TREAT-MENT. IDEA INDEX UNCLOGS YOUR MIND WITH OVER 130 IDEAS TO STIMULATE, QUICKEN, AND EXPAND YOUR CREATIVE PROCESS AND IS ESPECIALLY HELPFUL FOR FREELANCE DESIGNERS AND OTHERS WHO BRAINSTORM SOLO.

LAYOUT INDEX

BY JIM KRAUSE

ISBN 1-58180-146-7, VINYL PB, 312 PAGES, #31892-K

IF YOU'RE A DESIGNER WHO'S STRUGGLING TO COME UP WITH FRESH NEW VISUAL ELE-MENTS, IT'S TIME YOU DISCOVER THIS POCKET-SIZED COLLECTION OF THOUGHT-PROVOKING, CLEVER LAYOUTS THAT RANGE FROM TRADITIONAL TO CUTTING-EDGE DESIGN. IN LAYOUT INDEX, YOU'LL FIND THE INSPIRATION TO MAKE EACH NEW CREATION UNIQUE AND ORIGINAL.

THESE AND OTHER FINE BOOKS FROM HOW BOOKS ARE AVAILABLE AT YOUR LOCAL BOOKSTORE, ONLINE SUPPLIER, OR BY CALLING 1-800-448-0915.

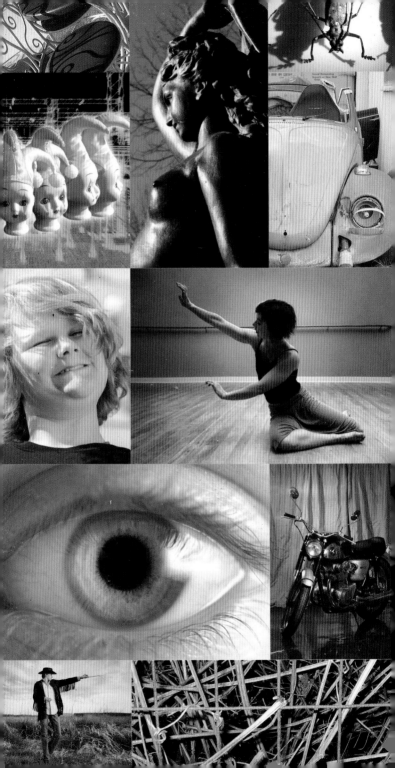